❧ WOMEN OF THE FIELDS

Women of the fields compares and contrasts the relationship between women's farm work and the imagery that surrounded it. Historians usually assume that women's work in agriculture increased from the late eighteenth century, began to decline in the 1850s, and vanished at the end of the nineteenth century. In contrast, the same period saw the steady and widespread growth of the rural idyll and the myth of the ideal wife and mother who supposedly lived in a rose-covered cottage, beside a village green, surrounded by a bevy of children and chickens.

This book rewrites agricultural history by putting the work done on the farm in a cultural context. Within this analysis, working-class women are not seen as passive victims of the middle class, but as active agents who frequently defended both their work and their rights as they saw them. *Women of the fields* describes the work that women did in agriculture, as seen in the parliamentary reports of 1843, 1867, and the 1890s and the meanings given to that work in the local and national press, farming advice books, autobiographies, and the art and literature of the period.

The author places her analysis within the context of the changing nature of agriculture at this time, in particular in the counties of Norfolk, Northumberland and Somerset, and explores the complex issues in terms of both class and gender.

Karen Sayer is a Lecturer in History at the University of Luton

Women
of the fields

REPRESENTATIONS
OF RURAL WOMEN
IN THE NINETEENTH CENTURY

Karen Sayer

Manchester University Press

MANCHESTER AND NEW YORK

distributed exclusively in the USA and Canada by St. Martin Press

Copyright © Karen Sayer 1995

Published by Manchester University Press
Oxford Road, Manchester M13 9NR, UK
and Room 400, 175 Fifth Avenue, New York, NY 10010, USA

Distributed exclusively in the USA and Canada
by St Martin's Press, Inc., 175 Fifth Avenue, New York, NY 10010, USA

British Library Cataloguing-in-Publication Data
A catalogue record is available from the British Library

Library of Congress Cataloguing-in-Publication Data
Sayer, Karen, 1967–
 Women of the fields : representations of rural women in the
nineteenth century / Karen Sayer.
 p. cm.
 Includes bibliographical references and index.
 ISBN 0-7190-4142-2.
 1. Women in agriculture—Great Britain—History—19th century.
I. Title.
HD6073.A292G77 1995 94-41738
331.4'83'094109034—dc20 CIP

ISBN 0 7190 4142 2 *hardback*

First published 1995
99 98 97 96 95 10 9 8 7 6 5 4 3 2 1

Printed in Great Britain
by Redwood Books, Trowbridge

Twinkle, Twinkle, little bat!
How I wonder what you're at!
Up above the world you fly,
Like a tea-tray in the sky.

<div align="right">Lewis Carroll, Alice's Adventures in Wonderland</div>

To my parents, Iris and Peter Sayer, who taught me to look at the world from a different perspective

≈ CONTENTS

❧ LIST OF PLATES

1 *Little Bo-Peep*, Margaret Thompson and William Rowe
 (By permission of the Special Trustees for St Thomas's Hospital)

2 *Bubbles – A Cottage Scene with Children*, John Dawson Watson
 (Courtesy of the Trustees, Cecil Higgins Art Gallery, Bedford)

3 *Gleaning*, Arthur Foord Hughes
 (Courtesy of the Fine Art Photographic Library Ltd.)

4 *Harvest Time*, George Vicat Cole
 (Courtesy of the City of Bristol Museum and Art Gallery)

5 *By the Farm Gate*, Henry John Yeend King
 (Courtesy of Sotheby's)

6 *One of the Family*, F. G. Cotman
 (Courtesy of the Board of Trustees of the National
 Museums and Galleries on Merseyside, Walker Art
 Gallery, Liverpool)

7 *Return of the Reapers*, Henry La Thangue
 (Courtesy of the Tate Gallery)

8 *Shepherd with a Lamb*, George Clausen
 (Courtesy of the Trustees, Cecil Higgins Art Gallery, Bedford)

9 *Milking Time*, William Mark Fisher
 (Courtesy of Sotherby's)

10 *Winter Work*, George Clausen
 (Courtesy of the Tate Gallery)

The plates appear between Parts II and III, pages 116–17

I, like many feminist academics want to locate myself for my reader, in order to expose some of the hidden motivations within my work, and to therefore make my work 'subversive'. For example, I feel that I should explain that I come from the East Anglian countryside, and this shaped my desire to write this book. I wanted to uncover some of the histories and explore the myths associated with the place I came from and the people there. However, though many friends and members of my family have worked on the land, I never have. If I accuse Jessie Boucherett of being at a social distance from her subject, when she wrote about fieldfaring women, then I should also point the finger at myself. I come from what can loosely be termed the rural lower middle class; I barely have an accent and I have an extensive education. On top of this, I am distanced from my subject by time. Those of us who are academics are often remote from the people and places we study. I also believe that this *does* make a difference to our work. Historians and feminist academics belong to their own very specific institutions – not as 'ivory tower' as they once were, but still pretty alien to the rest of the population – use their own exclusive language, claim their own expertise. This has caused increasingly agonised debate within the current women's movement, especially with the growth of Women's Studies, which is all too conscious of its possible remoteness from the everyday life of most women. I have therefore attempted a deliberate resistance, by trying to explain the theories I have used, and by avoiding a jargon-heavy style. But I still want to know if it is really possible to escape these structures; will grass-roots feminists really read my work?

The process of representation still shapes the way that we are taught to think about women – and, indeed, the countryside. We can resist the meanings of the images we see in films, adverts, TV, magazines, but why are they there, why do we need to resist them, what effect do they have on us? I place my work within the framework of these kinds of questions. To me, history is a very political subject, whether or not this is explicit within an historian's approach. History itself is far from being just about the past. It is a powerful element within a society's culture and ideology. History is the study of kowledge about the past, seen through the eyes of the present. It has often hidden as much as it has revealed, especially if we are going to think about women, and there are many approaches to the subject. It is important because it gives us a 'map' of the present, and it can be used as a way of legitimising, or resisting, authority. I use a very 'interdisciplinary' approach; I look at many texts and stray into other disciplines, but always with 'women-centred' focus. Each discipline – for example

literature or history – is really just a different 'mode of representation', a different way of talking about what happens or what has happened; literature and history are, on one level, just stories that help us to understand our culture and society. 'History' itself is now often seen to include tradition, memory, and everyday experience, as well as academic versions of the subject.

I have therefore tackled the representation of rural women – especially field women – politically, as a woman form East Anglia, who teaches history and who likes to go beyond the realms of what Seller and Yeatman called *1066 and All That*, by using a variety of texts and straying into the territory of other modes of study. I am aware, however, that no matter how 'self-conscious' I am, I am still shaped by the 'dominant hegemony', I still belong to a particular 'discourse' and work within a specific 'set of practices' or 'codes'.

K.S.

ᴅ᷎ ACKNOWLEDGEMENTS

I would like to thank the staff of the following libraries and archives: the British Library at Great Russell Street and Colindale; the Fawcett Library; University of Sussex Library; University of Luton Library; Trinity College Library; the Norfolk and Norwich Records Office, recently damaged by fire; and the Stockton Trustees.

I am also grateful to the following people for their help and support: my teachers at Portsmouth Polytechnic (as it then was), particularly Ena Ainsworth, who introduced me to this subject; my DPhil supervisor at the University of Sussex, Alun Howkins; the Gender and Feminist History Group at the University of Sussex, especially Gerry Holloway, who read and and re-read the thesis; the staff, volunteers, and Executive Committee members of the Fawcett Society; Jennifer Francis; and my colleagues at the University of Luton. In particular, I want to thank Ruth Robbins, who has tirelessly provided sound advice, criticism and encouragement; her friendship has been an invaluable source of inspiration. Last, but certainly not least, I want to thank Matthew Hoskins for technical advice about the realms of publishing and for human warmth.

Chapter 7 is a longer and substantially revised version of 'Field-faring women: the resistance of women who worked in the fields of nineteenth-century England' in *Women's History Review*, 2, no. 2, 1993.

❧ INTRODUCTION

Man for the field and woman for the hearth
Alfred Lord Tennyson *The Princess*, (1847).

This quote comes from a moment when English agriculture was at its height, producing more food than ever before; when the majority of the population still lived in the countryside; when women stayed at home as moral guardians of their families, to care for their children and soothe the troubled brows of their husbands; when men worked for their nation and their community; when children, saved by beneficent legislation, were finally able to play and begin to get an education. If this sounds ideal, it is. It was an ideal in the 1840s, and now belongs to a nostalgic vision of English history, constructed through the intersection of gender, class, and Englishness. These three ideologies coincided within the new versions of Georgic pastoral that emerged in the late eighteenth century – the representation of an idealised rural life found in literature and art, which came to provide a model of a simpler way of life based on honest toil. The result of this coincidence was the creation of the myth of rural femininity in which the most perfect of women lived an industrious and honest life, in an English country cottage. It is my intention to look at the construction of this myth, not by comparing it to an ephemeral 'lived' experience, which we as historians, distanced by time, class and probably environment, maybe even sex, with limited access to sources, can never hope to recreate, but by looking at the life of the poor rural woman as constructed by the middle class. This is a complex project, therefore before I begin, I need to define the terms I shall be using and provide some kind of theoretical framework.

As Michèle Barrett says, when looking at the creation of a myth, we must not only look at the images of women in a text, and for possible readings, but also at the material conditions of production, the material conditions which affect writers and artists in terms of their perception of society, their choice of form, genre, style, tone, implied reader and representations.[1] A representation can be seen as a language, a form of communication, based on shared understandings between the author and their audience. There are different systems of representation, or dis-

courses, which provide author and audience with a context in which meaning is created, for example the discourse of femininity, the discourse of pastoral, the discourse of literature. According to Foucault, these discourses can include not just the written or spoken word and visual images, but also the institutions associated with them. Discourses can intersect and share meanings, but they can also contain specific meanings which change over time. One should also look at the reception of a text in relation to the readers' material and social positions. In this study, I have incorporated this approach in my analysis of the reports written on women's paid work in the fields. The middle-class men who wrote the reports were at a remove from their subjects in terms of class, gender and location, and this is vital to our understanding of what was written and of the legislation which was passed. It is reasonable to assume that the men who wrote the reports had been educated by, and probably continued to read and receive, much of the art, literature and journalism of their day. Their actual consumption of the images of rural women found within these texts can be judged from their apparent perceptions of the women they then studied. The reports they produced tell us far more about the culture of the period in which they were written, or the discourses within which these men worked, than about the women themselves, and that culture is closely related to the material and social conditions under which such texts were produced. This book is therefore partly a study of the relationship between class and gender as seen in the interrelationship of a variety of texts. As Lynda Nead says, the dichotomy of the good/bad woman, which informs the discourse of femininity, is class specific, therefore '[the] representation of woman can never be contained within an investigation of gender; to examine gender is to embark on an historical analysis of power which includes the formation of class and nation'.[2]

This relationship does not have to be direct to be significant; it would not be possible to say, for example, that in paragraph x the reporter referred to an image seen in line y of a specific poem. We cannot specify what the meaning of line y would have been to that reporter. There is no intrinsic meaning in a text; a novel or a picture can be read in many different ways. Nor, as Barrett says, do texts directly reflect social reality or ideology; but they can give us 'an indication of the bounds within which particular meanings are constructed and negotiated in a given social formation'.[3]

The myth of rural femininity contributed to the production of the wider definition of domesticity in the nineteenth century. Barrett usefully pinpoints four specific processes aiding the construction of femininity then and now: *stereotyping* – seen by Barrett as patriarchal

'wish-fulfilment; *compensation* – the elevation of femininity/feminine values; *collusion* – the 'attempts made to manipulate and parade women's consent to their subordination and objectification' and 'women's willing consent and their internalisation of oppression'; and *recuperation* – the 'ideological effort that goes into negating and defusing challenges to the historically dominant meaning of gender in particular periods',[4] and this is a useful place to begin.

In this way I am effectively treating the parliamentary reports as historically specific cultural products, which belong to the ongoing construction and re-construction of the bounds and definitions of femininity and masculinity in the Victorian period, and which can be situated within the discourse of a newly professionalising bureaucracy. We can see the intersection of a variety of ideologies in the reports, which contributed to and come from the middle class hegemony of the time – Gramsci's theory of the complex way in which the ruling class maintains its authority to rule over other classes, through coercion and consent, in the social, political and economic arenas.[5] The reports, like novels or paintings, are also texts which contain 'a multi-dimensional space in which a variety of writings, none of them original, blend and clash. The text is a tissue of quotations drawn from the innumerable centres of culture. ... a text's unity lies not in its origin but in its destination'.[6] Barthes goes on the argue that the reader, rather than the author, then defines the reading of the text, and that it is not possible to pin down the reading to any particular moment in time. I am interested in the way different writings intersected at a specific period, in order to understand how meanings blended and clashed with particular effect in the nineteenth century. I have therefore used historically specific destinations for my analysis, and rather than a notion of one 'reader' I have focused on many 'readers', that is the parliaments of 1843, 1867–70, 1890 and the world of the publicists, who continued to re-create their own 'tissue of quotations' in the public arena of social concern, until satisfactory corrective legislation was passed.

In this I am not trying to say that there is an authentic reality, which novels, art, poetry, or even official reports should be faithfully reproducing, or that it is possible to read these texts as they were read when they were produced; this is neither possible, nor desirable. I am looking at the way in which the production of myth itself directly affected the lives of rural women; considering the effect on the dominant ideology of finding that the 'reality' did not fit the myth, and asking why this happened at that particular time. The myth of the rural woman is still with us and is still being constructed through the ever-changing discourses of femininity, national identity and pastoral, in many media;

the texts that I look at are part of a continuum of meanings, a chain of mythology.[7]

Women who worked and lived in the industrial and urban environments of the nineteenth century have been widely studied by feminist and socialist historians. For example the work carried out by Sally Alexander has looked at women's paid work in London, 1820–50;[8] Angela John has studied the women who laboured in the mining industry[9]; and there are now numerous narratives on and analyses of prostitutes and the Contagious Diseases Acts of the second half of the nineteenth century.[10] Since the publication of Sheila Rowbotham's *Hidden from History* (1973), there has been a virtual explosion of histories that aim to make women visible. Historians have also studied how *laissez-faire* was rejected in favour of protective legislation in the case of women and children, and how from the late eighteenth century perceptions of class and gender interwove to give rise to a relatively unified middle-class ideology of correct feminine behaviour, despite the material, political and geographic divisions within that class.[11] And, in the process, it has also been found that there were dissenters to this apparent hegemonic consensus. Men like Arthur Munby prove the rule by showing that individuals still lived by their own standards.[12] But amongst this ever-increasing body of research, and despite considerable historical work on women in rural America – largely initiated by interest in the pioneer woman as reality and as image – there has been very little written on poor labouring women who took paid work on English farms. Ivy Pinchbeck's first five chapters of *Women Workers and the Industrial Revolution* (1930) still constitute the most extensive piece of empirical research on women's work in agriculture, and many historians still rely on her work as an important source of data.[13]

We should ask how the paid work that agricultural women did, the legislation on their work, and the images produced around them compare with what we have discovered of urban and industrial women's lives. Studies on women who took paid agricultural employment have begun to show the way in this field by looking at what the women in question did, where, when and why.[14] But none have looked at the representation of these women in wider middle-class culture to see how this may have affected state intervention, or to see how the images fitted in with and affected the dominant definitions of femininity in the nineteenth century. Nor have recent sociological and geographical studies on the family farm and rural society addressed the past in any meaningful way.

By neglecting rural women, historians have overlooked an important arena for the construction of middle-class femininity. As Leonore

Davidoff *et al.* have noted, it was the wives and mothers who lived in the countryside and inhabited that most perfect of all homes, the cottage by the village green, who were supposed to epitomise the true ideal of femininity in their purity, innocence and sense of community.[15] The realisation of the two ideals of home and village community, which can be called the 'Beau Ideal' – 'that type of beauty or excellence, in which one's idea is realised, the perfect type or model' (*OED*, 1820)[16] – can be seen in the concrete reality of suburbia, model villages and the desire to escape the urban masses, which began to permeate bourgeois culture in the 1830s.[17] What happened when that ideal was found to be 'incorrect' or, rather, misplaced?

Women participated in a wide variety of paid and unpaid agricultural work during the nineteenth century. Their numbers fluctuate according to the season, area and the period under consideration.[18] Their pay varied according to the work they did, the county and even village they lived in, and, again, the date. The specific tasks they were involved in depended upon the kind of agriculture that was predominant in their area, the size of the farm, their class, and the period in question. The social and economic issues surrounding landowning and farming women in particular are very different to those surrounding lower class women, and in fact remain beyond the scope of this book. As we shall see, the liberal feminist Langham Place Group, founded in the 1850s to campaign for the right of married women to own property and the right of single women to work, suggested that wealthy women should take up farming as a fruitful and potentially respectable occupation. One of the group's number, Jessie Boucherett, came from a family connected with agricultural production and one of Barbara Bodichon's friends, Matilda Betham-Edwards, inherited a farm which she ran for a short time, before getting her living by writing.[19] Aside from this, not all lower class women in the country who took paid employment worked in agriculture. In fact, according to Alun Howkins' adjusted figures, only 0.63 per cent of country women were farm labourers at the peak of their employment in 1871.[20] Throughout the nineteenth century the majority of working-class women in paid work were actually domestic servants, whether employed in town or country. Hannah Cullwick and Hannah Mitchell were typical in that they went into town service, having been born and bred in the countryside.[21] Often, all that can be said is that the majority of women from working-class families did have to take paid work of some kind and that their final decision rested upon the jobs they could get in their area, the money they had at their disposal – service required the purchase of a uniform in many cases – and the age of any children in the family. A daughter would often stay at home to baby-sit

while the mother did the remainder of the housework, outwork, or went out to take paid employment.

Those women who took agricultural work were therefore married, widowed and single. Some only did harvest work, such as binding and gleaning. In the first few decades of the century they also reaped beside the men, and carried on doing so during the hay harvest and where the sickle did not replace the scythe in the corn-harvest.[22] As Michael Roberts has said, the corn-scythe was gradually introduced to English farming from the fourteenth century onwards. The process of replacing the sickle was a slow one, dependent upon overall cost-effectiveness, but by the end of the century the corn-scythe had become dominant, threatened only by the new reaping machines. This affected the extent and kind of women's work, as well as pay, at harvest-time because the sickle was seen as a women's implement, due to prevailing definitions of skill and strength. This meant two things for the women: firstly, that they were paid less than men as the corn-scythe took over, where they had been paid at the same rate; secondly, that there was steadily less demand for women who could reap, where previously they had been an asset.[22] Beyond harvest work, many women pieced together a variety of jobs in order to keep up a steady, though low, income throughout the year. These were mostly done out in the fields, for example stone-picking, muck-spreading, weeding, hoeing, pulling up and cutting turnips or mangolds, and were often physically hard, carried out in poor conditions, universally badly paid and rarely recognised as skilled.[23] Only those labourers who were perceived to be skilled could get annual employment – looking after stock, ploughing, hedging and ditching – and, as we have already begun to see, 'women's work' was generally not defined in this way. The only women to be employed by the year were farm servants and dairymaids. Farm servants did domestic work on the farm, and were available to do field, harvest and dairy work when required. They were often unmarried girls from labouring families who took this kind of job as a first step onto the ladder of service. Dairymaids, specifically hired for the task, *were* recognised as highly proficient employees, on whom the economic welfare of the farm could depend, but usually the farmer's wife took on this responsibility as part of her unpaid labour.[24]

The women who did paid agricultural work may not appear significant to us now. They did not have the numerical impact of factory women or servants, they of all working women seem to us to have led an idyllic life; even when they worked they were in the fresh air and were not using dangerous chemicals. However, like the pit brow lasses, 'what is more important is the fact that, ... they managed to cause such a stir.

The interest which they aroused ... was out of all proportion to their numbers'.[25] And this is what I want to address.

The counties of Norfolk, Northumberland and occasionally Somerset will provide us with a sense of the variety of experience of agricultural employment in nineteenth-century England. These are not intended to be representative regions; as Raymond Williams suggested in *The Country and the City* (1985), there are no representative regions in rural England.[26] Agricultural practice, wages and conditions were diverse throughout the eighteenth and nineteenth centuries; as I have already suggested, they varied from parish to parish, let alone from county to county. Region is also very important within rural history and in cultural representations of the countryside, because although the economic, social and political experience of the labourer – man, woman and child – varied considerably, region can also relate each villager's or labourer's sense of place, in terms of their familiarity with their local community's culture or traditions, their perception of social position within that community and others they might visit, and their experience of being different to individuals or groups from other places. As Alun Howkins has said, 'The term labourer ... is apparently an unproblematic one, yet it is hedged around with difficulties ... there is no such thing as an ordinary farm labourer and the description hides a variety of skills and status divisions'. As there was no one kind of female agricultural worker – they were married, single, widowed; part-time, full-time, casual, seasonal; well-paid, low-paid, paid in kind, paid in cash; they lived in or at home, and so on – so there are the same divisions, social economic and geographic, among men.[27]

The late eighteenth century saw a huge growth in agricultural production as new methods and working practices were introduced, but in the early nineteenth century this process of growth was interrupted, although longer term changes in the level of mechanisation and the organisation of labour continued. This was not a golden age of milk and honey for the labourer, as common lands were lost and prices rose; at times even farmers and landowners felt the chill winds of slump. During the agricultural depression that followed the Napoleonic wars, rich and poor were affected. Agriculture regained its prosperity from the 1840s, the period of 'High Farming', when even the repeal of the Corn Laws had little effect on the profits of the new agri-capitalists, although many smaller farmers fared less well. Though the application of 'modern' farming methods was still patchy and uneven across England – many farmers in Cambridgeshire and Sussex still used old techniques, such as oxen as draught animals – many farmers mechanised their methods of production.

Agricultural fortunes changed dramatically again in the 1870s,

when production was beset by strikes, floods and plague. American imports of grain and then livestock began to compete with home-produced cereals and beef. English agriculture fell into a slump. On top of increased competition there was disease in sheep and cattle, poor weather which destroyed crops and spread disease and widespread labour disputes between 1875 and 1879. The Education Act of 1870 partially removed children from the land, so labourers had to work harder to maintain the family income. Throughout this period, agricultural wages continued to fall in the south of England, and were not especially good even in the north, where competition with industry kept them higher. As the fortunes of farmers declined, and mechanisation spread, there were also fewer jobs to go round – though some of the new machines still needed labourers to serve them – and falling prices pushed wages down so that labouring families were left below the breadline. This poverty contributed to the formation of the National Agricultural Labourers' Union by Joseph Arch in 1872.

The government set up a commission to inquire into the state of agriculture in 1879; the Agricultural Holdings Act of 1883 came out of this and tried to enforce lower rents and better rights for tenant farmers. In 1892 the state tried to stem the flood of migration to the towns through another Holdings Bill on smallholdings and allotments; finally, an act which reduced agricultural rates was passed in 1896, despite a widespread outcry from urban MPs. Things began to improve again for farmers and landowners from 1900, but English agriculture was never going to return to the prosperous years of 1840–73, competition remained a constant and the work-force had largely left the land. By the end of the century wages had fallen by 20 per cent since the 1870s. Thousands of labourers' families had left the countryside. Over a million rural workers had emigrated or gone to the towns during this period. Whole parishes had disappeared. Farmers had gone bust, and huge tracts of land were left uncultivated.[28]

These changes in English agriculture, some of which were due to global competition, had a considerable effect on women's farm employment, and may provide us with a clue to their changing image through the century. Their story is usually told as a narrative, wherein their numbers, to a greater or lesser extent, grew from the 1830s to 1850, declined after 1851, and were insignificant by 1901. But it is hard to assess their actual numbers. This problem arises for two reasons. Firstly, the ten yearly censuses of the nineteenth century were taken in April, when very few women would have been employed. Secondly, many of the women worked with their families and casually, which did not fit the definition of work found in the censuses, which defined employment as

paid, public and full-time.[29] This has hidden the very real economic significance of women in agricultural labour and to the rural economy, which remained constant up to the end of the nineteenth century and beyond. The importance of this labour varied by region, but must not be discounted nationally.[30]

The widespread bias of rural and agricultural historians towards a focus on the more 'advanced' and arable counties of the south and east has often helped reinforce the story, and though this is being redressed, as is the absence of women, much remains to be done. Too much rural history repeats the work of Ivy Pinchbeck – with and without due credit to her – and gives no wider consideration to the more complex relations within agriculture, its continuities, changes and wider social, political, and economic context. The history of rural women may often seem to parallel that of urban women, but there are important differences between the two groups. Rural labour was, for a start, very different to factory labour, while the cultural context of the reports and the laws passed on farm work cannot be ignored. Statements about women's work in agriculture by officials and publicists alike have particular nuances which exactly oppose and are in tension with those on urban women, because of the cultural polarity between country and city that influences even today's rural history.[31]

Economically, agriculture moved from boom, to depression, to 'golden age', to depression. Industry and Empire drew on the rural population to supply the needs of capital. Each of these factors was significant to the way in which the countryside was represented in public bourgeois culture and to the context in which the parliamentary reports were written. Having taken on board the problematic nature of the empirical data, it is still possible to draw some conclusions about the story of women's paid and unpaid farm work. Their numbers probably did drop through the last half of the nineteenth century, but this decline was at a rate similar to that of men's falling employment, which varied by region. The rapid plunge indicated by the censuses did not take place.

When we look at the image of women's farm work, we can see that there was a complex and dynamic relationship between the official, public, literary and artistic discourses, which produced constantly shifting definitions of the rural and femininity. The evidence of the women themselves contributed to this process, in which the dominant ideology was reworked in visual and literary form. They had a very different view of what was right and wrong to those above them, as Jenny Kitteringham has noted in her attempt to retrieve an authentic history of the experience of farm women, but we cannot simply compare their accounts – already reworked through the ideology of those who collected the mate-

rial and our own expectations – with the representation of their lives from above.[32]

The images I have chosen do not all belong to 'great art' or the literary canon. In order to understand the relationship between discourses, the process of representation and negotiation inherent within the definition of rural womanhood, it is necessary to look at the mundane, that which belonged to the dominant ideology, and at the resistance to the ideology and social relations of the day, not just that which the discourses of art and literature have defined as the work of genius. For this reason, the book will begin with a survey of the origins of pastoral and some of the key images that recur throughout the nineteenth century. As I am taking the official reports as one mechanism by which ideology was transformed into 'reality' and by which ideology and image were confronted with 'the facts', I will then go on to use the production of the reports of the Special Assistant Poor Law Commissioners on Women and Children's Work in Agriculture (1843), the Royal Commission on the Employment of Children, Young Persons and Women in Agriculture (1867), and the Royal Commission on Labour (1893), as the pivotal points of the book in terms of periodisation. This, with an analysis of some key texts, will also provide a forum in which to analyse some of the issues being discussed. This is not to say that the novels, poems, illustrations, pictures, memoirs, newspapers and periodicals I have chosen exhibit universal values – rural imagery is in fact notorious for its unrepresentativeness – but it is necessary to provide some examples on which to ground and test our model of the constant traffic between reality and image. My reason for carrying out this project is political. As Lynda Nead says: 'Examining the work of particular orders of representation in the past is a step towards understanding the effects of representation and regulation today.'[33] How did the process of representation effect a concrete delineation of rural women's lives, and how does this continue to affect women today? This is the wider question I want to pose.

NOTES

1 Barrett, M., 'Ideology and the cultural production of gender' in Newton, J. and Rosenfelt, D. (eds.), *Feminist Criticism and Social Change: Sex, Class and Race in Literature and Culture*, New York, 1985, p. 77.

2 Nead, L., *Myths of Sexuality: Representations of Women in Victorian Britain*, Oxford, 1988, p. 8.

3 Barrett, 'Ideology', p. 80.

4 *Ibid*, pp. 80–2.

5 Gramsci developed his concept of a cultural hegemony between 1929 and 1935 in order to adapt the Marxist model of social relations, based on his observation of the social and cultural changes in the USSR that took place after the Russian

Revolution. Foucault, on the other hand, developed a new theory of the way power works in society by looking at the variety of relationships between powerful groups of people or institutions, which he called discourses. The two are often see as being in conflict, but I believe they can be used in a complementary fashion, as each is focused on different subjects, while both concentrate on the micro-dynamics of power. Foucault's key books include: *The Archaeology of Knowledge*, New York, 1972; *Discipline and Punish. The Birth of the Prison*, London, 1977; *The History of Sexuality*, 3 vols., New York, 1978. For Gramsci see *Selections from the Prison Notebooks of Antonio Gramsci*, (ed.) Q. Hoare and G. Nowell Smith, London, 1971.

See Nead, introduction for a good discussion of the production of images and meanings within and between literature, art and official discourses. The discourses of art and literature do not just sit on top of the economic base, they are part of the wider hegemonic process, but they also produce meanings specific to their level of practice, which cannot be simply reduced as a mirroring of other discursive practices. Literature and art do not simply adopt pre-formed ideologies, they work through a process of representation, which means that they alter what they represent in a specific way.

6 Barthes, R., *Image, Music, Text*, essays selected and translated by Stephen Heath, London, 1982, p. 146.

7 Barthes, R., *Mythologies*, trans., A. Lavers, London, 1972.

8 Alexander, S., 'Women's work in nineteenth century London; a study of the years 1820–1850' in Mitchell, J. and Oakley, A. (eds.), *The Rights and Wrongs of Women*, Harmondsworth, 1986.

9 John, A., *By the Sweat of their Brow: Women Workers at Victorian Coal Mines*, London, 1984.

10 Mort, F., *Dangerous Sexualities: Medico-Moral Politics in England Since 1830*, London, 1987; Valverde, M., 'The love of finery: fashion and the fallen woman in nineteenth century social discourse' in *Victorian Studies*, 1989.

11 Davidoff, L. and Hall, C., *Family Fortunes: Men and Women of the Middle Class 1780–1850*, London, 1987; Gray, R., 'The languages of factory reform in Britain c.1830–1860' in Joyce, P. (ed.), *The Historical Meanings of Work*, Cambridge, 1987; Valverde, M., '"Giving the female a domestic turn": the social, legal, and moral regulation of women's work in British cotton mills, 1820–1850' in *Journal of Social History*, xxi, 1987–88.

12 Davidoff, L., 'Class and gender in Victorian England' in Newton, J. L. *et al.*, *Sex and Class in Women's History: Essays from Feminist Studies*, London, 1985.

13 Tilly, L. A. and Scott, J. W., *Women, Work and Family*, London, 1989.

14 Horn, P., *Labouring Life in the Victorian Countryside*, London, 1976; Hostettler, E., 'Gourlay Steell and the sexual division of labour' in *History Workshop*, 1977; Kitteringham, J., 'Country work girls in nineteenth-century England' in Samuel, R. (ed.), *Village Life and Labour*, London, 1975; Snell, K. D. M., *Annals of the Labouring Poor*, Cambridge, 1985.

15 Davidoff, L., L'Esperance, J. and Newby, H., 'Landscape with figures: home and community in English society' in Mitchell, J., and Oakley, A., *The Rights and Wrongs of Women*, Harmondsworth, 1986.

16 Quoted in Davidoff *et al.*, 'Landscape', p. 144.

17 *Ibid.*, pp. 144–5.

18 Higgs, E., 'Women, occupations and work in the nineteenth-century censuses' in *History Workshop*, 23, 1987; Miller, C., 'The hidden workforce: female field-workers in Gloucestershire 1870–1901' in *Southern History*, 6, 1984.

19 *The Englishwoman's Review of Social and Industrial Questions*, April 1873, p. 156;
 April 1874, pp. 87, 144; Aug 1877, p. 376; Sept 1877, p. 426; Nov 1879, p. 481;
 Nov 1879, p. 484; Feb 1880, p. 85 and March p. 101–02, 116; July 1880, p. 332.
20 Howkins, A., *Poor Labouring Men: Rural Radicalism in Norfolk, 1870–1923*,
 London, 1985, p. 8.
21 Pahl, R. E., *Divisions of Labour*, Oxford, 1984, pp. 37, 64; Lown, J., *Women and
 Industrialisation, Gender At Work in Nineteenth Century England*, Cambridge,
 1990, p. 20.
22 Hostettler, 'Gourlay Steell'; Roberts, M., 'Sickles and scythes: women's work and
 men's work at harvest time' in *History Workshop*, 7–8, 1979.
23 'Sixth Report of the Children's Employment Commission (1862)', *PP* 1867;
 'Reports of Special Assistant Poor Law Commissioners on the Employment of
 Women and Children in Agriculture', *PP* 1843; 'Reports From the Royal
 Commission on Labour', *PP* 1892–94.
24 Valenze, D., 'The art of women and the business of men: women's work and the
 dairy industry c.1740–1840' in *Past and Present*, 130, 1991; pp. 142–69.
 Pinchbeck, I., *Women Workers and The Industrial Revolution 1750–1850*, London,
 1985, (1st edn. London, 1930); Andrews, G. H., *Modern Husbandry: a Practical
 and Scientific Treatise on Agriculture*, London, 1853; *PP* 1843; 'Reports of the
 Royal Commission on the Depressed State of the Agricultural Interest',
 1880–82; 'Reports of the Royal Commissioners on the Agricultural Depression',
 PP 1894–97.
25 John, *By the Sweat of their Brow*, p. 14
26 Williams, R., *The Country and the City*, London, 1985, p. 91.
27 Howkins, A., 'Labour history and the rural poor', in *Rural History, Economy,
 Society, Culture*, i, 1, April 1990, p. 116–20.
28 There are many agricultural histories on the rise and fall of English farming, and
 its wider social impact, including Mingay, G. E. (ed.), *The Victorian Countryside*,
 London, 1981; Howkins, A., *Reshaping Rural England: A Social History,
 1850–1925*, London, 1991.
29 Higgs, 'Women, occupations and work'; Miller, 'The hidden workforce'.
30 Howkins has recently noted this in 'Labour history', p. 118.
31 In particular see Pamela Horn, *Labouring Life* and *The Victorian Country Child*,
 Kineton, 1974.
32 Kitteringham, 'Country work girls', pp. 111–31.
33 Nead, *Myths*, p. 10.

Revolution and slump

1780–1850

Through a Claude glass darkly

I sometimes dream that I shall one day venture again before the public, something in my old manner, some country tales, and spiced with love and courtship might yet please, for Rural life by the art of cooking may be made a relishing and high flavoured dish, whatever it may be in reality

Robert Bloomfield, 1814.[1]

Robert Bloomfield was one of many poets to recognise the demand of the urban public for an idealised image of the rural, which could be made palatable and consumable, regardless of social reality. The language of consumption in fact recurred throughout late eighteenth and early nineteenth century texts with reference to the rural, but what we also see in this quote is a recognition by Bloomfield, who had been an agricultural labourer in the eighteenth century, that there were distasteful aspects to the 'reality' of rural life that the public would not accept, and which the artist or author might consciously avoid.

Up to 1800 at least, when Bloomfield's poem *The Farmer's Boy* was published, the town was seen as the location of all that was unnatural and constructed, while the countryside was viewed as an organic society and as part of God's creation. William Cobbett, though he was a radical, was not exceptional in his vehemence when he said, '*Wens* have devoured market-towns and villages; and *shops* have devoured *markets and fairs*; and this, too, to the infinite injury of the most numerous classes of the people.'[2] Or, as Cowper had said in 1785:

God made the country, and man made the town,
What wonder then, that health and virtue ...
... should most abound.
And least be threatened in the fields and groves?[3]

The countryside itself was supposed to possesses some kind of superior morality. Because of this the country poor were also said to be healthier and more virtuous than their urban counterparts. As C. Gray said in the commentary to William Pyne's *Microcosm* (1808) – the model of many later books published as guides to landscape artists, originally published as a subscription series from 1802 to 1807 — the urban populace did not have that 'bloom of countenance, that virtue in their looks, nor that rustic elegance in their appearance, which we find among the gay lads and buxom lasses in the hay-fields of the country'. Despite their 'dis-agreeable' manners 'rustics' were 'peculiarly pleasing in imitation, when accurately copied'. They could not be bettered in 'honour, honesty, benevolence, innocence', and were therefore much more worthy of artis-tic representation, and consumption, than townspeople: 'The man who can behold representations of such scenes without feeling a peculiar delight, ought to doubt his heart, as well as his taste'. Even though Pyne's illustrations did not necessarily fit what he knew to be reality, he still appealed to a higher truth to support his vision of a rural idyll. He used the biblical story of Ruth to chastise 'modern' farmers who denied the poor their right to glean; and with regard to virtues and vices, Pyne sug-gested 'we have no wish to speak scandal of the country'. In other words, even when conditions in the countryside were seen as impoverished, or morality low, he too made a conscious decision to transform reality into 'Doric' or biblical pastoral – the kind of pastoral that concentrates on nymphs and shepherds, rather than agricultural labours, which origi-nated in Theocritus' *Idylls* in the third century BC, and was continued in Virgil's *Eclogues* – even while recognising that the tastes of his day, the readings of his work by different members of his audience, would differ.[4]

This English rural idyll really only emerged in the mid-eighteenth century, as the industrial revolution haltingly, gathered speed. Until this time, 'Classic', idealised rural landscapes, rather than 'Historic' land-scapes, came from Italy. Artists were not as free as agricultural commentators and poets to choose their subject; many were caught between the need to professionalise their skills, the need for patronage in order to live, and the desire to do work based on inspiration rather than tradition. The 'Public' had a taste for portraiture and history, not the landscapes of new artists like Turner and Constable. Landscape was only palatable if it was dramatised. Gainsborough, Reynolds and Fuseli – professor of painting at the Royal Academy from 1801 to 1825 – all resisted the move to paint landscapes as they really were; 'views' were said to be mere 'topography' and very dull. Landscape was popular only in the form in which artists such as Titian, Poussin, Rembrant and Claude painted it. Fuseli believed of Claude's paintings that 'nature dis-

closed her bosom in the varied light of rising, meridian, setting suns; in twilight, night and dawn. Height, depth, solitude, strike, terrify, absorb, bewilder in their scenery. We tread on classic or romantic ground through the characteristic groups of rich congenial objects'.[5] Inspirational work such as this, which pleased his wealthy consumers in its tastefulness, meant that Claude was popular enough to warrant the creation of the 'Claude glass', which literally distorted and coloured the world to look like a Claudean picture. He and his contemporaries in Italy were also influential in the eighteenth-century taste for landscaping. The aristocracy did not really need to purchase a Claude glass in order to distort the landscape, as they could pay to manipulate their lands, while the cultural hegemony successfully distorted the rural for years to come for the less well-off.[6]

Rural life was painted following very particular conventions that insisted that the poor belonged to an organic community. By the end of the eighteenth century realistic art, by painters such as Constable, Wheatly, Morland and Gainsborough, had become increasingly popular, but old moral virtues continued to be emphasised alongside the new in representations of the rural poor, hence Pyne's insistence on accuracy, but avoidance of difficult social issues. Images of industrious peasants replaced pictures of idle peasants, but they were still happy and content. Increased realism therefore allowed older values to be maintained within a new set of artistic practices that made them more believable.[7]

Both the aristocracy and the new middle class bought this art, and by purchasing work that they found acceptable, this audience helped shape the representation of the rural. Their influence was unconscious, but effective none the less; they belonged to the discourse of art as much as the artists themselves. As Foucault tells us, discourses create new knowledges and pleasures, which can be involved in the exercise of power; this power is not just a matter of control or dominance, though: it can also produce new identities, meanings and ideas. If we focus on the poor, we can see that there was an increasing recognition of their existence as a separate class at this time, aided by the division between those who gave and those who received charity. The poor as a whole initially took on a newly distinct identity, either as a threat or as an object of pity, which then partly enabled the new middle class to construct its own vision of itself.

Class itself is a social relationship, never simply an economic category, largely formed in opposition to other groups who share different values and beliefs.[8] After 1789, the urban bourgeoisie feared revolution therefore they increasingly looked to the countryside to provide a model of a fair and stable society. Their desire for this model was articulated in

the form of increasingly available artistic and literary representations of the organic, rural community. The rising level of conflict caused by the loss of common land, the growth of the population, and greater levels of unemployment, was not made explicit in the discourse of art, but was still vital to the formation of the working and the middle classes. The discourse of art reworked reality to fit the nascent ideology. Books like William Pyne's *Microcosm* provided around 600 studies of working, and therefore industrious, peasants. He created a generic labouring peasantry for landscape artists, which was not only picturesque, cheerful and hard-working, but also safe – remote from the provincial and urban middle classes. Pyne did recognise a sexual division of labour; he was quite cate-gorical that: 'Milking seems by nature to be decidedly the business of the female.'[9] But women were as acceptably picturesque and distanced within their allotted tasks as men in this text.

While the middle class grappled for imaginary control of the rural poor, the urban environment was represented as consuming the English countryside and its people, to the detriment of the nation. William Cobbett, farmer's son and radical campaigner on behalf of the rural poor from the late eighteenth century, was unusual in that he used his past, his rural childhood, to criticise the present through the vehicle of pas-toral, but his attack on the city and the destructive influence of capital was commonplace. He denounced the enclosure movement, rising prices, urbanisation, and the development of capitalist agriculture because of their pernicious effects on the condition of the village labourer. He adhered to an apparently idealised and culturally dominant division between town and country, regardless of his radical politics. This process of representation was not a simple distortion of 'reality'. Even within Cobbett's social commentary the figures in the landscape did not so much represent real people, real labourers, as metaphors for their social condition. As Raymond Williams said in *The Country and the City*, 'A working country is hardly ever a landscape. The very idea of landscape implies separation and observation'.[10] The greater this separa-tion, or distance, in social and economic, regional and gendered terms, between the writer or artist and the figures they created, the more the social realities of rural labouring life receded from their vision; or, rather, the more these figures were reworked through a process of representation which maintained consent within the dominant ideology.

English painters like Gainsborough and Stubbs pursued ideal rep-resentations of perfect peasants within their landscapes, and they were not alone in this. Indeed, they did not always take the English country-side as their subject, though 'England' became almost interchangeable with the rest of Britain when it came to the ideal peasant, and it was

English national identity above all, with its connotations of honesty and stability, that came to be constructed through images of rolling hills and thatched cottages. On the Continent, peasants were represented both as little better than the animals, and as vessels of the true culture of their nation. As in England, peasants became the carriers of the new values of the period. However, peasants in Britain and the rest of Europe were not only seen hard at work, eating meals with their families, or as naturally pious. They were also expected to be closer to nature, to the earth, and therefore to sexuality. The peasant genre remained one of the few ways in which sexuality could be legitimately displayed for pleasure in nineteenth-century art. Peasant women and girls were often presented in a voyeuristic mode, as vulnerable and seductive; innocent courtship and moral allegories were just the other side of the discursive coin. The peasant woman, particularly the young, pretty peasant girl, was represented as erotic in ways which were not possible in the case of women from other classes, simply because of her distance from her middle-class audience and her country location, already the site of idealised and sexual imagery. Gender divisions, like class divisions, became tied to the discourses of sexuality and pastoral.[11]

What is especially interesting here is the way that many of these images used eroticised representations of female peasant children. Thomas Gainsborough was one of the more prominent artists to paint portraits of the peasantry, based on his Suffolk boyhood, such as his *Cottage Girl with Dog and Pitcher*, in which a young peasant – it is not possible to determine the sex of the child from the picture alone; we only know this is a female peasant by the title – poses with a puppy under one arm, held close to the chest, while a chipped jug is held dangling to the ground. The portrait is set against a romantic backdrop, the child is barefoot, has short, cropped hair, wears tattered clothes that could be Doric, and stands passively looking down towards her right. The piece is full of pathos; the tattered clothes and damaged pitcher signify poverty, while the puppy works as a metaphor for childhood. The child itself offers no threat to its audience: both puppy and child seem sad, but healthy. The owner of the picture was able to buy a contained peasant as an expression of sympathy for the poor, but with connotations of rustic simplicity which did not challenge the distance between observer and observed.

This can be compared with a late nineteenth-century painting by French artist William Bouguereau, that followed the Romantic style of peasant portraiture. In *The Broken Pitcher* (1891), an older peasant girl sits demurely by a well, a valley behind her. Broken jug at her feet, she gazes steadily at her audience. She is also barefoot, but is otherwise well

dressed in peasant costume; her hair is tied back, but wisps escape. The painting connotes rustic sexuality rather than pathos or simplicity. The girl's escaping hair, bare feet, and the broken pitcher become metaphors for sexual knowledge and danger. Although this piece is much more detailed than Gainsborough's, emphasising a powerful connection between the girl and her environment, and though the girl sits on the boundary between womanhood and girlhood, innocence and knowledge, both she and Gainsborough's *Cottage Girl* have been idealised through pastoral. Both also carry warnings: the one of poverty, the other of the power of the erotic; both require the viewer's intervention, their gaze, their help or their sympathy.

As Bloomfield and Pyne both noted, the peasant had to be spiced up for the urban audience's consumption. In this context the peasant woman or girl became particularly delectable; she was constructed for the urban, male gaze, in a careful reworking of ideology, through the discourses of pastoral, childhood and femininity. This, in turn, eventually helped define all women as decorative, consumable objects, whose bodies could be used as canvasses on which power was projected. But these representations also help reveal the tensions and oppositions within the new middle class values, and the processes of negotiation between old and new ideologies, dominant and nascent ruling classes, continuity and change, at this time. Peasants were poor, they wore tatty clothes, but they had to be healthy. Their poverty required the largess of their wealthy audience, but they could be contained within artistic representations as distant, disempowered figures in the landscape, especially as eroticised children. Yet these images were also created as the rural poor resisted the intervention of capital in the countryside, in food riots during Gainsborough's lifetime, in strikes as Bouguereau worked.

Pastoral hid and continues to hide the social and economic changes that took place in the countryside between 1780 and 1830. When poverty or distress did become visible, it was – and still is – most often blamed on outside forces; capitalist *agents provocateurs* were supposed to have somehow infiltrated and corrupted the countryside and its people. The great landowners, who did far more to change the countryside from a feudal to a capitalist society and who profited hugely from it, have never been seen as the culprits by those of us who sightsee, who read pastoral novels and poems, who join the National Trust or English Heritage. Raymond Williams asks us to pause for a moment on such tours around the countryside: ' … look at that land. Look at what those fields, those streams, those woods even today produce. Think it through as labour and see how long and systematic the exploitation and seizure must have been, to rear that many houses, on that scale'.[12] Or, as Roger Sales

has said, 'The "great lie" in pastoral concerns its presentation of change. Economic change in rural society is invariably presented as external agency, despite the fact that rural society carried the seeds of destruction within itself. Capitalism was really quite at home in both the long and the short grass of rural England. ... pastoral was thus propaganda for the establishment in general and the aristocracy in particular'.[13]

These men are asking us to consider the invisibility of class and exploitation within the countryside, and rightly so. I also want us to pause to look more closely at the labourers, the exploited, and to try to see who they were. Look at those fields, arable and pasture, look at the workers, try to see, are they men, women or children? What are they doing and why are they so out of focus? Pastoral is part of our answer, class also obscures our vision, but so does gender and the ongoing process of representation that defined ideal femininity by adapting both the reality and the image until there was a closer fit.

Artists and poets were being pushed towards a new form of production which focused on selling works as commodities, rather than seeking patronage. Thus despite their claim to a higher truth they increasingly had to keep an eye on the market. Artists like Pyne realised that pastoral was not just a matter of 'feeling', it was also a matter of taste. This led them to steer quite consciously away from more oppositional readings. Economists and farmers paid little attention to the social conditions of the labouring class as a whole, let alone women, while most artists and writers, of prose or poetry, described the rural as a purely natural landscape, constructed of sky, trees, hedges, fields and peasants. Only William Cobbett, and poets like Langhorne, Goldsmith and Crabbe, had attempted to raise social questions, such as rural impoverishment and unemployment, by 1800. Of these, only Cobbett looked at how poverty was being created through the spread of agricultural improvement and therefore capitalism. All were caught in the dilemma of continuity and change, of regarding the countryside as the one remaining site of stability while seeing it transformed under a new network of hedges and roads.

Agricultural experts like William Marshall and Arthur Young avoided these concerns by seeing agricultural labourers as economic units of production. In reference to women, both provided detailed descriptions of the work labouring women did, such as following quote from Young's *The Farmer's Kalendar*, first published in 1771:

> ... two women follow each mower, to gather it [corn] into parcels proper for sheaves, and lay them ready for a man, who follows them and binds.

The method is very expeditious and saves much expense; for the mowing does not cost half or a third what the reaping does, and the gathering is performed by women: all of which is one great advantage.[14]

In 1811 Marshall was still happy to suggest that women could be used in preference to men – women were 'more obedient and manageable' – despite some concern about the women of Lincolnshire: 'The women are very lazy; I have noted their indolence in spinning; Mr. Goulton's expression was, "they do nothing but bring children and eat cake"; nay, the men milk their cows for them; but the men seem very sober and industrious'.[15]

Women's agricultural work – in fact all labour within the cash nexus – was unproblematic, based on simple arithmetic within the discourse of professionalising agriculture. Though we can see, from Young's description of the harvest and cost of labour and Pyne's horror at the thought of men milking, that there was a sexual division of labour, working-class women's employment was still the norm. Even when Young, a major proponent of the agricultural revolution, baulked at the social consequences of the changes he helped bring about, he did not single out women's paid work as an issue or problem: 'I had rather that all the commons in England were sunk in the sea, than that the poor should in future be treated on enclosing as they have hitherto'.[16]

The tendency to support agricultural change continued despite Young's qualms, and can be seen again and again in texts published by farmers and in the journals of the Royal Agricultural Society. Harriet Martineau, a renowned political economist, and advocate of the enclosure movement, was convinced that it would eventually benefit the poor. Her novel *Illustrations of Political Economy, No. III, Brook and Brooke Farm, A Tale* (1834), aimed to encourage labourers to move away from subsistence when the enclosure movement was already well established. Within this text women's work was seen as providing a useful addition to the family economy, while dairy work was clearly a peculiarly feminine employment, which could even be elevated to the level of 'skill'. Within the discourse of political economy, as in the discourse of farming, country women had some economic worth:

> 'Has your eldest girl learned how to milk and churn?'
> 'Why no ma'am; but I think it is time she should. She might help her mother much that way'
> 'Indeed she ought; and if you like to let her come here at milking-time, our dairy-maid shall teach her to milk. Very few people are aware how much the value of the cow depends on the skill of the milker.'[17]

The countryside could be celebrated as the site of economic gain

and improvement, as well as mythologised, or its loss Romantically regretted.[18] While English Romantic poets and artists gave expression to individualism and morality centred in Nature, the provincial and metropolitan middle-class values of industriousness, competition and education were equally displaced onto the rural.

There was a comparable movement of new middle-class ideology onto the rural when the 'Report from his Majesty's Commissioners on the Administration and Practical Operation of the Poor Laws' was published in 1834. This highlighted a growing urban concern with rural conditions that focused on the country labourer as degraded and ignorant. The male peasant – often described as 'Hodge' in journalistic and literary works – was represented as consistently stupid; Hodge always needed education, charity, discipline.[19] The ideological focus of the report centred on Benthamite concerns that the cost of provision for the poor be kept to a minimum, and on this basis it looked to poor labouring women to add to the family wage. When one of the reporters, a Mr John Wilson, said that the cottages of Northumberland contained 'The blazing hearth, that keystone of all household and domestic comfort; perhaps the mother and younger children beside it,'[20] he used a metaphor for domesticity that came from the ideology of separate spheres, but he did not criticise the women's paid work. Femininity had not yet been universalised. This again reveals the process of constant negotiation within bourgeois hegemony. Farm work for women and children was not yet seen as a problem: it was an accepted part of agricultural practice. It was better to have an industrious peasantry than an idle peasantry, regardless of sex, or age, even though by this period middle-class women were expected to devote their time to their domestic duties and the church, and children's work in the factories was already under scrutiny. Local courting customs, scheming to get a husband, the profit that could be made out of having a bastard, or straightforward sexual desire were much more worrying to the reporters than the fact that working-class women were earning a wage.[21]

We can see a growing dialectic within bourgeois ideology in the late eighteenth century, linked to that class's perception of rural society. The industrial middle class, who were still in the process of formation, had little or no concrete control over the agricultural labourer, whether male or female, at this time. Authority still belonged to the old ruling class, the aristocracy, in the early nineteenth century, despite the agricultural revolution and the gradual move away from old feudal relations to ones based on cash. Yet by trying to control the cultural representation of the landscape during this period, the middle class revealed the way in which it was beginning to exercise some social, political and eco-

nomic control over it. The nascent bourgeoisie, regardless of the differences that still existed between them, saw the countryside and its people as simple and pure, and as simple and stupid. These ideas, and the late eighteenth-century images of peasant women as natural and pure, but also as natural and earthy and sexual, were not contradictory. They came from the wider acceptance of old signs, which were needed in order to call on the authority and legacy of landed ruling-class tradition, coupled with the development of their own new values. This can only be understood in the context of the literal location of old and new in country and city. The urban bourgeoisie remained in this dialectic with the countryside and its people throughout the nineteenth century, and this relationship can be seen as having informed all its dealings with them.

In his analysis of the relationship between the country and the city as seen in literature, Raymond Williams described the complex interweaving of the discourses of nostalgia, pastoral, golden age and Englishness which was, and remains, vital to an understanding of this perceived and actual division between the two sites. He looked at the way both have been simultaneously damned and praised. A vision of a better past has played a vital part in the dialectic of simplicity/stupidity versus complexity/corruption, of the natural as against the contrived that became the foundation of all representations of the rural.[22] Roger Sales has similarly discussed how pastoral hides reality and helps transmit dominant ideologies through a process which involves escape to a better place, the projection of the present onto the past, the acquisition from the past of values which apparently used to exist and still should, and finally the expression of regret, the mourning of what is lost. The desired values are simultaneously seen to be dead and gone, only appreciated by a few, yet timeless, and of value to all.[23]

These visions of the rural were particularly important at the end of the eighteenth century and the beginning of the nineteenth. The countryside increasingly became an arena in which conflict could be both disguised and worked through. The prevailing images of the rural poor as a unified mass – either as a distinct, threatening group, especially during the Swing riots of the 1830s, or as quaint carriers of English folk culture, who were industrious and cheerful – meant that they were rarely approached closely enough for their actual social conditions and identities to be questioned. The pastoral idyll persisted throughout the art and literature of the nineteenth century because traditional, paternalistic power was supposed to function best at a local, communal level. Organic, communal society was the continuing ideal and the countryside was seen to epitomise that vision. The rural became linked to Old England, stability, peace, prosperity and power. The village and its

people were represented as living this ideal. The country house embodied the vision of power, tradition and authority initially denied the new middle class. The cultural construction of the English countryside formed a link between past and present for the new middle class and legitimised their claim to authority on the back of the landowners.

Similarly, home and the family were defined through the discourse of Evangelicalism – an eighteenth-century revival of Anglicanism which stressed individual salvation and struggle – as the building blocks of society, and were believed to act out social life in miniature as the hegemony of the ruling class re-formed around the social, economic and political changes of the period. The body increasingly became a metaphor for society and the family: man at the reasoning head, woman at its caring, moral heart. That organic analogy coincided with the organic rural community, so that the village, specifically the cottage, became the site of the ideal of domesticity as well the ideal of community. These ideals of country, community, home and femininity intersected within middle-class ideology, despite that class's actual diversity.[24] Rural women became the stage on which pastoral and domesticity could be acted out.

We can see this in William Henry Hunt's water-colour *The Maid and the Magpie (A Cottage Interior at Shillington, Bedfordshire)* (1838). The painting belongs to the formation of separate spheres ideology, and the discourse of pastoral. A young woman in a blue apron and white cotton dress is sitting in a cottage, peeling and coring apples. She has paused in her work to turn – she has her back to us – and look round at her audience. As far as we can tell she is innocent and happy; she is smiling, rosy-cheeked, white-skinned and her hair is neat and tidy. The interior of the cottage seems bare, even impoverished, but it is full of the signs of rusticity and domesticity – pans, a kettle, jugs, plates, a broom, stools, a ladder, straw and a bunch of onions. Outside the window we can just see some trees, and hanging from the frame, a magpie in a cage. This picture worked at many different levels. It connoted a simple, rural life. It perpetuated rural social relations – the peasantry were poor but happy. It propagated nascent definitions of gender within the hegemonic process[25] – women's place was in the home. The magpie was a metaphor for the condition of the women, caged, yet safe; acquisitive and able to line her nest, to make a home. This reworked the ideology of the period in visual form for the urban bourgeoisie who consumed it. It helped define the country, in opposition to the city, the working class, in opposition to the middle class; and women in the domestic sphere, in opposition to men and the world of paid work. The middle class could be reassured that in the countryside at least things were as God intended.

The process by which poor labouring women, on whom the reports of 1843, 1867 and 1893 were going to concentrate, were represented could lead to ambiguity; they were not caged, but worked outside the bounds of the home. While industry was more important than femininity, this did not present a problem, but when domesticity was universalised, farm women gave rise to several new, often scandalous, identities. Poor labouring men presented much less of a problem to separate spheres ideology, as long as they were not idle and their changing identity fitted within the wider category of 'rural labourer' or 'peasant'.

In George Robertson's mid-eighteenth-century water-colour *Summer-Sheep Shearing*, men were represented unproblematically as working within the rural community, as the sheep are herded and shorn under the watchful gaze of the landowner's family – their position clearly signified by their dress. The title 'Summer' refers to Thomson's poem *The Seasons* (1730), which was still widely quoted well into the beginning of the nineteenth century by artists like Pyne. The picture connotes a generic peasantry, picturesquely and happily gathered together in rustic dress, posed in various attitudes that signify industry. Only the visitors are idle, except for a couple engaged in a romantic interlude, she in the costume of a shepherdess, he in hat, breeches, open shirt and jacket. In paintings like this, men were used as metaphors for industry, community, honour, wealth. By 1800, these men had become the embodiment of the honest freeborn Englishman. The inversion of this likened peasant men to revolutionaries, drunkards and idiots, who exhibited a base animal nature, which could be comic, threatening or prompt the viewer to sympathise with their plight. But, the inversion of masculinity was less threatening to the dominant culture than the inversion of femininity.

Robertson's painting also shows us that not all working women spoke scandal of the countryside; the shepherdess can be found in many examples of eighteenth-century pastoral as a metaphor for thrift, piety or romance, although she did not survive except as a character in children's literature and art. This may be because instead of representing bucolic bliss, by the 1790s the shepherdess reminded her audience of Marie Antoinette, who in pre-Revolutionary France had set a fashion for dressing up in muslin and playing with carefully groomed sheep at Versailles. The shepherdess also waned as the fashion for neo-classical pastoral declined in favour of a more English idyll in the late eighteenth century, when the public taste moved towards a move realistic mode of representation. The Shepherdess therefore became a child-like and childish version of pastoral, as we can see in Margaret Thompson and William Rowe's Doulton ceramic, *Little Bo-Peep* (Plate 1), made in 1876 for the

Lillian ward at St Thomas's Hospital in London.

Thompson and Rowe's *Little Bo-Peep* is surrounded by her sheep in a summer meadow and looks modestly away from her audience as she clutches her bow-bedecked crook, the feminised sign of her trade. She should be working, but she has become a metaphor for leisured femininity, distanced through her idealised location and in her dress, which is both supremely feminine and old-fashioned. She is either in costume and therefore fictitious, or she belongs to a different era, in which case she represents a 'golden age'. She evokes a continuity with timeless Old England which could appeal to children and comfort adults in a period of renewed imperial expansion and social conflict. The shepherd managed to retain his power as a symbol of Christ, used to great effect in William Holman Hunt's *The Hireling Shepherd* (1851), where the image was inverted to show a devilish young man dallying immorally with a coquettish woman, and letting his sheep stray into the corn. But the image of the shepherdess was reworked through the new discourse of childhood and her identity changed from one signifying simple romance, to an allegory of domestic and social simplicity, contentment, and English pastoral.

The discourse of childhood itself provided one of the most powerful images of the rural, and the construction of an idealised childhood helped disguise women within pastoral, as we saw in the discussion of *Cottage Girl with Dog and Pitcher* and *The Broken Pitcher*. The image of the rural as being equally represented by both the graveyard from the 1740s, and childhood from the 1780s, might at first appear bizarre. At first glance, what could be more disparate than Thomas Gray's 'An Elegy Written in a Country Churchyard' (1751) and John Clare's 'Joys of Childhood'? On further study, though, both poems reflect upon eternity, what has been lost, the nature of life, peace and tranquillity away from the hurly-burly of every-day – and, implicitly, urban – life. Both are concerned with the themes of continuity and change, and both have connotations of a natural morality which Wordsworth in particular stressed.

Williams noted that we can see in Clare and other Romantic poets how Nature, childhood and the past are linked or fused together. Childhood is also literally linked to the place where one is a child, and this was especially influential for Wordsworth who went on to use his childhood experiences as the moral foundation to his poetry:

> Low and rustic life was generally chosen because in that situation the essential passions of the heart find a better soil in which they can attain their maturity, are less under restraint and speak a plainer and more emphatic language; because in that situation our elementary feelings

exist in a state of greater simplicity and consequently may be more accu-
rately contemplated and more forcibly communicated; because the
manners of rustic life germinate from those elementary feelings; and
from the necessary character of rural occupations are more easily com-
prehended; and are more durable and lastly, because in that situation the
passions of men are incorporated with the beautiful and permanent
forms of nature.[26]

Wordsworth expected the countryside and its people to be un-
cultured; to provide an environment in which the adult could regain
something of childish emotions and sensibilities; a place in which the
'human mind' could be touched by the forces of Nature. Wordsworth,
like many other poets of his day, expected his art to educate his audi-
ence through the medium of pleasure, but was one of the first to situate
that education within the rural in a reaction against industrialisation
and the literary discourse of his time. He wanted writers to use a more
natural style, and took Nature – or rather the countryside and the peas-
antry – as his linguistic model. He assumed his inspiration would grow
organically from nature,[27] at which point, his concept of Art coincided
with the concept of organic society, at that time widely accepted by
conservatives who had taken on board much of Burke's criticism of the
French Revolution of 1789. Wordsworth, as a Romantic poet, linked
the discovery of individual morality to a beneficent, educating, nurtur-
ing Nature and to the innocence of childhood, but also re-presented the
countryside itself as childhood, which was always at a distance. This
model of Nature, which was originally quite radical, was soon widely
accepted by traditionalists and radicals alike in the representation of the
rural, because of its apparently conservative overtones. Clare used it in
his poetry: 'In nature's quiet sleep as on a mother's breast'.[28] Cobbett
looked back to his own rural childhood to provide him with a basic
moral standard of social relations. The construction of myth like the
rural idyll is never fixed, and the Wordsworthian model of nature was
itself eventually rejected because it was realised that Nature is not
always kind.

The Romantic poets saw childhood as a sheltered garden, as
closer to Natural morality, as a place in the country where adults could
retreat from the cares and corruption of everyday life. Childhood was an
Eden, like rural England, or vice versa, from which adults were exiled by
cruelty and exploitation.[29] Where that place or memory was disturbed by
ploughing, enclosure or other agricultural improvements, however,
where Nature was not nurturing but cruel, adult emotions could be
stirred for the poet; ' …dispossession, the ache of labour, the coldness of
the available world: a complex of feeling and imagery in the experience

of this man and everyone; of each personal generation and of this generation in history.'[29]

If we take this a step further we can begin to see that these emotions and their equivalents – fear of the world turned upside down, of the loss of stability, of the 'natural' order, of what is 'natural' – would be affected by the apparent intrusion of capitalist social relations into the countryside. These emotions would be felt not just when Nature itself was disturbed or disturbing, but when the figures seen to be natural elements of the landscape were also not as they should be. If, on investigation, the rural populace were not really content, hard-working, obedient; if the countryside was not really a place where there was space and freedom to roam in a landscape which embodied liberty, the most basic element of Englishness; where children were not really playing happily; where women were not really cooking and caring for their families, the 'memory' would be shaken in the same way as it would be by old common lands being ploughed. This vision of Nature as childhood and as the past was particularly threatened when official observers went to the countryside and found it to be a site of exploitation of women and children in the 1843 'Reports of the Special Assistant Poor Law Commissioners on the Employment of Women and Children in Agriculture'. The nightmare was made worse by the publication of the 1863, Sixth Report of the Medical Officer of the Privy Council. The majority of the population lived in the towns and the construction of femininity and childhood had both begun to be accepted as universals.

The urban middle class would not have had childhood experiences of the countryside by the mid-nineteenth century, but because of this they were more susceptible to the pain caused by the shock of actual knowledge about the rural. Clare escaped his bitter experience of concrete dispossession through a withdrawal into nature in his poetry, but he did know what that dispossession really meant to himself and to others. The urban middle class, especially that generation which had grown up in the towns, only knew the ideal of what the countryside should be like. When presented with the reality of it they had nowhere to turn except to public indignation and moral outrage. This news was old: Clare had already recorded the effects of the agricultural revolution in the 1820s, the 1843 report had similarly noted the existence of agricultural gangs, Young had baulked at the effects of the enclosure movement early on in the century, while Wordsworth and Cobbett had not been slow to rail against the spread of capital in the country. It was at a particular historic moment that these 'facts' caused panic, as we shall see, but they were always counterweighted with visual and literary representations, which adapted to accommodate them.

As Deborah Valenze says of the dairymaid, 'Her symbolic significance seems to have waxed as her status as labourer waned'.[31] The dairymaid or milkmaid was the most consistently picturesque working woman on the farm, and the image of this labour as supremely feminine, rather than just 'women's work' in the way Martineau used it, developed in the late eighteenth century and continued into the nineteenth century, serving to perpetuate the myth of rural femininity as the embodiment of domesticity and respectability in both periods. Another long-lasting image was of women at work during the hay harvest – haysel – and the corn-harvest. Most working women in a village would have been involved in both and they were usually represented positively. It did not seem to make any difference whether the women in question reaped, bound corn, turned hay or gleaned, all harvest jobs were equally acceptable and equally feminine. Even the socially conscious author of *The Song of the Shirt*, Thomas Hood described a beautiful gleaner, in his poem 'Ruth' (1827):

> She stood breast high amongst the corn,
> Clasp'd by the golden light of morn,
> Like the sweetest of the sun,
> Who many a glowing kiss had won.
>
>
>
> Sure, I said, Heav'n did not mean,
> Where I reap thou shouldst but glean,
> Lay thy sheaf adown and come,
> Share my harvest and my home.

Following the biblical narrative, beauty marked Ruth out as a superior member of the rural working class and enabled her to bridge the gap in the poem that she never would have crossed in 'reality'. The figure of Ruth, the gleaner, stands out as a metaphor for rural prosperity and bounty, as well as idealised femininity in the discourse of pastoral. Writers from Wordsworth to Hardy reiterated the vision of the good woman in the hay and harvest field, in a variety of forms. Wordsworth gave his 'Solitary Reaper' a voice of spiritual power which invoked timelessness, and a continuity of ceaseless industry on the land. In *Tess of the D'Urbervilles* Hardy focused on the work of binding and represented women not just as figures in the landscape, but as elements of it, as will be discussed in chapter 9.

Each of these identities changed and were adapted by the traffic between representation and reality, reality and representation. But they never threatened the social order, constructions of feminity, or led to a

moral panic. Only the field-worker was directly challenging within the hegemonic process, and only in the mid-nineteenth century. Wheareas negative images of field-workers abound during this period, the only description of an eighteenth-century field woman, either positive or negative, that I have been able to dig up is buried in a poem by James Hurdis. This includes a brief and rather innocuous portrait of a woman weeding, who likes to chatter with her friends if given a chance.

> Forth goes the weeding dame; her daily task
> To travel the green wheat-field, ankle-deep
> In the fresh blade of harvest yet remote.
> Now with exerted implement she checks
> The growth of noisome weeds, to toil averse,
> An animal gregarious, fond of talk.
> From 'The Favourite Village', James Hurdis (1763–1801)

Though this women is defined through her work and her dress, though she is likened to an animal within the rural idyll, she is far from being a moral threat to her audience. The field-worker does not become a virago until bourgeois hegemony is established, until the dairymain and harvest worker have become assimilated into the English rural idyll, and until the construction of femininity has begun to be universalised. And only then is legislation enacted in an attempt to regain control of her and her chattering friends.

NOTES

1 Quoted in Sales, R., *English Literature in History 1750–1830, Pastoral and Politics*, London, 1983, p. 19.
2 Cobbett, W., *Rural Rides*, original pub. 1830, London, 1957, p. 478.
3 Quoted in L. Davidoff *et al.*, 'Landscape with figures: home and community in English society' in Mitchell, J., and Oakley, A., *The Rights and Wrongs of Women*, Harmondsworth, 1986, p. 149.
4 Pyne, W., *Microcosm on a Picturesque Delineation of the Arts, Agriculture and Manufactures of Great Britain in a Series of Above a Thousand Groups of Small Figures for the Embellishment of Landscape*, original pub. 1806, New York, 1971, pp. 29–30, 53, 171, 188–9, 206.
5 Quoted in Ford, B. (ed.), *The New Pelican Guide to English Literature*, V, *From Blake to Byron*, Harmondsworth, 1982, p. 262.
6 For a full discussion of the history of landscaping and its relationship with other cultural forms of the time see Williams, R., *The Country and the City*, London, 1985.
7 Barrell, J., *The Dark Side of the Landscape*, Cambridge, 1983, pp. 1–16
8 See Thompson, E. P., *The Making of the English Working Class*, London, 1988, introduction.
9 Pyne, *Microcosm*, p. 77.
10 Williams, *Country*, p. 120.

11 Brettell, R. R. and C. R., *Painters and Peasants in the Nineteenth Century*, Geneva, 1983, pp. 59–62, 75–8, 90, 95, 107–16.

12 Williams, *Country*, p. 105.

13 Sales, *English Literature in History*, p. 17

14 Young, A., *The Farmer's Kalendar*, Wakefield, 1973, 1st edn. London, 1771., p. 232.

15 Marshall, W., *Review and Abstract of the County Reports to the Board of Agriculture*, III, London, 1818, 1st edn., 1811, pp. 142, 379–80.

16 Quoted in Williams, *Country*, p. 67.

17 Martineau, H., *Illustrations of Political Economy No. III, Brook and Brooke Farm, A Tale*, London, 1833, p. 37.

18 Williams, *Country*, pp. 61–71.

19 Howkins, A., 'From Hodge to Lob: reconstructing the English farm labourer 1870–1914' unpublished paper, Norwich, 1986, pp. 1–6.

20 'Report From His Majesty's Commissioners on the Administration and Practical Operation of the Poor Laws', *PP* 1834, pp. 409, 410–11.

21 *PP* 1834, pp. 741, 629, 109, 111–12.

22 Williams, *Country*, pp. 1–12.

23 Sales, *English Literature in History*, pp. 15–18.

24 See Nead, L., *Myths of Sexuality: Representations of Women in Victorian Britain*, Oxford, 1988, pp. 39–42; Davidoff *et al.*, 'Landscape'; Williams, *Country*; Bermingham, A., *Landscape and Ideology, the Rustic Tradition 1740–1860*, London, 1987.

25 See Nead, *Myths of Sexuality*, pp. 5, 7–8, 36.

26 Wordsworth, W., and Coleridge, S. T., *Lyrical Ballads*, original pub. 1798, ed. Brett, R. L., Jones, A. R., London, 1991, p. 245.

27 Robbins, R., 'Modernism, the late Victorian heritage', unpublished paper, Luton, 1993, pp. 3–4.

28 Williams, *Country*, p. 139.

29 1800 Preface to Wordsworth, *Lyrical Ballads*, pp. 244–49

30 Williams, *Country*, p. 139.

31 Valenze, D., 'The art of women and the business of men: women's work and the dairy industry c.1740–1840' in *Past and Present*, 130, 1991, pp. 142–69.

Laborious but healthy occupations

The parliamentary reports of the nineteenth century still provide rural historians with the bulk of their evidence. They have provided much of the data on women's agricultural work, wages and conditions used in this book. They supplied publicists and authors in the nineteenth century with most of their empirical information.[1] The reports were part of the new official discourse brought about by a change in the state. Old areas of the bureaucracy were expanded from the 1830s and staffed with a new cadre of educated civil servants. The government itself was rationalised, new ministries were established and old sinecures abolished. Local government was reformed through the Municipal Corporations Act of 1835 and Peel set about reorganising policing. The new Royal Commissions, gathering their information empirically, belonged to a process of rationalisation and centralisation of the state as the new middle class began to gain power; where before the state was concerned with the regulation of trade and defence of the realm, it now began to intervene on social issues like public health. This process of intervention was not a simple imposition of monolithic power from above, though. It also involved a change in ideology as new political economists like David Ricardo, who wrote about the control of the money supply, Jeremy Bentham, Adam Smith and Thomas Malthus proposed new theories on how to run the economy and society that produced new forms of management, new identities and new concepts. Power is not just about repression. This can be seen in the mismatch between the formulation and the implementation of policy. Vested interests resisted the solutions offered by the state, and experts and politicians were divided on the expediency and desirability of the measures they discussed. These debates themselves involved the intersection of new discourses, which produced new identities and concepts; the social meanings of health and disease, for

example, included definitions of physical and moral welfare which became evident throughout the work of officials, experts and publicists.

This constant scrutiny of society and industry by the intervening state might appear to contradict the equally important development of *laissez-faire*. The parallel adoption of *laissez-faire* and intervention by the early nineteenth-century state is easier to understand when it is remembered that neither ideology was universally accepted. Classical political economists were more often in favour of *laissez-faire* than those who were social reformers, but both groups were themselves politically, economically, culturally and ideologically diverse. Moreover, it is perfectly possible for one person to hold apparently contradictory beliefs at the same time. Though the nineteenth century the industrial and commercial bourgeoisie lauded the benefits of free trade, individualism and *laissez-faire*, constant exceptions to these principles were made. Interventionism and *laissez-faire* constantly challenged and adapted – rather than excluded – each other. *Laissez-faire* was not rejected as a guiding vision;[2] rather, the constant interplay of each idea reveals the working fluidity and adaptability of any ideology defined across several overlapping discourses. The construction of femininity was subject to the same kind of dynamic.

The first report on the employment of women in agriculture, the 'Reports of Special Assistant Poor Law Commissioners on the Employment of Women and Children in Agriculture' (1843), was written under the auspices of the Poor Law Commission, and provides our first example of an excursion by the state into the countryside on a specifically gendered issue. However, though many of its findings were critical, it actually presented the public with little that would have shocked bourgeois sensibilities, and created little concern for the condition of the peasantry. The evidence was collected, but not reworked through the ideology of domesticity, or even of childhood. To begin to understand why, we need to consider the social and economic context in which it was written.

Appointed in December 1842 by the Home Secretary Sir James Graham, the four Assistant Commissioners were given just thirty days in which to study each region. Mr A. Austin covered the counties of Wiltshire, Dorset, Devon and Somerset, Mr Vaughan went to Kent, Surrey and Sussex; Mr Stephen Denison looked at Suffolk, Norfolk and Lincolnshire; Sir Francis Doyle visited Yorkshire and Northumberland. They commenced their report by defending their integrity; they claimed that the reports did 'appear to contain as complete a view of the material facts ... as ... can be expected'.[3] But lack of knowledge on the subject of inquiry among 'labourers, farmers, and persons of a superior grade',

coupled with a fear of the 'inclination, … both in the case of the labourers and that of their employers, to mislead',[4] still presented obstacles to a thoroughgoing enquiry.

The 1843 report was a minor affair; it was not given many resources and was appointed during the Christmas recess. When it did report, its findings were not discussed by Parliament. Whereas the 1842 report on women and children in mining had caused a massive outcry,[5] the conditions of women and children in agriculture did not outrage public opinion for twenty years. The 7th Earl of Shaftesbury had a pet theory about this. He wrote in his diary for 16 December 1842 that the Commission had been set up as a personal attack, prompted by his criticism of industry; 'it is calculated first to delay and then to oppose my efforts.' He had already been criticised by political economists for interfering in the affairs of capital, thanks to his work on the 1833 Factory Act, the regulation of chimney sweeps in 1840, and the Mines and Collieries Act of 1842. These criticisms were often put in the context of his trying to be a reformer in industry when his father's labourers in Dorset 'were in a state of desperate ignorance and reckless despair'. In fact, whenever he criticised agricultural conditions the gap between him and his father grew, so he actually had very little influence on the running of the estate until he succeeded him in 1851, despite the opinions of those contemporaries, such as Harriet Martineau, who chose to attack him on this issue.[6]

The conditions on his father's estate were bad, according to the report written by Assistant Commissioner Alfred Austin, but not as bad as comparable estates in Somerset.[7] It does not seem likely that a whole report, even a minor one, could be entirely directed against one man. The rural inquiry did offer comparative material with the previous surveys of industrial employment, but it is more likely that it was directed not at Shaftesbury in particular, but at the landowning class as a whole, in a wider attempt to discredit them within the ongoing Corn Law debates of the period. The report was then disempowered by pastoral when it entered the public domain. *The Times*, which was one of the few publications to mention it, in three articles and a letter, informed its readers in a leading article on 7 January 1843 that an investigation had been undertaken, but it doubted if 'these certainly laborious, but still healthy occupations – salutary indeed, as well to the mind, as to the body – are to be looked upon, to however injurious an excess they may be imposed and however pitifully they may be remunerated, as in any sort ranking with the employment to which women have been subjected in the coal mine'.[8]

The Times then confirmed Shaftesbury's suspicions on 7 July 1843,

when it quoted an unnamed 'Leading Whig-Radical Journal', which, though it criticised the church and landowners more than *The Times* liked, showed up the poor conditions in the countryside to the paper's satisfaction. In this case, the future 7th Earl of Shaftesbury's speech at an agricultural meeting in Blandford, was the real focus of the article, which contrasted his comments with the report on his father's estate in Dorset.[9] On 30 August 1843 the paper finally used the report in a critique of the New Poor Law.[10] This diverse application of the evidence at the very least demonstrates the malleability of 'reality' in public discourses, which could equally turn 'the facts' either into a critique of Shaftesbury or into a diatribe against the bourgeois supporters of Edwin Chadwick, according to the ideological needs of the paper. Chadwick was the Benthamite secretary of the Poor Law Commission, and had worked on the development of the New Poor Law itself, a perfect example of policy which had not quite become practice, but which had contributed to the production of the new identities of 'deserving' and 'undeserving poor'.

In the previous chapter we saw how the development of English pastoral aided the re-creation of the countryside as a place of refuge, a retreat from the cares of the everyday world of capital relations, providing an arena in which the concerns of urban life could be worked through, via the discourses of domesticity and childhood, and enabling the new bourgeoisie to rescue old forms of power, inherent in the organic community, in order to gain authority. Pastoral also offered authors and artists the chance to mourn what appeared to have been lost and to criticise the present. These developments worked to make the growth of capitalist agriculture invisible, and through the use of ideal images of domesticity added to constructions of femininity, masculinity and childhood. This discourse can be seen in the concerns of the Assistant Commissioners, which, coupled with the nascent bourgeois ideology of separate spheres, influenced the representation of rural women in the reports in very particular ways. Although as the articles in *The Times* demonstrate this was not the only available reading of these texts. Even an apparently straightforward discussion of agricultural gangs in East Anglia intersected with much wider concerns about the state of the poor and the organic community.

The agricultural gang originated in the village of Castle Acre in 1826. A group of twenty or so women and children were hired and supervised by a male labourer, who was commissioned by a farmer to get a particular piece of work done. Usually the work was some miles from the village, which meant an early start – 6a.m. in the summer, and a late finish, sometimes 9p.m. at night, and a long walk of between two to five miles morning and evening, while sometimes the distances involved

necessitated the gang travelling in a cart or staying overnight in a barn. In 'public' gangs the gangmaster was given the wages by the farmer and passed them on to those under him, taking a cut for himself. In 'private' gangs the farmer paid the workers directly, though the division was really only a technicality. If it rained and the gang had to stop work, the labourers did not get paid. The work was done by the piece and consisted mostly of pulling, setting up and singling turnips, weeding and hoeing wheat, and stone gathering.

The agricultural gangs, Assistant Commissioner Stephen Denison believed, resulted in 'hardship and immorality' and contained 'a large balance of evil'.[11] His argument was that the 'close' parishes in north Norfolk had to get their labourers from the 'open' parish of Castle Acre. This village, because it was open, was said to be 'the most immoral place for the size in the whole county', therefore if ganging was ended the situation would only worsen as unemployment increased. Gangs were better than idleness, even though they were 'very destructive of the real elements of happiness to those who are so employed', and prevented parents from caring properly for their children.[12]

It is important to note that this form of labour already existed in 1826 because it did not cause real public concern until the 1860s. Labour shortages were particularly acute in the Fens where the land gained from drainage had no villages to supply a work-force, and much of the debate about the gangs revolved around the issue of open and close villages that Denison discussed. The traditional history of the open and close villages is as follows. A third to a half of Norfolk villages were 'close', in other words they had a major land owner controlling them. Most squires did not exercise an iron grip over their villages, but were still considerably powerful and influential. They could limit the numbers in the village, pick and choose who lived there, oversee church attendance and ration charitable provision. The population was usually smaller in these villages, the majority followed the local landlord in the Anglican religion and the housing was good. Open villages, which were not supervised by a landowner, were made up of speculatively built and often dilapidated cottages rented out by a variety of property owners. They were supposed to be freer communities; Nonconformity could thrive there and social divisions were less obvious. There has been a recent suggestion, though, that this system of parish organisation was itself constructed as a scandal, centred on the settlement laws, which puts this history and the story of ganging into an interesting perspective.[13]

Certainly, the 1843 and mid-nineteenth century vision of the gang as an immoral form of labour was partly constructed through a vision of Castle Acre as 'the coop of all the scrapings in the county.'[14]

The two scandals became inextricably linked through the rural idyll. The close village fitted the ideal model of an organic community and was proof of the reality of the rural idyll. The open village mimicked the social and economic relations seen in the town, was the opposite of the organic community, and was proof of the existence of capitalism in the country; which was, of course, not recognised within the construction of pastoral. The gang not only came from the open village, it also paralleled industrial and slave-like employment patterns. It should not be surprising that the gang was therefore seen as the worst possible form of employment for women and children in the English countryside. What is more surprising is that it was allowed to go relatively unremarked beyond the auspices of the official enquiry.

The solution to this dilemma lies partly in the very real need of farmers for the gang in order to work their fields, and in the discourse adopted by Denison in looking for a solution. He laid the blame for rural working-class immorality at the door of the landowners, who were supposed to maintain paternalism and organic social relations in the country, but his faith in their policing of the peasantry was not entirely shaken. He agreed with a correspondent, a Mr John Pierson of Framlingham in Suffolk, that Norfolk's landowners and farmers were basically 'a spirited body of agriculturists, and have only to be told to correct the evil.' He believed the greater the contact the poor had with the rich the more the gentry's 'birth and station ... [would] tend to civilise' the peasantry, who had momentarily been tainted by alien and urban social relations. He used the language of paternalism, public health, and evangelicalism to express his belief that once the landowners had done their job 'Castle Acre would not be reproached ... its own native population would be uncontaminated by the refuse of other parishes'.[15]

Denison saw working-class women as different from the women of his own class, belonging to the unified peasantry we have already identified, and this difference allowed him and his urban, bourgeois audience to accept women's employment in the fields. The ideology of domesticity was not yet universal, he was reassured that old forms of power would maintain rural women's respectability, and he therefore suggested that this difference was natural, and to be expected. This sharp division identified the middle and landowning classes as superior to the rural working class, who needed discipline, education and civilisation, but who offered no real threat to the ruling class. The old mechanism of feudal power was so desirable partly because it was still supposed to be effective in exactly this way. Denison's report did, however, offer enough material for other commentators to be more critical of the gentry than he had been, and to

offer a less optimistic analysis of the situation. His interpretation of the data did not constitute an exclusive reading and it is worth exploring the way in which the official enquiry inspired one publicist at least to write of the horrors of the countryside.

Charles Kingsley was a Christian socialist, a campaigner for sanitary reform, a clergyman and an author who was deeply concerned by the social issues of his day. *Yeast – A Problem* was written in 1847–48 for *Fraser's Magazine*, and published as a novel in 1851. Macmillan took it up in 1866 and it was reprinted throughout the nineteenth century. The novel addressed the problems of established religion and the condition of the rural population in the 1840s and was originally published in *Fraser's* to catch the attention of the landowners who subscribed to the journal. In the book, Kingsley used the device of conversation between his main characters to explore rural social relations. Two men, the upper class Lancelot Smith and the working-class Tregarva, discuss country life, while two upper-class sisters, Honoria and Argemone, undertake charitable and philanthropic works as young ladies bountiful. Through these characters Kingsley used his experiences as a curate at Eversley in Hampshire, as well as evidence from the 1843 report, to describe the cottages, work, wages, food, health and morals of the poor in the countryside and to tear down the vision of the rural idyll.[16]

Yeast challenged the bourgeois hegemony, yet also used the rural as a stage on which to project urban fears of the mass. For instance, cottages were criticised as unhealthy and unacceptable places to live, and integral to this attack was a criticism of morality among the poor, especially of poor women. The animal-like dirt, physical and moral filth and hints of incest led to utter disgust in some observers; Argemone, unlike her sister Honoria, would not sit 'beside the bed of the ploughman's consumptive daughter, in a reeking, stifling, lean-to garret, in which had slept the night before the father, mother and two grown-up boys, not to mention a new-married couple, the sick girl, and, alas! her baby.'[17]

Here the implied immorality of the whole family sleeping together, and the known immorality of the daughter in question, has as much impact as the smell, lack of air and ill health of the girl herself. Norman Vance has suggested that the family and morality were very important to Kingsley's perception of the dignity of life. Coupled with this, Kingsley believed women should guide and advise their men in matters of morality, and sustain their manly, Christian strength.[18] The family were therefore stripped of dignity and hope, as well as moral salvation. The same issues were already being raised in respect of the towns. Kingsley aimed to shatter the dream of rural life as idyllic, naturally innocent and happy by drawing on dominant concerns about the state of

the poor in the city. Like Clare and Cobbett he attacked the distant vision of the countryside which hid the causes of poverty, but drew on the discourses of medicine and religion to do so instead of nostalgia.

Living conditions in the villages were not much better than those in the towns. Cottages were small, usually two rooms – one up, one down – and poorly built. Landowners found it more profitable to let houses fall down than to repair them, because of the Poor Rates, which were levied on property. Speculative builders, on the other hand, wanted to cut costs in building in the first place, as in the towns. Thanks to this there was a notorious housing shortage in the countryside, while existing houses were often unfit to live in. Labourers paid high rents, out of low wages, for bad housing. Many villages also relied on communal cooking facilities for baking, and in many counties fuel was in short supply due to the loss of woodland and common rights. Wordsworth even included the poem 'Goody Blake and Harry Gill, A True Story' in *Lyrical Ballads* (1798) on this very subject, because of his own concerns about the Dorsetshire poor at that time.[19]

Kingsley reworked this material reality through the ideology of Christian socialism and used rural women as figures in his landscape of the poverty of human life. He represented them as the passive victims of capital, who lacked the privileges of women from the middle and upper classes.[20] This shifted the burden of moral welfare onto the shoulders of upper-class men, who protected their own wives, sisters and mothers while others suffered. Tregarva, the working-class representative who guides the reader in the form of the hero Lancelot, says of dutiful Honoria: 'If she had been born and bred like her father's tenant's daughters, to sleep where they sleep, and hear the talk they hear, and see the things they see, what would she have been now? We mustn't think of it. … You ask the rector, sir, how many children hereabouts are born within six months of the wedding day. None of them marry, sir, till the devil forces them.'[21]

The two male characters move to a fair, where they see the whole depraved rural population gathered together. Among them were 'girls and brazened faced women, with dirty flowers in their caps, whose whole business seemed to be to cast jealous looks at each other, and defend themselves from the coarse overtures of their swains'. But 'lo ! The language of the elder women was quite as disgusting as that of the men, if not worse.'[22] By the 1840s, when this book was written, prostitution had already become the subject of official observation and social control,[23] and we can see the language of prostitution entering Kingsley's text. The women's dirty flowers and brazen behaviour become metaphors for the debased trappings of their femininity. Their language was more 'disgust-

ing' than the men's, which signified gross sexual immorality. They were inversions of Kingsley's middle-class ideal of womanhood. But these women were not prostitutes, they were field women:

> 'It's the field work, sir – the field work, that does it all. They get accustomed there from their childhood to hear words whose very meanings they shouldn't know; and the elder teach the younger ones, and the married ones are worst of all. It wears them out in body, sir, that field-work, and makes them brutes in soul and manners.'
>
> 'Why don't they give it up ? Why don't the respectable ones turn their faces against it ?'
>
> 'They can't afford it, sir. They must go afield, or go hungered most of them. And they get to like the gossip and scandal, and coarse fun of it, while their children are left at home to play in the roads, or fall into the fire, as plenty do every year.'[24]

In this passage, the very fact of their work degrades the women: it corrupts them by association; it is physically hard; they have to take it for economic reasons, but they grow to enjoy it; and they are demoralised to the extent that they become bad mothers. This construction drew on the dominant representation of factory women as well as prostitutes, who were equally defined through their opposition to the middle-class vision of femininity. Working-class women who visibly took paid employment helped define respectable bourgeois womanhood through what it was not. But it was only acceptable for working-class women to exhibit difference as long as femininity was not defined as natural and universal. As respectable femininity became naturalised, the distance of class came to be regretted and working-class women could either be seen as a threat or as requiring protection. Within this universalised ideology, women who took paid work were increasingly seen as unnatural women, unable to fulfil the natural, feminine role of motherhood because of their labour and economic activity; it is this discourse that Kingsley is beginning to engage with, though for him the environment is more to blame than the individuals, as he is still influenced by the public concern about overcrowding and disease in the towns. At this point field women become signs of a wider moral or social decay, projected onto the countryside.

It is probable that Kingsley did actually use the government report as a factual basis for this description,[25] as well as his own experience of rural Hampshire. But despite sharing the same religious and paternal ideology, Kingsley offered less hope for rural improvement than Denison because of their divergent political thought, the former a Christian socialist, the latter a conservative. Kingsley began to raise awkward questions, which he claimed were meant to stimulate debate

like yeast acting on bread, but he offered no solutions and emphasised that things were only getting worse.[26] Kingsley used the details in the official report to criticise upper-class society for dereliction of duty, and was, if anything, too successful in his aim. The story was found to be too challenging for *Fraser's* aristocratic audience, who nearly bankrupted the magazine by withdrawing their subscriptions; Kingsley was forced to conclude the tale prematurely, and we can find signs of his distress in the novel where the author intrudes to tell us he is not a 'Plymouth Brother' or 'Communist' as the papers are suggesting; he is just trying to put on paper the concerns of the young and to shed light on the facts as they stand.[27]

The explosive mixture of religious debate and social critique was too much. But like Denison's report and Cobbett's writing, Kingsley's story offers a fascinating example of the ideological issues, changes and continuities seen in the religious and socialist discourses of the early to mid-nineteenth century. *Yeast* contributed to the universalisation of middle-class ideology, but also reveals a continuing, if hopeless, belief in the old duties on landowners to the poor in its attack on declining standards among the gentry. Like radical Cobbett and paternal Denison, Kingsley used an assumption of a better past to criticise the present.

In the end, Honoria loses her beauty and sits in a dark chamber, uncomplaining and always giving, whilst constantly crying over the spilt milk she cannot mop up. Her slow, hidden, martyr's death from an unknown disease becomes a metaphor for the unremarked spread of social decay in the countryside. We can see that, as a passive, 'good' woman, she can organise as many charitable events, write as many children's stories, read and pray as much as she likes – but as long as she *is* passive, she is powerless. She will never recover as long as she continues to smile at visitors, cry in secret, never sigh and never plead. As long as pastoral hides reality, the countryside will never revive.

Kingsley was concerned about rural social relations at a time when English agriculture was beginning to boom. He did not simply try to project urban issues onto the countryside. In *Yeast* he effectively used a new middle-class ideology to criticise the spread of capital. Honoria was powerless, but the subscribing landowners were not: 'My dear readers, I trust that you will not ask me just now to draw the horoscope of the Whitford poor, or of any others. Really that depends principally on yourselves'.[28] To use the metaphor he offers us, the disease that was corrupting the poor was the spread of the cash nexus, passed on by the contaminated gentry. Honoria was a metaphor for the rural; feminine, passive, powerless, silent, she was the destroyed organic community, the disenfranchised peasantry. Of course, Kingsley based this critique on an

assumption, taken from eighteenth-century pastoral, that once upon a time the peasantry had been happy, not weeping. The rural idyll coloured the vision of socialists as well as Romantics. But Kingsley was steadfast in his resolution that the present countryside needed to be cured of the ills he saw, even if that resolution was, as we might expect, shaped by the same class and gender distances which prevented any real improvement. He finally makes it quite clear that philanthropic palliatives will not suffice, and like Cobbett threatens that revolution may be the result of inaction. Honoria is left alone in her sorrow, because her more active, intellectual, rebellious sister, who fulfilled elite visions of femininity by living a life of indolent luxury, has already died of typhus, which she caught when struck down by sudden guilt and concern for the poor. Argemone knows who to blame as she is also a metaphor for the bourgeoisie: 'Their neglect, cupidity, oppression are avenged on me! Why not? Have I not wantoned in down and perfumes, while they, by whose labour my luxuries were bought, were pining among scents and sounds, one day of which would have driven me mad! And then they wonder why men turn Chartists!'[29]

The men who wrote the 1843 reports were still at a loss as to why men turned to Chartism. They still expected the ruling class, either the gentry or the bourgeoisie, to find an answer to the problems they unearthed, and they consistently avoided any discussion of the social consequences of enclosure and new farming practices. The report on Northumberland, which presents us with a particular exception to the rule in its representation of rural women, is no different in this. Official discourse worked to support the cultural hegemony of the ruling class through a mechanism which linked the rural poor to Englishness, the organic community and femininity, and made rural women the carriers of the values of industry, thrift, and domesticity. Reality was adapted and reworked through the use of women's paid farm work as a sign of rural poverty within other contemporary debates, such as those around the Corn Laws or the New Poor Law. The projection of urban issues onto the rural – such as concerns about women and children's work – which acted to disempower the fears of the ruling class in this case, can also be seen at work here. In 1863 this process of displacement collapsed, so that fears about the position of women and children in the countryside became concrete and warranted actual intervention in the form of legislation, but for the moment these fears were contained. This containment can best be seen in the representation of the women of Northumberland, who were constantly held up as paragons of virtue. The term 'bondager' should at least have evoked connotations of slavery, but despite an initial recognition of some protest by those who 'enlarge upon the misery

and iniquity of bondage on the free soil of Britain, and topics of a like description,'[30] the bondagers gradually came to embody all the domestic and rural virtues usually celebrated in art and literature, and actually contributed to the myth of the rural idyll. The bondagers were also exceptional in English agriculture, in that they were contracted by their employer for a year at a time. Most Northumbrian women working in agriculture were probably employed as part of a family; a 'bondager' was a woman specifically hired by a hind (a male labourer, hired on a regular basis, who lived on the farm) to fulfil his contractual obligation to supply casual female labour to his employer, a distinction which escaped most officials and publicists. The system was established to cope with the regular labour shortages of the agricultural year. It ensured that a farmer always had ample employees, despite the scattered nature of the farmsteads in this county.[31]

Assistant Commissioner Sir Francis Hastings Doyle set the precedent for this process of compensation. Doyle was an oddity among the new expert elite who contributed to the 1843 report in that he went on to succeed Matthew Arnold as Professor of Poetry at Oxford in 1867. He had trained as a barrister in the 1830s, was Receiver General of Customs from 1846–69, and was Commissioner of Customs until 1883. But he also published several volumes of poetry and popular ballads – his best-known work was probably the patriotic 'Private of the Buffs' – and the discourse of literature intrudes throughout his report.

While the bondager system did cause some concern, Doyle at least was steadfast in his view that 'as ... this bondage is simply an engagement for a year, upon specified terms, it indicates, I think, some confusion of thought to speak of it as slavery'. On the whole, he said: 'What I saw of the northern peasantry impressed me very strongly in their favour: they are very intelligent, sober, and courteous in their manners; their courtesy moreover, is not cringing, but coupled with a manly independence of demeanour; added to this, crime ... is all but unknown in agricultural Northumberland'.[32] This sums up perfectly the definition of the industrious male peasant that was transmitted by and created within pastoral. Indeed, Doyle was the only Assistant Commissioner to refer to the rural population as the 'peasantry'. He frequently interjected more emotive comments into his text than his fellow reporters. With regard to agricultural production, for example, he said: 'The wolds are a wide expanse of naked hills, which spread themselves over the northern half of the East Riding. Till within these 50 years they produced nothing but rabbits,'[33] which neatly described the rapidly changing agricultural landscape of the north of England in the early nineteenth century, without the use of the turgid facts and figures which

came to dominate the parliamentary report later in the century. This use of the forms and codes of literature in an official text enabled him to elevate the bondager above the mire of sexuality.

There were what he called occasional 'breaches of female chastity', but the real cause of this, as in the other reports, was the necessity of the poor sleeping together like animals, so that 'any degree of indelicacy and unchastity ceases to surprise'. This, as we have seen in *Yeast*, was a projection of urban concerns about the physical and moral health of the masses in the towns onto the rural stage. On reflection, he could not see why any 'particular evil is supposed to result from their [women] labouring in the fields. It is against the glove-makers and dress-makers, as a class, that charges of unsteadiness are made'.[34] Doyle presented his audience with a complex interweaving of old and new values. He, like the other reporters, stressed the importance of education – which he described, with qualification, as 'anything but good, (if book-knowledge be of the value which it is the fashion to suppose)',[35] morality, religion and health in accordance with the dominant hegemony. But he agreed with his landowning witnesses, who did not think 'the bondagers are less chaste than the other women of the county, though their occupations render them somewhat masculine.'[36]

Doyle's stance on women's employment in Northumberland and his use of a wider set of discourses gave him the scope to rework and hide the continuing economic necessity of women's labour in agriculture, as well as nascent bourgeois ideology and social relations. The most vital area of women's work in Somerset, dairy work, was not really attacked by Alfred Austin, who reported on that county, beyond some concern for the women's health, but he was never able to retrieve that work within domestic ideology having once criticised it. Austin, who emphasised the sheer hard labour of this 'work that is never finished' and rejected the idyllic image of the dairymaid, had to settle for a recognition of the economic importance of the dairy to the farmer, which partially placed this employment outside of the bounds of femininity.[37]

Those who were closest to agricultural production, and who were engaged in the production of their own discourse of expertise, constantly reveal a greater acceptance of women's farm work, regardless of the rural idyll, class or wider visions of femininity. Tenant farmers, who aped the lifestyle and values of the urban middle class, had very few qualms about employing women within official discourse, however, acceptance of field women and their economic significance was dependent upon pastoral visions of an industrious and sober peasantry, and therefore the distance of class *and* location; they had to become exceptions to the moral and social bounds which encircled bourgeois femininity. As Lynda Nead says

of the apparent strength of the woman in George Elgar Hicks' painting *The Sinews of Old England* (1857), strong arms and a tan as 'signs are essential, they connote the differences between this woman and the middle-class ideal ... They reassure that this woman is respectable but different from the middle-class woman and provide the point of closure between the middle class and the class below it'.[38] Pastoral as well as class enabled the representation of the Northumbrian bondagers to remain positive throughout the century, when other representations of poor labouring women became problematic.

John Ruskin, probably England's most influential contemporary critic of art, architecture and society, believed that there was a fundamental moral and physical division between a properly tended countryside, a garden, and an exploited countryside, a wasteland. Englishmen made a daily choice between Eden and waste in Ruskin's mind. In his fairy-tale *The King of the Golden River* (1841), Treasure Valley is a spiritual battleground for three brothers: two make money by exploiting it, but thereby destroy it, while the other husbands it and becomes spiritually and literally wealthy. Ruskin repeatedly used this juxtaposition of a tended garden and a barren wasteland in his later work. He had envisioned a happy society in pastoral terms even before he began to write on social issues. The ideal environment was an organic, rural community, based on parental hierarchies between rich and poor, farmers and the land, bishops and their flocks.[39]

We can see this as an expression of the very real social, political and economic tensions between old and new farming, feudal and capitalist agriculture, continuity and change of the early nineteenth century. Capitalism had produced vast riches for larger farmers in the late eighteenth century, but by the 1840s England was still only just emerging from the slump of the post-Napoleonic agricultural depression. The 'Hungry Forties' had been preceded by a period in which fears of revolution were commonplace in town and country. England could not always be seen as a civilised nation of contented peasants, matronly women, breadwinning men, piety, health and purity. Even labouring men's sturdy independence was being threatened, so that their wives had to take paid work. On investigation, it was found that the rural was no longer the embodiment of English freedom and liberty, but had become the location of poverty and distress. This same tension can be seen in the works of many authors, including official reporters like Denison, activists like Cobbett, and socially concerned novelists like Kingsley, despite their diverse political beliefs. Individual labourers – men, women and children – passively existed in the shadow of these wider issues or were occasionally brought out into the light of social investigation as signs of

rural decay. But at this point they could be rescued within the discourse of pastoral, which was still capable of the recuperation of the ideal in the face of 'reality'.

NOTES

1 See Kingsley, C., *Yeast – A Problem*, London, 1895, (1st edn. 1851).
2 Taylor, A. J. P., *Laissez-Faire and State Intervention in Nineteenth-Century Britain*, London, 1972, pp. 11–12, 43–4, 48–9, 53, 64.
3 'Reports of Special Assistant Poor Law Commissioners on the Employment of Women and Children in Agriculture', PP 1843, p. xiv.
4 *PP* 1843, p.1.
5 John, A.V., *By the Sweat of their Brow: Women Workers at Victorian Coal Mines*, London, 1984.
6 Hodder, E., *The Life and Work of the Seventh Earl of Shaftesbury, K.G.*, London, 1888, pp. 236–7, 279–82.
7 *Ibid.*, p. 280; PP 1843, pp. 19–22.
8 *The Times*, 7 Jan 1843, leading article.
9 *The Times*, 7 July 1843, p. 4.
10 *The Times*, 30 Aug 1843, p. 4.
11 *PP* 1843, pp. 220, 280.
12 *Ibid.*, pp. 223, 225.
13 See Banks, S. J., 'Nineteenth-century scandal or twentieth-century model? A new look at "open" and "close" parishes', *Economic History Review*, 2nd Series, xli, 1988.
14 *Ibid.*, pp. 274.
15 *Ibid.*, p. 280.
16 Collins, B., *Charles Kingsley. The Lion of Eversley*, London, 1975, pp. 56, 64–5, 89, 96–8, 109, 121, 133, 362; Vance, N., *The Sinews of the Spirit: The ideal of Christian Manliness in Victorian Literature and Religious Thought*, Cambridge, 1985, p. 34.
17 Kingsley, *Yeast*, p. 19.
18 Vance, *The Sinews of the Spirit*, pp. 113–24.
19 Wordsworth, W., Coleridge, S. T., *Lyrical Ballads*, (ed.) Brett, R. L. and Jones, A., R., London, 1991, p. 54.
20 Kingsley, *Yeast*, pp. 61, 150.
21 *Ibid.*, p. 61.
22 *Ibid.*, p. 177.
23 Nead, L., *Myths of Sexuality: Representations of Women in Victorian Britain*, Oxford, 1988, pp. 96–7.
24 Kingsley, *Yeast*, p. 177.
25 Vance, *The Sinews of the Spirit*, p. 81.
26 Kingsley, *Yeast*, pp. 199, 275.
27 *Ibid.*, p. 199; Collins, *Charles Kingsley*, pp. 105–09.
28 Kingsley, *Yeast*, p. 275.
29 *Ibid.*, p. 245.
30 *PP* 1843, p. 298.
31 Howkins, A., *Reshaping Rural England: A Social History, 1850–1925*, London, 1991, p. 19–22, 50–51; and see Mrs Williamson, 'The bondage system' in anon., *Voices From the Plough*, Hawick, MDCCCLXIX, for a first-hand and very critical

account of this system.
32 *PP* 1843, p. 298.
33 *Ibid.*, p. 282.
34 *Ibid.*, pp. 293, 298–9.
35 *Ibid.*, p. 291.
36 *Ibid.*, pp. 299–300.
37 *Ibid.*, p. 5.
38 Nead, *Myths*, p. 43.
39 Spear, J. L., *Dreams of an English Eden: Ruskin and his Tradition in Social Criticism,* New York, 1984, pp. 52–4.

All their sweet employments

The 1843 parliamentary report was aimed at a select audience, and only entered the wider public domain via newspapers and periodicals which were not always sympathetic to its aims or conclusions. The majority of the official reporters themselves, with the exception of Sir Francis Hastings Doyle, used a nascent language of bureaucratic expertise, which employed scientific and rationalist values of objectivity that allowed them to remain aloof from their subject. They used the condition of rural women and children as a metaphor for the spiritual, moral and physical welfare of the entire agricultural working class, which in turn contributed to the formation of the language of normalcy and deviancy, defined what was respectable and what was not, and aided the formation of middle-class identity.

'Their morality [field women's] ... appears to me to be that of the women in general of the agricultural labouring class, and which cannot be considered as high. This is owing to their poverty, and to the habits they are accustomed to from their infancy, and to the want of proper education to raise them above their sad condition.'[1] The issues raised in this quote parallel similar concerns with poverty and education in the cities, but were coloured by a different context when projected onto the countryside: the paternalism which recurred throughout the 1843 report and the culture of pastoral. If we take on board the empirical details gathered hurriedly in 1843 we can see something of the conditions under which the labouring population lived at this time, and which had led to the Swing Riots and other labourers' revolts through the 1830s. The quality of village life did not remotely resemble the prevalent cultural visions of a rural idyll. Thanks to the ongoing process of enclosure, the growth of capitalist agriculture and the slump in prices which followed the Napoleonic wars, life in the villages had begun to resemble that in the cities for the working class. This led to increased fears among farmers and clergy alike of a loss of stability in the countryside, and thus

their evidence often mirrored the conclusions drawn by the reporters themselves, equally fearful of revolting masses in the towns. New and old ideologies combined in debates on the condition of the countryside. The bourgeoisie partly formed through the reorganisation of these ideologies, as new cultural meanings formed around new, powerful positions within the dominant hegemony, which took on board some values, while others were excluded. The bourgeoisie did not create these values, rather they adopted and nurtured them. Any real understanding of the representations – of rural women therefore depends upon a much wider understanding of debates about the country and the city, education and health, the construction of femininity, the definition of Englishness, and the significance of evangelical religion, as we have already begun to see.[2]

The Anglican church had been an important authority in rural England for centuries, and was still a significant regulatory power in the villages, despite the spread of new denominations and dissent among the labourers. In the towns, religion, in the form of evangelicalism in particular, provided the middle class with respectability and gentility, and was a major component of the ideology of domesticity by the early 1840s. It helped produce a wide range of new identities, especially within the discourse of sexuality, adding to, for example, the construction of the identity that came to be known as the prostitute. The new capitalist farmers equally hankered after the authority of gentility, and as they withdrew from village society and developed their own class consciousness, they took up religion as family units. In the villages the middle class gained and preserved their new respectability by holding private services.

The religious revival which began in the late eighteenth century was widespread by the early nineteenth. Where the Anglican church was weak, Methodists and Independents filled the gaps, especially in the open parishes of East Anglia. Absentee Anglican clergymen were increasingly replaced by more active evangelicals committed to the new values of industriousness and self-help. In this way, the clergy were still part of the village elite and maintained, or even increased, their prestige. The evangelicals were especially energetic in preaching their gospel with enthusiasm and putting their values into practice through good deeds such as Sunday School education and the organisation of clothing clubs in the local community. The clergy were taken to be among the most reliable witnesses throughout the 1843 report, and it is not surprising that many of their views coincided with those of the official experts; they coupled new middle-class concerns with eighteenth-century ideology. The constant emphasis on immorality in the cottage home, for example, was closely linked to the development of medico-moral poli-

tics, and new social practices in the towns, where professionalising medical men and the clergy increasingly carried out their own expert surveys on the condition of the working class.[3]

Rural working-class women belonged to a rapidly changing society where the values of separate spheres were not yet universally established and new forms of working-class respectability were only just evolving. But labouring rural women, children and men already belonged to a world where the clergy could affect their physical, as well as spiritual, well-being, and where labourers were constantly bombarded with ideologically-loaded messages. Local charitable societies and agricultural associations, which were widely established at this time by the clergy and Anglican farmers, encouraged the promotion of stability through prize-giving. The Docking Union Association, established near Norwich in 1840, was typical with its aim of 'promoting and rewarding good conduct and encouragement of industry and frugality amongst labourers, servants and cottagers'.[4]

Subscribers to the Association, mostly men but also some wealthier women, provided money for prizes to shepherds, agricultural and domestic servants, labourers and other paid workers. The rewards included some for women who had managed to rear the most children in the neatest cottages, without recourse to parish relief. As the Association progressed, more prizes were given to women for domestic achievements and fewer paid to servants. Earlier, a Lying-in and Clothing Society, established in the same area in 1816, had tried to ensure that 'no woman who has had a child *before* marriage, shall be admitted until she has had *two* children *after* marriage',[5] a careful practical and ideological compromise which attempted to spread new values, but also accepted that their adoption would be a slow process. The ideal organic community could take on a life of its own, despite the best attempts of clergy, farmers and gentry to discipline it; Norfolk was well known for its children born out of wedlock. There was clearly a process of negotiation inherent in the operation of even regulatory power at an everyday level.

The rural elite increasingly tried to follow the values of the urban middle and upper classes and to instil these values in the rural poor, but sometimes they had to call in an expert to help them achieve their aims. In 1836 Dr James Kay-Shuttleworth, author of *The Moral and Physical Condition of the Working Classes Employed in the Cotton Manufacture in Manchester* (1832), co-designer of the New Poor Law of 1834 and urban Benthamite proponent of medico-moral politics *par excellence*, visited the Norfolk Loddon and Clavering Poor Law Union to provide advice on the establishment of a new workhouse. He immediately demanded

that a chaplain be appointed; required that adverts be placed for a respectable married couple to act as schoolmaster and mistress; established a medical club, so that the poor could obtain medical attendance outside the workhouse; oversaw the children's religious education and recommended that girls be taught domestic duties by helping in the workhouse, while boys could learn agricultural skills by working in its grounds; and finally ensured that 'pauper dissolute women be accommodated in the attic on the women's side of the house in order that due subordination and morality be maintained among the female inmates'. Not only did the Poor Law guardians accept his advice, their fulsome praise in the minute books reveals the extent to which they were in awe of him.[6] The influence of the new cadre of experts extended well beyond the city or empirical Royal Commissions and brought with it its own pleasures for the rural middle class. They were then able to take on a much clearer identity as members of the bourgeoisie, with a set of shared values, ideologies and goals.

Within these official and religious discourses country women's bodies were constantly used as metaphors, not just for the condition of the organic community, but also for the English landscape and Nature. Traditionally, as Sherry Ortner has said, where men have represented Culture, women have represented Nature. This is the case in literal, biological terms – women are associated with child-bearing and childcare, while men are supposed to build, paint, write and become politicians – but this also means that women are linked to Nature in the dominant hegemony. This is important because Nature and the natural are usually undervalued in comparison to Culture, which is supposed to be superior because it involves the transformation of what is natural. Of course, women raise children and therefore transform them, which can produce contradictory images of women living in small clearings of culture in the wilderness of nature – which occasionally allows them to be elevated above the wild – but men and masculinity are never ambiguous within this polarisation.[7] This becomes especially important in the discourse of race, or national identity, and in the universalisation of domesticity as ahistorical and 'natural'.

The new English pastoral that developed in the late eighteenth century increasingly became linked to Englishness as foreign trade expanded in the early nineteenth century. However, as urbanisation continued, there was an increasingly popular vision of the urban as more sophisticated, civilised and progressive. As the urban became culturally superior to the rural, English culture was increasingly seen to be superior to that of native populations in the colonies. The peasantry might be moral and hard-working, but they were also seen as poorly educated, a

little too simple. Rural women in particular were associated with the natural: they instinctively behaved morally when elevated, or instinctively behaved like beasts when the image was inverted, because they knew no better unless guided by their betters. Within this polarity, the urban middle class were empowered and their authority to intervene was legitimised, despite the moral impact of Wordsworthian Nature. Some authors, such as Richard Cobbold in *The History of Margaret Catchpole* (1845), went to great pains to explain that a natural morality was no good without a cultured understanding of Christianity. William Howitt's *The Rural Life of England*, published in 1838, is an excellent example of the ideal of rural femininity, constructed through an interweaving of Nature, nation and domesticity.

As the son of a Derbyshire farmer Howitt could claim a certain degree of cultured expertise on rural life, and his country books were popular throughout the century. *The Rural Life of England* was in its third edition by 1844. This kind of text provided the urban middle class with the vicarious pleasure of travelling to the English countryside, where they found a world of natural stability and tradition; of continuity as opposed to change, supported by factual detail garnered from the discourse of agriculture; a world in which their social superiority was never in doubt, despite a critique of the city, because of the inferior position of Nature. Typically enough, the opening chapter of Howitt's book consisted of a celebration of England and Englishness and an eroticised exposition of his research 'penetrating into the retirements, and witnessing the domestic life of the country in primitive seclusions and under rustic roofs'. In a Wordsworthian adoration of Nature, he then contrasted the 'peaceful simplicity of the country' with the 'crowding, noise, political contention and turning night into day, of London'. Of life in the countryside he wrote, 'It has everything in it which is beautiful and may become glorious and Godlike. ... [the] country and its manners remain almost as simple and picturesque as they did ages ago'.[8]

In his construction of pastoral Howitt used the medieval discourse of humours, which, among other things, linked the effects of the weather to a nation's character. He, like Assistant Commissioner Denison, also described the civilising and beneficial influence of the aristocracy on the peasantry. The rural labouring population were represented as children, who were not as intelligent as their cultured town comrades, but possessed a simple morality because of the influence of Nature. Set within this construction, women were constantly used to heighten the picturesque, constructed for the cultured urban gaze. In reference to the farmer's 'good and skilful dame, and the no less skilful and comely daughters' at work in the farm kitchen, Howitt said he could sit

all day and watch 'all their sweet employment, and hear all their sweet words ... [in] this milk-and-honey-flowing kitchen.'⁹ The wife and her daughters, situated at the intersection of both the rural and domestic idylls, were represented as industrious objects of desire, while the rural and the kitchen were presented as sources of natural abundance. All were organic, consumable, edible and desirable. Howitt's images of sweetness and comeliness connoted ideal femininity, the Beau Ideal of the domestic sphere.

Howitt was, to some degree, aware of the drudgery of working-class women's lives, but when these women entered the harvest field he was still able to conjure up an idyllic glamour around them. As labouring women emerged from their cottages in a 'beclouded and unimaginative dreary state, ... to work or to glean', they were transformed into 'The comely maiden with her rosy face, her beaming eyes, and fair figure, [who] brings with her mirth and joke'.¹⁰ Their work was projected onto their bodies, so that the happiness of haysel made the women happy, its idyllic summer setting re-presented dull women as comely women, some virginal and desirable, the older ones jolly peasants.

Using Claudean, eighteenth-century imagery of the peasantry as picturesque clowns, and the Nature/Culture divide, Howitt could represent rural women as either 'objects of admiration' or 'stout village matrons'. The labouring class were at a social remove from Howitt and his audience. They were distant figures in a landscape, labouring for England's benefit, 'the toiling children of these Kingdoms'.¹¹ Though the issue of children's employment was contested at this time, the metaphor of childhood allowed authors like Howitt to distance the rural working class, and to objectify and celebrate the peasantry in support of paternalistic ideology, which could then be adopted as a legitimate form of power, or subject position, by the new middle class. The images Howitt used had not changed greatly since their construction in the late eighteenth century, but their significance changed as England widened its trade and urbanised. Though the city presented particular problems to the middle class, it was also increasingly celebrated for its culture. The move to suburbia was as much formed through a desire to maintain cultural links with the city, as to gain greater access to the health of the country. What we also see in Howitt's prose is the influence of the language of expertise.

The list of male witnesses in the 1843 reports consisted of landlords; farmers, sometimes including smallholders or market-gardeners; clergymen; local medical men; local officials, such as Poor Law administrators; bailiffs; labourers hired by the year, like shepherds, stockmen and ploughmen, and, finally, day labourers. But women were also inter-

viewed and were often the wives of these men, or farm servants, dairy-maids, and casual female labourers. In the report on the gangs, the children who worked in them were also interviewed, as were the masters who controlled them. To what extent can a reading of their evidence be seen to be determined by the meanings imposed on it by the experts who interviewed them? Their evidence provides the only real documentation of working-class ideology at this time; most labourers were illiterate and left no written record of their lives. It also provides us with a rare source of conflicting views on agricultural labour in 1843. Other sources include the labourer poets like John Clare and Mary Collier, who were few and far between, and folk songs, which we will consider shortly.

One woman, Mrs Sculfer, was quoted at length in Denison's appendix on the gang system in Castle Acre:

> I have six children; three girls and three boys; my two eldest girls go out-most to my grief that I am obliged to send them. They worked for Mr. Fuller (the chief gang-master) more than for any one else. Mr Fuller has four or five overseers; he has 100 people in his employ.
>
> I know the gangs generally bear a very bad character; but I don't know myself that any ill-conduct goes on in the fields. It's my belief that it's the ruin of them. They never settle to anything after it.
>
> My eldest girl has a thorough dislike of it. She almost always goes crying to her work. She would do almost anything than it. The worst place she could get anywhere, poor thing. I wish I knew of any place I could get for her, but I don't. I am sure I don't know what to do.
>
> My second has been, to say, brought up in the fields. She does not mind it.
>
> It was said that Fuller won't allow bad discourse, but he's not always with them; and these great boys won't mind the overseers.
>
> They have been to Winch; then they ride. Fuller takes them in a wagon; then *they ought* to stop all night; but my husband won't allow it; for they sleep in barns or anywhere; that's what they said. There's pretty work for boys and girls! We would not agree for ours to stop, by no means; not if they lost their work.
>
> If they go in a morning and stay only a little time from rain or other cause, they don't get paid; so they get each one of the gang to do short work, and then don't pay them; but still the work's done; that is the master's gain.
>
> I never heard anyone who did not say they disliked it.[12]

Another woman, Mary Churchman, said the evidence of Mrs Sculfer was quite correct. She then added that there was a lot of bad language used in the fields and that some of the gangmasters were the worst part of the job. Her daughter testified that Mr Fuller had a particularly bad reputation: 'I know there's scores of girls as he's ruined: some of the

gangsmen are as big blackguards as there is anywhere.'[13]

If we turn to the general evidence on the women of the fields, we can see that gang women and other field labourers in Norfolk carried out a wide variety of agricultural work. In 1843 it was noted that they worked at stone-picking; pulling couch grass; planting corn – by dibbling – and setting turnips, peas, and beans; hoeing and weeding; hay-making, including loading hay; harvest work such as binding and gleaning; picking potatoes, pulling turnips and gathering mangolds, wurzels and carrots for about 7*d* to 8*d* a day. Those who were normally in-door farm servants typically joined the fieldworkers at hay-making for 10*d* to 1*s* a day with beer, and during harvest time most village women were involved in tying sheaves and gleaning, while some women still reaped. In-door farm servants and farmers' female relatives also worked in the dairy. This involved milking, which necessitated rising at 4.00 in the morning, and keeping the dairy clean by scalding the equipment and washing the floors. The milk was separated, churned and made into butter. If cheese was made this had to be pressed, turned every day and regularly wiped. Many farmers' wives were also involved in rearing poultry and the young stock of the farm, and marketing the final product, as well as managing the women who worked under them.[14]

The reports may or may not provide an accurate summary of the precise conditions, pay and labour undertaken by field women, but if we read them suspiciously they do show that the observed differed from their observers in their understanding of women's paid work. Clearly the women had a definition of respectability that centred on an attack on the sexual and economic exploitation of power that was an issue for their middle-class observers. The relationship with their supervisors and employers and the experience of work became the locus around which working-class women constructed their own identity. The women of the fields were highly critical of the conditions in which they and their children were employed, and refused to be subject to them – despite the material necessity of paid work. In this way, they defined themselves as respectable wives and mothers in opposition to both farmers and gang-masters; able and willing to stand up to their employers on behalf of their children, the women were conscious of their exploitation. To see working-class women simply as the passive victims of bourgeois objectification in official discourse would be to misunderstand the way that power works in society and the multiple readings and meanings in a text.

Beyond this, when we look at the apparent acceptance of new values within the working class, we also need to consider the positive aspects of consent. This is vital to an understanding of the Foucauldian concept of discourse. Femininity was defined through an image of plea-

sure, it did not simply restrict women's lives and cause them pain. This pleasure could be won through the special status accorded some roles, which made femininity a desirable goal;[15] the 'successful' wife and mother was given a certain amount of authority within bourgeois society. Self-sacrifice was praiseworthy and ennobling; the middle-class woman knew that she should aspire to domesticity as a special moral occupation which was publicly celebrated and officially endorsed. For working-class women, this carried with it the added pleasure of the end of drudgery and hard physical labour, which might explain why women steadily left agricultural employment through the second half of the century, as more alternatives became available, and as men began to win higher wages. We do not have much record of the working-class response to the practice of official observation outside of the reports themselves. We cannot know what meanings this practice had for them, or discover their readings of these texts – most of the working-class witnesses were illiterate and of course they had no access to the final reports – but we do have a cultural record of their relationship with their employers in the form of folk ballads and songs. None of these are directly attributable to women, as traditional ballads which recounted heroic exploits and sentimental romances, often sung from the woman's viewpoint, were in decline by 1820, but they do provide us with a sense of wider working class identity and ideology. Early nineteenth-century folksongs show labouring men's pride in their work and increasingly the songs recount stories in which labourers were pitted against landlords. Resistance through the medium of regret at the passing of paternalism and lost rights was a common theme, while the new capitalist farmers were often the butt of jokes. These large farmers and local tradesmen were widely attacked for aping the gentry and profiting from the French wars; pride, avarice, greed and laziness were especially viewed as vices of the rich, not the poor, and reveal a working-class identity in-the-making.[16]

Though landlords were criticised as much as farmers, the rural working class did not prefer the look of town life, according to the songs of the period. Numerous songs praised the country over the city, by lauding the material benefits of agricultural employment, or by telling a story of a peasant who went to town and outwitted the city folk. This highlights the complex social relations within the countryside and a possible fracture in the formation of a unified working-class consciousness between country and city. Many songs idealised the countryside in a way that paralleled eighteenth-century pastoral and we do not know how these were sung – seriously or sarcastically – nor how they were received. But those which criticised the towns, especially London, at least reveal a

rural working-class ideology that resisted both metropolis, and the fashions of the middle and upper classes. *The World Turn'd Upside Down*, a song dating from 1820, makes it clear that 'Lunnon myther, is the devil', populated by shopkeepers who go bankrupt, ladies who wear no petticoats, men who wear stays, thieves and pawnbrokers.[17]

There was also pleasure in consumption. Howitt for one offers us a vision of rural women that is almost literally consumable, within a wider discourse of the body that made women into signs of rural felicity and fecundity. Of all the agricultural labour done by women in nineteenth-century England, dairy work was one of the most exhausting, as we can see in the evidence of the reports, but it was also constructed as one of the most pleasing metaphors for industrious domesticity. In Somerset, where dairy work formed working-class women's main employment – paid and unpaid – the report of 1843 stated that doctors in the county often saw women who had suffered badly from it, with 'such symptoms [as] – pains in the back and limbs, overpowering sense of fatigue most painful in the morning, want of appetite, feverishness, &c.'[18]

As we saw in the previous chapter, the parliamentary reports largely passed over this employment. This was to a large extent because the dairy was expected to be part of the home, or at the very least it was attached to the farm buildings. Dairywomen and milkmaids therefore worked in the safety of the domestic sphere and within sight of the farmer. If we consider Foucault's panopticon, his description of the process of observation, based on the architecture of prisons and other institutions, that is vital to the exercise of regulatory power, the dairy provided a building within which morality was guaranteed. In the fields, there was little supervision except by working-class men, who might not be any more reliable than the labourers they watched; this became a key part of the debate about field work in the 1860s. Dairywomen could also be equated with the edible, natural products that they worked with, in other words, female liquids, butter and cheese. Their skin, as we shall see in a later chapter, was constantly referred to for its milky whiteness, which introduced the discourses of class and race into the process of representation. Finally, the work itself was seen to be feminine because it required natural kindness, sweet songs and soothing words to get the cow to give down her milk.

The milkmaid or dairymaid should not be seen simply as an ideal image, however; she also became a category, like the prostitute – who can be defined as any woman who transgressed the bounds of middle-class morality, as Nead suggests. The Foucauldian concept of a category incorporates the ideal image *and* its opposite and works to set up boundaries.

Here, I would argue, boundaries are established between different modes of femininity. Categories do not describe groups which already exist, but rather help define and categorise a group according to class and sex, as well as race. This is an historically specific process which adds to the changing construction of femininity and its regulation.[19] The dairymaid could be any woman who fulfilled the ideology of 'natural' femininity. She was not as important a construction as the prostitute, but she did constitute an identity produced across the discourses of art and literature throughout the nineteenth century. Similarly the 'gleaner' became part of the wider definition of class, race and femininity produced by a set of contesting legal and religious discourses and the practice of visual and literary representation. Gleaning was a contested right in the nineteenth century. It was a major source of income, especially in East Anglia, for labouring families, and when farmers attempted to end the practice from the late eighteenth century the women who undertook the work were central to the protests that resulted.[20] The image of Ruth was constantly drawn upon by artists and philanthropists alike in support of the cause of the peasantry and the value of charity. Ruth became an important sign within the debate over self-help and philanthropy that produced the identities of the 'deserving' , i.e. industrious, and 'undeserving', i.e. lazy, poor. Images of rural women in fact became very general signs of a disrupted and damaged rural landscape, as well as metaphors for idealised Nature and domesticity in the public domain as a whole. The liberal *Morning Chronicle*, for example, began to conduct its own social survey of the nation's poor in 1849–51 and introduced its report on the countryside by putting women's agricultural work into the context of the wider rural condition, as *The Times* had done in 1843.

The *Morning Chronicle* made it clear that women could not be workers and fulfil their role as wives and mothers as well: 'One of the worst features attending the system [women's field work] is the cheerlessness with which it invests the poor man's house'. Its solution was for men to receive higher wages, so that the women would not have to work in the first place. In the *Chronicle*'s letter on the South-west, the paper narrated how the sexual morality of the whole of the rural working class was being corrupted by their low wages and poor living conditions. This was highlighted by descriptions of the immoral state of the women, particularly those who worked in the mines and fields:[21]

> In some parts of Cornwall the immorality of the females at work about the mines is notorious and proverbial....
>
> Nothing can be more fatal to the young girl, after the training which she has received in the home, than the work to which she is early consigned in the fields. She there often meets with associates, even of her

own sex, who speedily qualify her for any criminalities in which she may be afterwards tempted to participate.[22]

Later, the paper looked at the gang system as a major area for concern in Norfolk, which it believed was 'attended with a considerable amount of evil to the person employed'. Quoting the 1843 inquiry, the *Chronicle* laid the blame for the system at the landowners' door and went on to stress the physical hardship involved in the work. When the *Chronicle* finally referred to the high level of illegitimacy in the county, it did not place the blame for this on women's work in the gangs. Again, it followed the lead of the 1843 report by focusing on the poor living conditions in rural districts.[23]

The Morning Chronicle was sympathetic to the condition of the poor and lower classes, so it catalogued labouring women's morality, health and work as part of its wider concerns. Their bodies became metaphors for social decay. Education, self-help, industriousness, religious guidance and the fulfilment of their duties to the poor by the wealthy and employers, were the accepted paternalistic solutions to the ills the paper described.[24] It regretted the loss of older social relations, and used the rural as an arena in which to express this. Neither labouring men or women were blamed for their degraded state, instead their condition was seen as a sign of the general collapse of rural society, not the cause of it, because pastoral guaranteed that the ruling class would still be seen to discipline them.

What is especially interesting here is the use of interviews and descriptions of the detail of rural life. The desire to find witnesses seems to have gone wider than the official discourse of the parliamentary report, in which the witnesses became case studies and their evidence became a mode of representation in itself. Lynda Nead – whose model I have found especially valuable in beginning an analysis of the relationships between discourses and the way that the visual definition of femininity contributed to the maintenance of bourgeois hegemony – stresses how in *Discipline and Punish* Foucault describes the importance of the interview as part of the wider process of categorisation. The interview and empirical evidence define what is normal; they judge each individual on the basis of what is seen to be the norm, and help construct that norm. This process became increasingly important within the discourses of imperialism and medicine as new theories of evolution enabled white middle-class 'explorers' to categorise their finds as 'types' when investigating not only other races, but also classes and deviant groups.[25] This was a language which became especially important in the representation of rural men, women, and children in the middle of the century.

The norm of the rural idyll was constantly being redefined from 1830 to 1850. On the one hand, authors like Howitt were writing new English pastorals for the pleasure of the urban bourgeoisie. On the other, there was a rapid growth in the research and publication of social surveys which developed alongside the increased use of parliamentary reports, and frequently laid claim to the same objective and scientific impulses and methods. Many actually used evidence from the official inquiries they emulated. By the middle of the century authors like Richard Heath often used this practice to disseminate official empirical information. These were the precursors of the discourse of social science which developed at the end of the century, led by researchers such as Arthur Wilson Fox, S. Rowntree and Henry Mayhew. They show an ongoing tension between the myth of the rural, created by and dependent upon distance and used as social metaphor, and the increasing need and desire to explore the countryside like a foreign country, as the process of urbanisation and universalisation of values adopted by the middle class continued. In effect, these two practices were not separate: they informed each other and brought about a real regulation of rural women's lives, as well as the production of new identities such as 'dairymaid', 'gleaner', 'bondager' and 'ganger'.

The Canon of Durham, W. S. Gilly, described the lives of the agricultural labouring population of Northumberland in *The Peasantry of the Border* (1842). Like the 1843 report on the county, which referred to his efforts to improve rural housing,[26] Gilly attacked the morality of the population as corrupted by the crowded rooms they slept in. But unlike Doyle, he could not accept the use of women in field work.[27] He quoted an anonymous French author on the subject: 'The greatest evil in our rural districts, is the degradation of the female sex, by their employment in labours adapted for men. ... like heavily laden beasts of burthen ... their skin is wrinkled, their faces burnt, their features masculine, and they sink into a premature decrepitude more hideous than that of old age'.[28]

Their moral corruption was played out on their bodies. The women were said to know nothing of domestic skills; they were defeminised in behaviour and appearance because they had taken on aspects of masculinity. The only way to stop the 'evils' continuing was to re-educate the women, and to re-form their femininity. It would be preferable to remove them from the fields, the site of their corruption, altogether. Work, domestic duty and appearance became linked through the discourse of Nature: 'The mother of a family is a moral power, fertilising the mind and opening the heart to affection and charity and every virtue. ... Restored to their proper place and occupations woman would

regain her proper appearance, and with it her influence ... '.[29] If put back in their place, the home, the women would regain their moral and physical femininity. Their displacement into the fields had only temporarily damaged them. Gilly, while setting out to describe the realities of country life in the north and appealing to the ruling class on behalf of the working class, had ended up attacking women fieldworkers for their unfemininity and failure within the rural and domestic idylls, which necessitated a reworking both of the reality and the idyll. His representations of them as ugly, corrupted by men's work, and as bad wives and mothers added to the middle class construction of femininity and finally extended definitions of separate spheres to the countryside and its working population.[30] He used the French author to give his ideas authority, and the fact that this testament came from France helped universalise the ideal. This process of universalisation was a sign of things to come, when rural women who had gone to the fields would no longer be retrievable.

Rural women were represented as perfect child-like peasants within the discourses of literature, art and social investigation. Despite alternative images of them as prostitutes, they were recuperated and seen to be in need of paternalistic protection by their social superiors. The categories of the dairymaid and gleaner also helped define the norm for working-class rural women, against which they were constantly judged. Their bodies, as belonging to the land or Nature, became a metaphor for the condition of the rural population as a whole, and the constructions of idealised femininity. The representation of rural women offered a kind of bridge between these discourses and acted as signs of sickness, decay and poverty or health, industry and fecundity within the bourgeoisie's cultural hegemony that could provide the middle class with either a warning or a voyeuristic thrill when consumed.

The peasantry as a whole were still often seen as children – children of the soil, of the land, of England, of Nature – regardless of their sex. Childhood itself was seen as a garden, as controlled Nature, and the peasantry were represented as still living within that garden, the garden of England, despite changes in agricultural production, war, peace, depression and riot. Actual labouring children were surveyed as part of the wider concern for the condition of the children of the poor, which began to stress the need for education over industry as values nurtured by the middle class were universalised.[31] But the intersecting ideals of domesticity, childhood and Englishness that were played out in the rural idyll actually worked to undermine the impact of their material reality, compared to the horrors of life in the city. Rural men, who constituted the remainder of the peasantry, while feared as drunkards and criminals,

fears which the violence of the 1830s had exacerbated, could still be seen fundamentally as peasants whose labour and poverty was distanced and hidden within pastoral, who could act as carriers of new values and ideology concerned with industry, thrift and piety.

The country was increasingly in tension with the city, so that the Beau Ideal regularly had to be rescued in the first half of the nineteenth century. Forays into the countryside challenged the rural idyll, while new positive constructions of the urban as the centre of culture offered an alternative perspective on the city, if the middle class were able to sanitise it. Even in the 1840s Carlyle could still describe 'these our industrial ages ... [as] ... chaotic, distressed, distracted'.[32] We have to wait until the 1860s to see a real shift in the representation of the rural as a result of new social realities, the apparent achievement of a golden age in agricultural production and the increasingly secure identity of the middle class. The guardianship of the countryside and its populace still rested on the shoulders of the gentry. Even in the open fields it was assumed that they were present in some form, observing and disciplining their workers. The projection of urban concerns onto the countryside therefore enabled the middle class to rescue the power of the organic community from the past. Instead of threatening the construction of the rural idyll, this process served to reinforce it, because urban social issues became disempowered and were apparently containable within the village.

NOTES

1 'Reports of Special Assistant Poor Law Commissioners on the Employment of Women and Children in Agriculture', *PP* 1843, pp. 24–6.

2 Green, N., and Mort, F., 'Visual representation and cultural politics', in *Block*, no. 7, 1982, p. 63.

3 Mort, F., *Dangerous Sexualities: Medico-Moral Politics in England Since 1830*, London, 1987.

4 Docking Union Association poster, 1840, Norfolk Records Office, SO17/1, 488x.

5 Docking Union Association poster, 1840, Norfolk Records Office SO17/1, 488x; Lying-in and Clothing Society, Bawburgh Rule Book and Minutes, 1816, Norfolk Records Office, SO 24/1, 501x4.

6 Loddon and Clavering Minute Book, 1836–37, Norfolk Records Office, C/GP 12/65, 91, pp. 10–11, 33, 81–3, 383, 402–3.

7 Ortner, S. B., 'Is the female to male as nature is to culture?' in Rosaldo, M. Z. and Lamphere, L. (eds.), *Woman, Culture and Society*, Stanford, 1974, pp. 69–86.

8 Howitt, W., *The Rural Life of England*, Shannon, 1971, facsimile of 3rd edn. of 1844, pp. viii, 4, 16, 20.

9 *Ibid.*, pp. 93–5.

10 *Ibid.*, pp. 112–14.

11 *Ibid.*, pp. 2, 114, 405.

12 *PP* 1843, p. 275–6.

13 *Ibid.*, p. 276.

14 *Ibid.*, pp. 216–7, 231, 235–6; Marshall, W., *Review and Abstract of the County Reports to the Board of Agriculture*, iii, London, 1818, 1st edn. 1811, pp. 332–3, 379; Young, A., *The Farmer's Kalendar*, Wakefield, 1973, 1st edn. London, MDCCLXXI, pp. 164, 231–3, 237, 246. 'Reports of the Royal Commissioners on the Agricultural Depression', *PP* 1894–97, pp. 101, 71; Pinchbeck, I., *Women Workers and The Industrial Revolution 1750–1850*, London, 1985, 1st edn. London, 1930, pp. 9–13, 103–4.

15 Nead, L., *Myths of Sexuality: Representations of Women in Victorian Britain*, Oxford, 1988, p. 24.

16 See Dyck, I., 'Towards the "cottage charter": a new look at economic relations in nineteenth-century rural England', in *Rural History, Economy, Society, Culture*, i, 1, 1990, pp. 95–111.

17 Holloway, J., and Black, J., *Later English Broadside Ballads*, London, 1975, pp. 282–3.

18 *PP* 1843, p.5.

19 Nead, *Myths*, p. 95. For an excellent description of the different jobs and wages of dairy- and milkmaids see Pinchbeck, pp. 10–16, 103–04, and D. Valenze 'The Art of Women and the Business of Men: Women's Work and the Dairy Industry, *c.* 1740–1840' in *Past and Present*, 130, 1991, pp. 142–69.

20 Morgan, D. H., *Harvesters and Harvesting 1840–1900, A Study of The Rural Proletariat*, London, 1982, pp. 152–62; King, P., 'Gleaners, farmers and the failure of legal sanctions in England 1750–1850' in *Past and Present*, 125, 1989, pp. 116–50.

21 *Morning Chronicle*, 15 May 1843, p. 2; Razzell, P. E. and Wainwright, R. W. (eds.), *The Victorian Working Class, Selections from the 'Morning Chronicle'*, London, 1973, pp. 9–11.

22 Razzell, *Selections*, p. 34.

23 *Morning Chronicle*, 26 Dec 1849, p. 4–5; Razzell, *Selections*, p. 56; *Morning Chronicle*, 5 Dec 1849, pp. 5–6; 8 Dec 1849, p. 5; 26 Dec 1849, pp. 4–5.

24 *Morning Chronicle*, 5 Dec 1849 pp. 5–6; 8 Dec 1849, p. 5; 26 Dec 1849, p. 5.

25 Nead, *Myths*, pp. 150–2.

26 *PP* 1843, p. 299.

27 Gilly, W. S., *The Peasantry of the Border: An Appeal in Their Behalf*, Edinburgh, 1973, 1st edn. 1842, pp. 19–20.

28 *Ibid.*, p. 20.

29 *Ibid.*, p. 32.

30 *Ibid.*, p. 31.

31 Cunningham, H., *The Children of the Poor – Representations of Childhood Since the Seventeenth Century*, London, 1991.

32 Carlyle, T., *Past and Present*, London, 1899, 1st edn. 1843, p. 250.

Golden age

1850–73

Utterly shameless women

The cultural, economic and social background we have just considered had changed by the time the 1863 'Sixth Report of the Medical Officer of the Privy Council' was published. Matthew Arnold had become Professor of Poetry at Oxford. British agriculture had entered its golden era of 'High Farming' and the middle and working classes had become relatively well established. Parliament had also entered its second phase of report writing. The only way that we can begin to understand the furore that erupted over women's field work in the 1860s is to work through the representations in each of the reports, which can be outlined simply as follows. To begin with, the 1863 report focused on women's labour as the cause of infant death, particularly among women working in the agricultural gangs of the area around the Wash, the Humber estuary, and the rivers Waveny, Yare, Bure and Wensum, which had gained a reputation for an infant death rate as high as that recorded in some of the largest cities.[1] This, with increasing complaints from the clergy and reformers in the countryside, in turn led to a speech by Lord Shaftesbury in May 1865 calling for the Children's Employment Commission to inquire into the use of children in agricultural gangs. Originally, in 1843, he had seen this subject as a personal attack, as he believed the conditions on his father's estate in Dorset were represented unfavourably, compared to those in industry. Twenty years later he described children's employment in this system as 'utterly inconsistent with the spirit of the age and entirely at variance with the principles of recent legislation as applied to other branches of industry.'[2]

As we will see, Shaftesbury had shifted from a stance of fear about his own position as an employer, to a paternalistic and interventionist viewpoint that extended to all children in paid work. What is important here is that although he was especially concerned with children's employment, he also stressed the idea that girls who worked in the gangs would become unsuitable wives and mothers.[3] This concern, based on a

belief in respectable femininity, and influenced by the distance between the ruling class and labourers in the countryside by this time, was later highlighted in the report itself. When published in 1867, the 'Sixth Report of the Children's Employment Commission' caused a massive public and parliamentary outcry. There was a major debate in the Commons on its findings on 2 April 1867, and in the press *The Times*, *The Mark Lane Express*, and local papers such as *The Central Somerset Gazette* and *The Norfolk News* all reported on the subject. As a direct result of the report, therefore, the government established the Royal Commission on the Employment of Children, Young Persons and Women in Agriculture, which looked at the question of women's field work in a national context.

This Commission was widely regarded by politicians and feature writers alike as a delaying tactic on the part of the government.[4] For this reason Shaftesbury began a campaign to regulate the gangs. On 11 April 1867 he declared his intention of submitting a bill after Easter, using the same principles as the Factory Acts;[5] in other words, regulation of hours, age at which children could begin to work and separation of the sexes, wherever feasible. By the end of August 1867 the Agricultural Gangs Act (30 and 31 Vict. C.130) had been passed. It stopped all children under 8 years of age working in gangs, and ended the mixed-sex gang. All masters had be licensed and a woman supervisor was needed if women or children were employed. This act, which had a concrete effect on many women and children employed in agriculture, was directly derived from and constructed by middle-class definitions of sexuality, pastoral, femininity, and childhood.

While the Gangs Act was being debated, the Royal Commission on the Employment of Children, Young Persons and Women in Agriculture was established on 18 May 1867. Whereas the 'Sixth Report of the Children's Employment Commission' had concentrated on the gang system in the east of England, this new inquiry was much wider in its scope. Its brief was to ascertain whether the principles of the Factory Acts could be applied to agricultural employment and to find out how country children could be better educated. The Commissioners had to ask what work was done, whether this work was regular, and if it was too much for those involved. Further, they asked if the work affected the women's morals, and if it prevented them from becoming good wives and mothers.[6]

It is apparent that the questions the Commission asked were already shaped by the dominant ideology, particularly in reference to Englishness, morality and domesticity, though each reporter had a different approach and position within this context. The Commission also

defined agriculture as an industry which could be regulated like manufacturing. Farming was constructed as just another branch of science and capitalist production. The farmers themselves believed this to be compatible with an increasing desire for middle-class respectability, akin to gentility and paternalism,[7] and were already engrossed in the formation of their own discourse. But this also indicates a withdrawal from pastoral within official practices, which embraced an increasingly empiricist methodology. The 'Sixth Report of The Medical Officer Of The Privy Council' in particular aimed to be objective in its collection and presentation of data, framed as it was not just by official discourse, but also medical languages.

The 'Sixth Report of The Medical Officer Of The Privy Council' was written in 1863 by Dr Henry Julian Hunter.[8] As we have seen in reference to Kay-Shuttleworth, men like Dr Hunter had been involved in the process of professionalisation in medicine since the 1840s, and had played a major part in the formation of dominant middle-class ideology. This had focused on health and morality and had shaped state policy so completely by this time that the evidence of a doctor was accepted as unbiased fact in itself, which could not be questioned by those operating within the bourgeois hegemony.[9] Doctors, like the clergy, had become respectable figures. In terms of its obvious specialisation as a purely medical survey, this report is distinct from the others. But the manner in which a doctor felt able to discuss medical issues using the language of morality is typical, and was repeated in the evidence given by experts in later reports.

The report was presented to the Privy Council, under the Public Health Act of 1858, by John Simon in 1864. An Officer of the Privy Council from 1858 to 1876, and eventually President of the Royal College of Surgeons 1878–79, Simon was a medical expert of high standing. Under him, Dr Henry Julian Hunter wrote 'On the Excessive Mortality of Infants in Some Rural Districts of England'. The concern was that the east of England, which had no factories or high mortality rate for other age groups, had 'an infantile mortality rate which is equalled by a few of the larger towns'.[10] This anxiety was worsened by the cultural construction of the countryside as the centre of innocence and peace that we have already looked at. The new image was especially alarming in contrast to the old, but can also be seen as a projection of urban concerns onto the rural, which in 1843 had allowed issues of social disease to be contained. The conclusion Hunter reached was unsurprising in these terms, but his use of language also shows a heightened state of concern, compared to the previous report. Hunter said that the cause of death was women's work, rather than the 'soil, climate or

malarious influences'. The women's work was a 'more fatal enemy'; it was supposed to induce premature birth, and lead to illegitimate conception, abortion, and wilful neglect.[11] The report developed into a contestation of working- and middle-class values and highlighted a growing concern with infanticide and bastardy in medical and anthropological discourses.

The category 'bastard' was defined according to what was seen to be legitimate and illegitimate within the language of penal reform, and its meaning constantly shifted in the nineteenth-century. It had already come to be seen very negatively through debates about bastardy in the formation and operation of the New Poor Law. In literature, sensation novels had explored bastardy and began to call legitimacy into question, but post-Darwinian debates about the origin of the species and evolution of humanity shifted the definition again. There was also a widespread fear of infanticide expressed in many novels written in the 1850s and 1860s,[12] especially in the works of Charles Dickens and Wilkie Collins, and we can begin to see some of these concerns re-emerging within the official discourse at this point. The fact that many children who worked in agricultural gangs were 'illegitimate' remained implicit within the debate about field work as it entered the public arena.

Dr Hunter began his report by initially praising the women for their 'superior industry', which benefited their families through the extra income they brought in. He also said they were healthy, strong and independent: 'they are to be met morning and evening on the roads … looking wonderfully strong and healthy'. In other words, their bodies carried the signs of masculinity, but this in itself was not attacked as it signified the women's class position, as did their industry. Their health was also seen as a good thing within new anthropological discursive practices which were beginning to stress the need for English women to maintain the race by giving birth to strong and healthy children. It was the language of evolution which in fact informed the wider concern of the report as a whole. It was when the women failed to meet middle-class definitions of purity that they were strongly criticised, as they then crossed the boundary of respectable working-class femininity and effectively took on the identity of the prostitute. This failing was presented as an inevitable and disastrous result for women if they undertook field work. Field women were always 'tainted with a customary immorality, and heedless of the fatal results which their love of this busy and independent life is bringing on their unfortunate offspring who are pining at home.'[13] In other words, an independent woman was a contradiction in terms. A true woman had to be a good mother, for the benefit of the race, and a good mother was domesticated: her life was bounded by four

cottage walls. She could not be good if she was independent of the home, removed from familial or middle-class surveillance. Following Foucault we can see that field women had literally and metaphorically stepped beyond the bounds of regulation.

The women were therefore represented by Dr Hunter as, at best, careless and unthinking mothers. They did not know how to look after their children when they were with them and when they went to the fields it was claimed that they left them in the hands of ignorant child-minders: 'A poor girl, brought up in a gang, seduced in the field, and afterwards suddenly taken there in labour, will bring in to a family a child for whom no provision has been made, and where it is most unwelcome ... it is a matter of course that she should turn to the old woman who professes to keep a school for such babies.'[14] The whole of the girl's sexual life became subject to the reporter's and reader's gaze; that which should have been private became public. At worst, the women became cackling witches laughing over the likely death of yet another illegitimate child: 'A worse degree of criminality is found in older mothers ... [who, having lost one or two babies] ... begin to view the subject as one for ingenuity and speculation.'[15] The women were accused of infanticide by Hunter's medical witnesses.[16] The women were dehumanised; they had regressed in evolutionary terms into a state of visible barbarism which was not suited to the English landscape. But that observation was based on speculation and rumour, because in reality the reporters could never really observe the women's behaviour – the panopticon was not available – and thus they imagined the worst. Because the women did not follow the norms of respectability, it was assumed that they indulged in every form of deviancy.

Beyond the issues of sexuality, the whole of the East Anglian working class were also described as constantly taking opium. In this context, the mothers and child-minders were further blamed for the death of children through the widespread use of laudanum, a solution of opium, to keep them quiet while they were at work.[17] Virginia Berridge and Griffith Edwards believe that opium was widely taken by labourers in the nineteenth century to ease rheumatism. Before the refined drug became available poppy-head tea was used in East Anglia, and addicts remained there until 1913. The drug was sold in market towns and was often used in animal medicines. 'Godfrey's' and other cordials were made up by chemists to be given to children.[18]

The medical witnesses of the Privy Council report were clearly shocked by this 'lethal' practice, for which they could see no legitimate medical use, and which they said caused the labourers to fall asleep at their work. They even found that 'To meet the popular taste, but to the

extreme inconvenience of strangers, narcotic agents are put into the beer by the brewers or sellers'. Beware the penetration of working-class space, any kind of depravity may result. Worst of all, doctors were frequently called to rooms full of 'snoring ... squinting ... pallid and eye-sunken ... poisoned' babies. They believed opium to be the most common cause of infant death.[19] The working class, as Berridge and Edwards note, saw opium in a different light. It was one of their standard forms of self-medication, and generally accepted by them as part of everyday life; and as a necessity required by the work itself and the social relations within which they were employed.[20] We can see this in a description of harvest-time by a labouring woman, Mary Coe: 'Some of the women had their babies on their backs and they'd give them a little bit of laudanum on sugar to keep them asleep. I think most of the women did that – especially when they was binding, because they was working for the Master, so their children had to be kept quiet then'.[21] Another woman, Mrs Flinton, from Lincolnshire, explained how their maid had been given opium as a child. 'Her mother used to go to work on the farms, you see, and she used to give her a drop or two of laudanum and take her in the pram, so she'd sleep while she came home.' As a result the woman had to have the drug regularly as an adult, 'then Edith could do all the work there was to be done; but she got really beat wi'out it.'[22]

Working-class women recognised that the addicts had to have opium, but did not judge them for it. Further, there was a tacit acceptance that their mothers had had to give it to them as children. Berridge and Edwards therefore argue that the criticism of opium use in official and medical discourses was class-based.[23] However, in this case it was also linked to the construction of femininity. Women who worked in the gangs, or nursed the children of those who were labouring, were particularly attacked for its use. They not only failed to be good mothers because they worked, but also because they gave their children opium. This was seen as an unnatural practice. The category of motherhood, as one mode of respectable femininity, was defined through what it was not, as much as by any kind of ideal image, in official, medical and moral discourses.

By 1865 public concern about ganging had grown so great that Lord Shaftesbury demanded that the Children's Employment Commission look into the use of children under the system. On 12 May 1865 he declared to the House of Lords that the effects of gang labour on children were 'pernicious and demoralising'. He went on to stress the importance of femininity by establishing women as their 'natural protectors'. He also said that girls were especially morally hurt by the gangs. To

describe how this problem affected those involved, he used authoritative medico-moral language: 'the moral contamination to which they were exposed was positively frightful'. Ultimately, the women and girls became unsuitable domestic servants, wives or mothers.[24] In other words, they did not fit the dominant, middle-class definition of femininity after working in a gang. The use of the polarity of Nature and Culture allowed them to be seen as evil.[25]

Shaftesbury succeeded in his aim of getting further research done on the issue and the resulting 'Sixth Report of the Children's Employment Commission' was presented in 1867 and its findings were alarmist. Gang employment was reiterated as the cause of infant deaths due to 'immorality, miscarriage, neglect of nursing infants by mothers, and drugging them with opium by the persons with whom they are left, as well as the extraordinary quantities of opium used by the population in general'. The health of the gangers was otherwise seen as particularly good, except in the case of children and young women, who were represented as especially physically vulnerable to the cold and wet. Women and children's bodies were equally fragile. However, the report stated clearly that its main concern was with morality: 'The moral condition is … the point of chief importance to be considered in the question of gang employment'.[26] And in this respect it painted a dismal picture indeed.

Though the 'Sixth Report of the Children's Employment Commission' was meant to look only at children's work women were also brought under scrutiny. It used the anthropological and evolutionary language of 'types' to describe the women in the gangs; they were 'those who had forfeited their chance to better employment, or whose habits are coarse and irregular.' As a result, the children were said to have become 'hardened by early association with vice'.[27] Because women were the supposed natural guardians of the family's morality, and because the family was seen as the building block of society, this imagery was especially threatening within middle-class ideology. It was also particularly damning for the women concerned.

The women were represented as dangerous, independent and masculine, viragos such as a person with middle-class values would fear meeting on the road, as if merely seeing them could corrupt:

> [Their language and behaviour were]… coarse, rough even to strangers so much so that a respectable person meeting a set of these girls and women 'cannot venture to speak to, scarcely to look at them, without the risk of being shocked by them'. … some of the big girls and young women seen returning from work were strangely bold in look and manner and such as I [Mr J. E. White, commissioner] should certainly have avoided speaking to.[28]

Every aspect of the women's work offended middle-class sensibilities, from the necessity of hitching up their clothes, to having to go to the toilet publicly, both of which were eroticised:

> mixed gangs are ... objected to on the grounds of indecency. In the case of females, their dress as it is often worn or as arranged to avoid the wet, and the stooping nature of the work are said to involve a certain amount of exposure, which excites the notice of the other sex, and leads to indecent remarks. ... [because of] long absence and distance from home ... in an open country, with no place of retirement within reach ... escape from observation is hopeless ... what is commonly thought decency must be sacrificed.[29]

The women did not adhere to middle-class standards – universalised as what was 'commonly thought decency' – and were represented as inversions of femininity. They were out of control. As a result, all field work by women was condemned. The only men to be criticised for immorality, such as drunkenness and physical or indecent assaults on women and children, were the gangmasters.[30] Here, working-class masculinity was constructed through the inversion of acceptable male behaviour: loss of self-control and the abuse of authority and power. The women and children were constantly seen as victims, the men as victimisers, in accordance with the ideology of gender.

Significantly, women's haymaking harvest and dairy work were not discussed. Only field labour was carried out in the public arena, beyond the home, and involved mixing with men who were not family members, or in large groups of other women beyond acceptable supervision. Pastoral had apparently failed and the landowners were no longer seen to regulate the rural poor. The report concluded: 'For females field work must always, under any system, be open to some objections, and working in companies, even without workers of the other sex, can probably never by any care be made a satisfactory mode of employment for them. It must destroy a certain amount of natural delicacy, and take them from occupations more suitable to their sex, and in some degree unfit them for home duties'.[31]

Yet the reporters were caught in the dilemma that both the families and the farmers were still believed to need the women's labour.[32] Many opinions were offered in the report itself, and in Parliament, as to the solution. The summary report called for a partial or complete exclusion of girls and women from the gangs and a limit on the age at which children could join. Nor did it want the gangs to be of mixed sex. Gangmasters, it was recommended, should be licensed, with women supervising the females. Finally, it said that women and girls should not

have to work in the wet, or at weeding wet crops.[33] In effect this policy was enacted in Shaftesbury's Agricultural Gangs bill of 1867, after some wrangling over the minimum age.

In other words, the gangs were to be controlled by legislation which was produced through the dominant constructions of Englishness: the gangs connoted slavery, which was alien to English soil; femininity – respectable femininity had been lost, to the detriment of the race; sexuality – deviance was presumed to exist, because the gangs worked beyond the sight of their families and the bourgeoisie, with men who were drunkards and rapists; and childhood – the innocence of the child had to be maintained, regardless of class or gender. There was an attempt to contain and control field labour and the representation of women was vital to this attempt. Where limits were placed on actual working conditions, these were based on the concern within medical discourse for the physical susceptibility of women and children to the wet. Women's and children's bodies were literally, as well as metaphorically, seen to be threatened by hard agricultural labour. Adult male labourers remained unprotected and were only restricted when they abused those weaker than themselves: women and children. Yet the operation of middle-class ideology through law was problematic.

The report reveals that although it was preferable for women to supervise the female labourers, this equally went against accepted bourgeois definitions of femininity. Women, if they were respectable, were not meant to be authoritative enough to maintain control of the gangs. In this case, if they were powerful enough to succeed, they were then believed to be unfeminine and therefore unsuitable.[34] This was in spite of middle-class women's authority as educators and philanthropists, roles which were legitimised as part of the widening definition of motherhood, which began to include social nurturing as well as literal biological function, due to the agitation of reformers and the 'surplus woman question', which meant that not all women, regardless of their respectability, would be able to marry and have children. The report finally noted that there were children working in other forms of agricultural gang, and in other farm work, which it had not been asked to look at. It pointed out that although an inquiry had been carried out in 1843, this had been short and had had no effect. In this way, the Children's Employment Commission pushed for a further investigation, and it called for interventionist legislation on agricultural employment which went far beyond the public gangs of East Anglia.[35]

As soon as the findings of the Children's Employment Commission were known questions were asked in Parliament. On 2 April 1867 there was a long debate on the issue in the Commons, where

both the government and the remainder of the House condemned women and children's work in the gangs. The languages of race, sexuality, purity, health, femininity and domesticity combined to present a powerful construction of Otherness, in which gang women became utterly alien and remote to the urban bourgeoisie. Even those MPs elected by the farming interest felt they could not speak against the resolution that this form of labour be regulated by principles based on the Factory Acts.[36]

The only point of contention was whether to have another report before action was taken. The government preferred to delay and on this point asked the advice of H. Tremenheere and E. Tufnell, who had served on the Children's Employment Commission since its inception in 1862. Both had worked on other Royal Commissions, and in this sense were professional reporters. In the end Tremenheere, a Benthamite, and Tufnell were reappointed as sole Commissioners when the Royal Commission on the Employment of Children, Young Persons and Women in Agriculture was established in 1867.[37]

On 11 April 1867 another debate, lead by Lord Shaftesbury, was held in the Lords. In his speech Shaftesbury regretted the delay in legislation and declared he would introduce his own bill after the Easter recess. This condemnation of the system was again supported from all sides of the House.[38] The representations of inverted femininity in each case were much like those used in the reports. During the debates the women were described as having 'the most horrible and frightful feelings ... The recklessness of human life by these women was something terrible, nay, almost brutal.'[39] The women were dehumanised and became bestial Others through the languages of prostitution and race. The 'Sixth Report of the Children's Employment Commission' itself was said to reveal 'melancholy and startling facts ... [which showed that] there existed a degree of ignorance, of immorality, of depravity which if they found in any foreign country would at once confirm them in saying "this is indeed a country devoid of the blessings of civilisation"'.[40]

The rural working class became a savage race within Britain. Within this construction the women of the fields had lost 'self respect ... [and gained] dirty and degraded habits ... slovenly and slatternly households, [and] the alienation of husbands by the discomfort of their homes'.[41] The girls were uneducated, unclean, independent, lazy, sexualised, and ultimately unnatural in their inability to perform feminine tasks. They developed 'boldness, next ignorance, then unchastity, want of cleanliness, incompetency in sewing, mending, cooking and other household work, indifference to parental control, and unwillingness to apply themselves to any regular employment to gain a livelihood.'[42]

These girls inverted the middle-class values of industry, education, and health in their degraded femininity. They took on all the signs of native populations in the colonies. The rural was at such a distance as to have become a foreign shore, though where they had expected to find bounty, beauty and innocence, the middle-class discovered death, disease and sexuality. The shock of this was much worse than that of finding similar traits in the urban population, already supposed to be somewhat degraded and corrupt, but at least within reach of middle-class surveillance and regulation.

The correct response to these horrors was to be humbled.[43] The politicians were suddenly worried that the rural population which supplied so much of England's wealth was threatened with moral contamination: 'if this hardening and cruel influence [is] allowed to continue and increase it would hardly be possible to conceive the injurious effects it must have on the whole of our future agricultural population'.[44] By 20 August 1867 Shaftesbury's Agricultural Gangs Act had been passed. The Commission on the Employment of Children, Young Persons and Women had begun in May of the same year, and continued to report until 1870. Its images closely resembled those in the previous reports and the parliamentary debates. Clare Sewell Read, an MP and farmer, whose speech to the Agricultural Association at North Walsham in East Anglia was used as evidence, was typical in his response when he said 'If I were a farm labourer, nothing would give me greater pain than being compelled to send my girls to field labour'.[45]

The predominant representations in the report were of women who had lost all pretensions to respectable femininity through their paid work. The women had become masculine in their behaviour and dress. When married they, like many other working women, were doubly represented as the antithesis of true womanhood, as they became both 'bad wives and bad mothers'. They were blamed for the moral downfall of their men, who went to the pub because their wives had failed to prepare their meals and did not keep their houses warm and clean.[46]

The evidence was presented as conclusive by the Reverend James Fraser, who reported on Norfolk. Fraser had already worked on the Popular Education Commission from 1858 to 1861, and for the Schools Commission from 1864 to 1867. At the time of the 1867 Commission he was rector of Ufton, and in 1870 became Bishop of Manchester, where he helped to arbitrate in the 1874 and 1876 printing trade disputes. He also had a long-term interest in co-operation and was a supporter of Joseph Arch, leader of the National Agricultural Labourers's Union (NALU) established in 1872. Considering the subject of women's employment caused Fraser 'much perplexity', but he was clear about its

deleterious effects: 'Not only does it almost unsex a woman, in dress, gait, manners, character, making her rough, coarse, clumsy, masculine; but it generates a further very pregnant social mischief, by unfitting or indisposing her for a woman's proper duties at home.'[47]

According to his witnesses, therefore, the women were universally damned. Fraser was puzzled by the solution, not the perceived and accepted problem. He saw that women needed the work to add to their families' 'scanty resources', and acknowledged that though the girls were unfit to be domestic servants, 'it is doubtful if our social system has the capacity of absorbing more'.[48] He concluded that in the end 'the feeling of resentment of control and the love of a spurious independence which are said to be produced by employment on the land, is not really produced by anything special in the form of that employment, but simply by the fact that those who earn their own livelihood will be their own masters and mistresses'.[49] In other words, women should not become economically independent, and should not do any form of paid work. Work belonged to the masculine sphere; women who earned a wage trespassed across the bounds of gender. Fraser ultimately believed that the only way to end the 'evil effects' of agricultural work – often itself just called 'the evil' – was to trust the 'curative influences of education and social progress'. He saw these as already coming into effect through the women themselves refusing certain work and the general improvement of agriculture.[50]

Fraser believed further legislation on the issue would be 'vexatious, interfering, uncalled for, or inopportune.'[51] Fraser was, therefore, an adherent of the principle of *laissez-faire* as well as a dedicated user of medico-moral discourse. Although he investigated the most notorious county in terms of women's farm work and, like his witnesses, condemned those involved as inversions of femininity, he still believed only guidance through education would work to end the problem. He seems to have tried to sympathise with the women, by recognising their financial plight. He wanted the women, through men's higher wages, to be better off, so that they would not want to work. Then they could educate their girls so that they, in turn, would not go into the fields. This became the solution later offered by the NALU in their campaign for a breadwinning wage, but Fraser also wanted the landowners to take on their responsibilities to their labourers by building more and better cottages, so that their medical and moral health would not be shattered from the start. And he wanted 'distinctions of caste' to end.[52]

What Fraser was therefore ultimately arguing for, through the languages of paternalism, religion, sexuality, education and femininity, was a return to older social relations – a return to pastoral. Yet he also

believed in domesticity and new definitions of respectable femininity. He represented women who worked in agriculture as corrupt and corrupting, but his real concerns were much wider than this. He brought into question any form of women's work in the statement that the issues were not peculiar to agriculture, and he criticised the whole of rural labouring society as degraded: 'The two deepest stains in the moral condition of an English village are the unchastity of its women and the drunkenness of the men'.[53] Country men, as well as women, had fallen in his eyes, though immorality was clearly gendered. The rural population had become corrupted like labouring men and women in the towns, which put the lie to the idea that the same social and economic relations did not exist in both environments. It is interesting to see a man with otherwise quite radical politics try to tackle this issue within the confines of official discourse. As in the 1843 report by Doyle, it becomes clear that official texts do not always adhere to an empirical methodology, despite the shared ideologies of their reporters. This may seem self-evident, we should not generalise from any one report, but the final text did ultimately belong to a practice which aimed to normalise a range of identities, which were used as a framework in the formation of policy. This process is multi-layered, and though each reporter occupied different social, economic and political positions, they all added to the wider definition of femininity and deviancy, through a shared ideology of gender.

It was the reporter for Northumberland, as in 1843, who appears to have done the most to challenge middle-class definitions of femininity. Joseph J. Henley had been the private secretary to the president of the Board of Trade in the 1850s, and as such was probably a Benthamite.[54] After the 1867 report he became a fairly regular government employee, as a Poor Law Commissioner and on various later official inquiries. Henley, unlike Fraser, was a professional state employee and believed in factual research and balanced surveys. Yet at times his interest in the women seems akin to that of Arthur J. Munby, who praised working-class women for their strength and masculine appearance, and supported their right to work. Often, Henley seems to follow in the more pastoral footsteps of Doyle.[55] Henley did not rail at working women as independent, imperfect females, but described them as good wives and mothers, thoughtful, intelligent, unselfish and contented. In this report the regularity of their work was even represented as an advantage,[56] 'tending to rear a fine race of women, who make the best wives for labourers and are invaluable in a national point of view as producing and rearing a fine population'.[57] He praised their bodily strength: 'The Northumbrian women who do these kinds of labour are physically

a splendid race; their strength is such that they can vie with the men in carrying sacks of corn, and there seems to be no work in the fields which affects them injuriously, however hard it may appear.'[58]

Henley even defended the women's right to use horses, normally seen as a masculine job, in a way that bordered on the satirical:

> [Respected men see] ... women driving and leading horses [as] dangerous and objectionable, unsuitable in every point of view. [But the women say] 'we fight to drive the carts, it is easier work than loading.' They are undoubtedly as fit to be trusted as those of the same sex, in a higher social position and of greater rank, who drive horses in the highest condition in every description of carriage; and with regard to the latter few would be bold enough to suggest that they do not show as much science and nerve as many men, or to propose legislative interference.[59]

Added to this, Henley proclaimed that anyone who met them in their cottages would see 'he has been in the presence of a thoughtful, contented, and unselfish woman.' Nor did he think the work made them immoral, despite a shared concern with the reporters in 1867 about bastardy and infanticide. Though the bastardy rate in Northumberland was apparently high, he defended the women by noting that the statistics themselves could be inaccurate and by emphasising that the level of infanticide was lower in the countryside than in the towns.

However, as in 1843, this apparent exception to the usual depiction of women fieldworkers was not a contradiction within the construction of femininity. Only the acceptance of their 'masculine' strength was unusual, and even this can be explained through the context of new evolutionary theory. In this Henley resembled the barrister and diarist Arthur J. Munby, who said of the bondage system that 'it trains up the wenches to be hardy and lusty and familiar with out-door ways: and it keeps up a wholesome protest against the molly coddles, to see a whole countryful of stout lasses devoted to field labour only ... spending their days in the furrow, and only coming indoors, like the ploughman and the carter to feed and sleep'.[60]

The significant point in Henley's case is that the women who worked were said to be single and under the supervision of male relatives, both while at work and travelling to and from it.[61] The women fulfilled their roles as mothers and wives; they were seen as contented and unselfish, as both peasants and women were meant to be. Where women fieldworkers were represented elsewhere as an inversion of femininity, the women of Northumberland were praised for fulfilling much of the construction, thanks to apparently staying within their cottages and

the closure of class connoted by their bodily strength. Physical differences between middle- and working-class women were acceptable, even desirable, within the bourgeois hegemony, as long as the latter remained 'respectable' – adhered to the ideology of domesticity – as they worked to maintain class differences. Henley was not nearly as happy with the situation in the south of the county, where 'many married women go out to work, neglecting their homes, and leaving a child that ought to be at school to look after the house'. Nor did he like single women having cottages together: 'it cannot be said that the practice is conducive to morality'.[62] Women should stay within sight of their families.

Ultimately it can be seen that Henley largely believed in the same definitions of femininity as the other reporters, and had the same moral values. He argued against legislation because he believed it was not needed in Northumberland. What Fraser hoped for had apparently come to pass: the children were already kept from work and sent to school by their parents. Those women and children who did work had plenty of rest and did not have to walk a long way to the fields; they were also physically and morally healthy. Finally, married women stayed at home. Each of these points, coupled with the necessity of women's labour to the farmers of the county,[63] legitimised women's agricultural work in Northumberland and acted as a paradigm for the construction of working-class femininity as a whole. Northumberland had come up with what appeared to be the perfect solution to the dilemma of maintaining respectability within the working class. Rural working-class women in the other counties were represented through the language of prostitution precisely because it was not possible for them to be recovered in this way.

NOTES

1 'Sixth Report of the Medical Officer of the Privy Council', Parliamentary Papers *PP* 1863, pp. 454–6.
2 *Hansard*, clxxix, pp. 176.
3 *Ibid.*, pp. 174–7.
4 *Hansard*, clxxxvi, pp. 1024, 1472, 1476; *The Times*, 13 April 1867, p. 9, and 20 July 1867, p. 9.
5 *Hansard*, clxxxvi, pp. 1472–3.
6 'Reports From the Commissioners on the Employment of Children, Young Persons and Women in Agriculture', *PP* 1867–70, xvii, pp. viii, 'commission'.
7 Obelkevich, J., *Religion and Rural Society: South Lindsey 1825–1875*, Oxford, 1976, pp. 313–18.
8 All biographical material from Collinge, J. M., *Officials of Royal Commissions of Inquiry 1815–1870*, London, 1894; *Who's Who of British Members of Parliament: A Biographic Dictionary of the House of Commons, Based on Annual Volumes of 'Dod's Parliamentary Companion' and Other Sources*, Brighton, 1976; *Who Was*

Who, London, 1962; *The Dictionary of National Biography*, London, editions 1908–1964.

9 Mort, F., *Dangerous Sexualities: Medico-Moral Politics in England Since 1830*, London, 1987, pp. 25–36, 42–6, 60–8.
10 PP 1863, p. 454.
11 *Ibid.*, pp. 456–8
12 See Jenny Bourne Taylor's paper 'Representing illegitimacy in Victorian culture', given at the Victorian Literature and Literacy Theory Conference, Luton, 1994; forthcoming in R. Robbins and J. Wolfreys (eds.), *Victorian Identities: Social and Cultural Formations in Nineteenth-Century Literature*.
13 PP 1863, p. 456.
14 *Ibid.*, p. 457.
15 *Ibid.*, p. 458.
16 *Ibid.*, p. 457.
17 *Ibid.*, pp. 458–61.
18 Berridge, V. and Edwards, G., *Opium and the People, Opiate Use in Nineteenth Century England*, London, 1981, pp. 30–40, 43–4.
19 PP 1863, pp. 458–9, 461, 469.
20 Berridge, *Opium and the People*, pp. 45–7.
21 Chamberlain, M., *Fenwomen, A Portrait of Women in an English Village*, London, 1975, p. 29.
22 Kightly, C., *Country Voices, Life and Love in Farm and Village*, London, 1984, p. 225.
23 Berridge, *Opium and the People*, pp. 48, 97–104.
24 *Hansard*, clxxix, pp. 175–6.
25 Ortner, S.B., 'Is the female to male as nature is to culture?' in Rosaldo, M. Z. and Lamphere, L. (eds.), *Woman, Culture and Society*, Stanford, 1974, p. 86.
26 'Sixth Report of the Children's Employment Commission (1862)', PP 1867, pp. 74–5.
27 PP 1867, p. xii.
28 *Ibid.*, p. 77.
29 *Ibid.*, p. 77.
30 *Ibid.*, p. 78.
31 *Ibid.*, p. 78.
32 *Ibid.*, pp. 78–80.
33 *Ibid.*, pp. xv–xviii.
34 *Ibid.*, p. 78.
35 *Ibid.*, pp. xxiii–xxiv.
36 *Hansard*, clxxxvi, pp. 1004–25.
37 *Ibid.*, p. 1024.
38 *Ibid.*, pp. 1456, 1465–77.
39 *Ibid.*, p. 1006.
40 *Ibid.*, p. 1011.
41 *Ibid.*, p. 1017.
42 *Ibid.*, p. 1017.
43 *Ibid.*, p. 1011.
44 *Ibid.*, p. 1007.
45 PP 1867–70, xvii, p. vii.
46 *Ibid.*, pp. 16, 123, 169.
47 *Ibid.*, p. 16.
48 *Ibid.*, p. 17.
49 *Ibid.*, p. 17.
50 *Ibid.*, pp. 17–18.

51 *Ibid.*, p. 18.
52 *Ibid.*, pp. 17, 22, 35–6, 40, 45. For one of the best discussions of the changing language of social stratification see R. Williams 'class' in *Keywords: A Vocabulary of Culture and Society* (London, 1983).
53 *Ibid.*, p. 45.
54 Jeremy Bentham (1748–1832), political economist and Utilitarian, aimed to promote 'the greatest happiness of the greatest number'; he was a proponent of rationalisation, and in particular helped codify the criminal law and make the Poor Law more efficient. He was influential upon a generation of thinkers, politicians and professionals, who aimed to follow in his footsteps.
55 For discussion of Munby see Hudson, D., *Munby, Man of Two Worlds*, London 1974; Stanley, L. (ed.), *The Diaries of Hannah Cullwick, Victorian Maidservant*, London, 1984; Davidoff, L., 'Class and gender in Victorian England' in Newton, J. L., *Sex and Class in Women's History*, London, 1985.
56 *PP* 1867–70, xvii, pp. 53–4.
57 *Ibid.*, p.70.
58 *Ibid.*, p. 53.
59 *Ibid.*, p. 54.
60 *Ibid.*, pp. 54, 58–60.
61 Munby, A. J., diaries held at Trinity College Library, Cambridge, 1863, xxi, pp. 241–2.
62 *PP* 1867–70, xvii, pp. 54, 58, 71.
63 *Ibid.*, pp. 53, 56.
64 *Ibid.*, pp. 53, 70.

Nine out of ten women prefer field work

In her essay on 'The Natural History of German Life' in *The Westminster Review* in 1856, George Eliot called for a detailed examination of the lives of the rural poor and wrote an urgent critique of pastoral. We can see that Eliot's own vision of the rural was somewhat clouded by a stereotype of the peasantry as apathetic, coarse and slow, corrupted by modern life and urbanisation. She accepted the opposition between town and county that constructed the former as cultured, the latter as untaught. But she insisted that artists and writers go and look at the peasantry more closely, that they begin to paint a more honest picture of rural life. This was their foremost duty, indeed their social responsibility, both to their readers and their subjects. In her view artists, writers, thespians and musicians still predominantly created a 'notion that peasants are joyous, that the typical moment to represent a man in a smock-frock is when he is cracking a joke and showing a row of sound teeth, that cottage matrons are usually buxom, and village children necessarily rosy and merry'.[1] Eliot therefore expected authors to be shocked when they finally took a closer look at the countryside:

> Observe a company of haymakers. When you see them *at a distance*, tossing up forkfuls of hay in the golden light, while the wagon creeps slowly with its increasing burthen over the meadow, and the bright green space which tells of work done gets larger and larger, you pronounce the scene 'smiling', and you think these companions in labour must be as bright and cheerful as the picture to which they give animation. *Approach nearer*, and you will certainly find that haymaking time is a time for joking, especially if there are women among the labourers; but the coarse laugh that bursts out every now and then, and expresses the triumphant taunt, is as far as possible from your conception of idyllic merriment. That delicious effervescence of the mind which we call fun,

has no equivalent for the northern peasant, except in tipsy revelry; the only realm of fancy and imagination for the English clown exists at the bottom of the third quart pot.[2] [my italics]

George Eliot – the pseudonym of Marian Evans – was a liberal-minded woman from the provincial middle class, who wanted to be judged as a 'writer' not as a 'woman'. She advocated social reform and frequently wrote passionate, radical rejections like this of the literary and moral concepts of her day.[3] She was at a social distance from the haymakers herself, though she was a woman with some sympathy for women, so she was shocked by working-class manners and morals. However, she argued that no legislation should be passed on the countryside without detailed research, because of the 'associated images' connected with 'the terms "the people", "the masses", "the proletariat", "the peasantry", by many who theorize on those bodies with eloquence, or who legislate for them without eloquence'.[4]

When Eliot wrote this essay, England was in the midst of the period which James Caird named 'High Farming', approximately 1846–1873, when more farmers than ever before were practising the new methods and using the new science of capitalist agriculture. Not all farmers profited, and the labourers did not especially benefit from this boom, but it came to represent a high point in English agricultural production. Steam pumps were used to drain the fens more efficiently than ever before, machine ploughs and steam engines were used to turn the land more thoroughly, and machines began to appear to help with all aspects of agriculture, especially arable farming. New crops also proliferated and livestock production went through its own revolution as cross-breeding led to new strains and the improved appearance and quality of cattle, pigs and sheep. This was a time of high yields, low costs and improved profits for large-scale farmers. This was also the period in which new theories of evolution were beginning to develop – many of them based on Darwin's *Origin of the Species* – and proliferate through official, artistic and literary discourses, as well as scientific and philosophical thought. These debates often helped rationalise gender, as well as race and class, in Victorian Society, through new concepts like social Darwinism, recapitulation – in which every human being passed through every stage of human development, from amphibian to civilisation – and, later in the century, eugenic theory.[5]

The official and public representations of the rural working class were, of course, formulated through the new and contested definitions of Nature, domesticity and femininity adopted by the bourgeoisie, as well as older, Romantic visions of pastoral. If we follow Eliot's advice, we

might expect images of working women in radical publications to be less moralising, but both middle- and working-class representations of field women were still based on the expectation that women were passively subject to the power relations of gender and class, much of which was linked to the desire for respectability. Working-class radicalism, rural women's evidence of their working conditions and middle-class feminist solutions to the 'surplus women' question were all forms of self-representation, many of which operated through the internalisation of many of the values and ideologies already adopted by the middle class.

As we saw in Chapter 3, by the 1850s many publicists were beginning to look for empirical evidence from the parliamentary reports to demand radical change within rural society. Their predecessor, William Cobbett, had combined careful descriptions of agriculture with scathing social commentary,[6] but these writers used the discourse of statistical, objective research and evidence from the parliamentary reports to help prove their case in measured, rational language. Their representation of the field woman is particularly interesting because the prostitute – the identity given the field woman in 1863 – was so often used as a metaphor for the pernicious influence of socialism and unionisation at this time.[7] They had, somehow, to maintain or formulate a definition of a respectable working class, while also defending working-class women and the practice of radicalism. This was achieved through a reworking of separate spheres that legitimised single women's paid work and the use of the married working woman as sign of decaying social relations in the country, due to the spread of capitalism, not the spread of socialism. This, in turn, reinforced much of the dominant construction of femininity; though, in this case the desire for a male bread-winning wage was more important than the need to prove credit-worthiness that had prompted the bourgeoisie to adopt leisured femininity as a sign of prosperity in the first half of the century.

Alexander Somerville, born in East Lothian, son of a carter, ex-cowherd, journalist, author of *The Whistler At the Plough* (1852), was typical of radical working-class men when he used the distanced and objective language of the parliamentary reports, despite his swiftly signalled difference from the official observers:

> I proceeded to examine into the physical and moral condition of the people of this district [near the Thames] for I was surprised (a commissioner, if examining into the state of the colliery or factory workers, would say shocked) at the extreme depression under which each family, each principle of independence, each feeling of humanity struggled. Irregular employment, family discomfort, female prostitution, drunkenness, idle habits, gambling, absolute ignorance, and in many cases,

starvation almost absolute, were the prevailing characteristics of the-working population.'[8]

For Somerville, the women's immorality was just one of the many hardships suffered by the rural poor, as had already been said in the radical press of the 1840s, a symptom rather than a cause of rural decay. When a man described how he and his wife were glad that their baby had died, for Somerville they became perfect signs of the horror of capitalist agriculture, not icons of human corruption.[9] He watched the figures in the landscape of High Farming and was appalled. *The Whistler at the Plough* contained careful inversions of both middle-class lifestyle and the rural idyll. The title of the book itself was a jibe at constructions of merry peasants, whistling without a care in the world, as well as a claim to expert knowledge – he signed his published letters as 'One Who Has Whistled At the Plough'. He attacked the middle class for allowing the poor to exist in such a depraved condition while they lived in idle luxury, and constructed respectability based on regular male labour, independence, industriousness, education, savings, sobriety and a comfortable family life, founded on female chastity. This definition of working-class respectability was later mooted by Fraser in his report on Norfolk in 1867 and became particularly significant in working women's relations with the NALU after 1874, as we will see in Chapter 7. But to what extent might the women themselves have shared this vision?

Rural women have left us with very little written evidence with which to compare accounts like Somerville's, aside from the case studies in the official reports. Memoirs, autobiographies and oral history have begun to make up for this gap in our knowledge, but the retrieval of this kind of evidence from the early nineteenth century is almost impossible. In addition, except for Mary Chamberlain's *Fenwomen*, most published oral histories of the countryside have concentrated on men's memories. John Burnett's work has begun to make up for this absence, and Charles Kightly's *Country Voices* includes several women, but the work of George Ewart Evans is sadly lacking in women's stories.[10] Beyond oral history, only Jenny Kitteringham has really given consideration to the women's own culture and ideas in comparison to those of the middle class who reported on them. Mrs Burrows' account of her childhood employment in a gang is therefore one of the few easily accessible memoirs written independently of the official reports. Published in a collection of working women's letters, produced in 1931 by the Women's Co-operative Guild, her writing above all stressed the effort and the physical hardship involved in the work, especially for children:

In the summer, we did not leave the fields in the evening until the clock

had struck six, and then of course we must walk home, [2–5 miles] and this walk was no easy task for us children who had worked hard all day on the ploughed fields.

In all the four years I worked in the fields, I never worked under cover of a barn ...

Had I time I could write how our gang of children, one winter's night, had to wade for half a mile through the flood.[11]

Mrs Burrows' account of ganging in the 1860s was very different to that provided by the parliamentary reporters and publicists; she seems to have shared many of the same concerns, but also worked through a different system of representation. Though she frequently made use of religious discourse to give her testimony legitimacy and respectability, and used the language of slavery to attack the exploitation she had seen, she described the work itself physically, not morally, as hard, cold and laborious. She represented the gang children as victims, or slaves, of the large farmers they were employed by in an opposition of town and country that raised the urban experience above the rural: 'it felt like Heaven to me when I was taken to the town of Leeds, and put to work in the factory. Talk about white slaves, the Fen districts at that time was the place to look for them'. When she talked of opium addicts, she pitied rather than condemned them.[12] She also stoutly defended her mother, using the same definition of working-class respectability that Somerville promoted: 'my mother worked like a slave to keep a home over our heads. Not once ... did she ever ask or receive charity, and never did she run into debt. Scores of times I have seen her sit down to a meal of dry bread, so that we might have a tiny mite of butter on our bread, and yet she never complained'.[13]

This testimony could be read either as consenting to bourgeois ideology, or as dissenting from it, but both readings are representations of reality, not reality itself. The woman's self-sacrifice, defined as a form of pleasure within domesticity, included her paid employment, pride and a desire for economic independence which did not belong to bourgeois femininity. Although they were desirable characteristics in the working class, in the form of self-help, it was this very pride and independence of a wife and mother that the official observers abhorred in field women.

Mrs Burrows' text is, of course, problematic if we are trying to understand why field women were represented as prostitutes or signs of social decay by the middle and working class in 1863–70, because it is a child's account – or rather a memory of childhood – constructed many years after the event, within a totally different historic and cultural context. What is interesting here is the way that field work is remembered, and the use of field work as providing supporting evidence for the project of the Women's Co-operative Guild, founded in 1883, which

aimed to educate working class-women and to improve their lives through campaigns on divorce, maternity reform, benefits and the vote, but which remained effectively liberal rather than revolutionary. As Virginia Woolf said, 'if every reform they demand was granted this very instant it would not touch one hair of my comfortable capitalistic head'.[14] Mrs Burrows' use of the phrase 'white slaves' comes directly from the debate about the Contagious Diseases Acts (of 1864, 1866 and 1869) and critique of the double standard by feminists and working-class men in the second half of the nineteenth century. 'White slaves' at that time were identified as girls who had been seduced and abducted to work in brothels, and were constructed through the discourse of race and commerce, as well as the language of deviant sexuality. This issue alone, raised initially by W. T. Stead in *The Pall Mall Gazette*, brought about the Criminal Law Amendment Act in 1885, which legislated on a variety of sexual practices. The term then became a metaphor for immorality, like prostitution and venereal disease, and was regularly used by feminists as an example of the general exploitation of women in their campaign for enfranchisement. As Millicent Garrett Fawcett said 'a knowledge of the facts [raised by Stead] will make a great many people understand for the first time one of the reasons why women ought to have votes.'[15] Mrs Burrows was therefore using a very familiar feminist language and her own childhood to criticise the position of women and children in late Victorian society.

There was much more evidence given to officials by women and children in the 1860s than in 1843; the establishment of penal languages in art, literature and official discourse promoted the use of this kind of normative individual and homogeneous testimony, as we have already seen. Observation penetrated every nook and cranny of the countryside in an attempt to regain control of the rural. When we look at these interviews we can see that many of the women's ideologies overlapped with those of the reporters; again, the operation of power depended upon negotiation and consent as well as coercion. In Norfolk, for instance, many women seemed to prefer service as a job for their daughters. Mary Cole, a shepherd's wife, was quoted at length in the appendix to the 1867 Royal Commission on the Employment Children, Young Persons and Women in Agriculture, possibly because her testimony was so easily incorporated within the dominant reading of the report as a whole, though we can still read texts like this suspiciously and find meanings which are not determined by the dominant cultural hegemony.

Mary Cole had had fourteen children, eight of whom were girls. She had taken in washing and never done field work herself because, in

her opinion, her family would have suffered. Her boys had gone out to work when they were quite young, but she had let none of her daughters go to the fields – all were in service at the time of the interview. Also, because she had not been educated she had made sure that all of her children had gone to school, despite considerable peer pressure to do otherwise.[16]

> She was often blamed by her neighbours for not sending her girls into the fields, but her heart was high, and she wouldn't. She said to herself, 'We'll see how it'll turn out'. It's the ruination of the country, girls going into the fields; they will make neither good wives nor good mothers; and what do they know of needlework? They get bold and wild, and independent of their parents. Why, there's three of them joined together and took a house by themselves at Sedgeford, to be their own masters.[17]

This extract sounds remarkably like the arguments of the clergy and other middle-class men who gave evidence to the report, and one wonders if she gave her deposition with a view to engaging her interviewer. Foucault discusses how the process of confession – 'all those procedures by which the subject is incited to produce a discourse of truth about his sexuality which is capable of having effects on the subject himself' in the discourse of psychiatry[18] – works within a power relationship and provides pleasures for interviewer and interviewed, as well as regulation. But her self-sacrifice and her success in adhering to the ideology of femininity clearly brought its own pleasures for her, as had Mrs Burrows' memory of her mother's respectability in the face of adversity. Mary Cole's view of the world can be contrasted with that of Sarah Watting, a labourer's wife who did field work with her 11-year-old daughter. Watting believed in having at least three rooms in a house, which coincided with notions of working-class respectability. But unlike Cole, she still felt that taking her children to the fields was an acceptable way of bringing them up – as long as they were over 10 and worked under their mother's supervision – because, as she emphasised, she and her children had to work in order to have enough money to live on. What is highlighted here is that although Sarah Watting, Mrs Burrows and Mary Cole had come up with apparently divergent practices, all felt equally able to lay claim to elevated femininity, in the face of material circumstances that were very different to those of the middle class.[19] Like Somerville, they had negotiated a new working-class identity within the ideology of domesticity.

Françoise Barret-Ducrocq discusses this kind of self-representation in *Love in the Time of Victoria*, in which she studies the depositions made by working-class women who wanted to leave their children at

London foundling hospitals. These women had to prove their respectability to the trustees, despite the fact that they had already broken the bounds of morality by becoming pregnant outside of marriage. Each case reiterated the same experiences, the same needs, but each one was original. Working-class men and women aimed to be represented through a common set of easily identified moral qualities: 'sobriety, cleanliness and modesty of dress, institutionalization of sexuality, religious observance, regularity of employment, prudence and seriousness of distractions.' But this self-regulation was often missed by bourgeois observers, who saw the working-class, especially working class women, as easily contravening middle class codes of reputable conduct.[20]

What Barret-Ducrocq also highlights is the representation of the street as the site of debauchery and immorality. The middle class traversed specific avenues at particular times of day; to step outside these bounds was to be taken for a dilettante. The working class, however, lived much of their lives on the streets, in the way that villagers carried out much of their daily business on the green. Because it contravened their own practices, middle-class observers were wary of this public life, and ventured into working-class concourses as social explorers, with the assumption that all kinds of deviancy would be practised there. This was usually confirmed; it was a self-fulfilling prophecy. Unless a woman was obviously engaged on an errand, she was usually assumed to be a whore. Her very presence in public space signified her immorality, as femininity was largely defined as private, domestic, focused on and within the home. This did not just regulate women's lives, it also helped produce the category of the prostitute, the unfeminine woman who was assumed to live and work on the streets. Working-class women's clothes also signified their indecency. Middle-class women's bodies were given finite limits within corsets, and were covered by layers of petticoats; their clothes were determined by the conduct appropriate to a woman, and themselves operated to restrict their actions, though they brought with them the pleasures of consumption. In contrast, working-class women's clothes became signs of their unfemininity and sexuality: they did not wear corsets, their dress was colourful, dirty, damaged and sweaty, their hair was untidy. Working-class women's actual behaviour was also seen to be unfeminine; they were noisy, they got drunk, they went out in groups with their friends and sweethearts.[21]

By 1860 the *universalisation* of womanhood, as defined by the bourgeoisie, was widely accepted within the bourgeois hegemony. The languages used to condemn those children and women who did not conform to this ideal drew on early nineteenth-century debates on slavery, the construction of alien races as un-cultured savages in anthro-

pology, and a fear of moral and physical contamination by deviant sexualities. Categories and identities produced within one discourse were used as metaphors for social decay in another. For rural women and children, these debates intersected because of the projection of urban concerns onto the rural, which caused the partial collapse of pastoral. Both childhood and femininity were widely represented as gardens of innocence, but in 1863 it was found that innocence no longer existed in the garden of England. The walls had broken; the semblance of Culture vanished and women and children regressed to a state of Nature, to savagery and uncivilised or bestial behaviour. The description of opium-drenched children in the 1863 report represented them as puny, fish-like creatures, both un-English and inhuman, as if they had not passed through the full process of recapitulation. Their mothers were demoniac Liliths (Lilith was Adam's first wife, who was thrown out of Eden), who had produced corrupt offspring, guarded by witches, not buxom wenches. The dream of childhood as a sense of place and of Englishness as pastoral meant that when on closer inspection the English countryside was found wanting, a site of capitalist production not merriment and innocence, there was a subsequent loss of certainty and identity for the middle and the working class, both of whom participated in the production of domesticity and respectable femininity. This in itself lead to panic.

Field women were also energetic, loud, boisterous women, even after a day's work. They swore; they tucked their skirts up, and their clothes became wet and muddy from their labour. Eliot was right when she said that a casual observer would be shocked by their jokes and taunting, drinking and laughter. They were also painfully visible, carrying out their work in the fields. It was therefore assumed by the bourgeoisie that they carried out every other part of their life there, in public, to the amusement of the working-class men who were supposed to watch over them, but were themselves untrustworthy. The fact that some middle-class observers found this extremely threatening has already been noted, so the women had to work hard to regain a sense of decorum when they were interviewed, as did their male relatives. Mr Hardy for one, an innkeeper, insisted that 'Nine out of ten women prefer field work to domestic service, and as regards their morals they are as good as any other women'.[22] Emma Bell in Northumberland said she 'could nae do' if her children did not work, even if, as Anne Mills, the wife of a hind, suggested 'a shilling is worth nothing without religion', or if the women were so 'sair wrought' by field labour, as Mrs Nesbit, the wife of a shepherd, put it, that it was 'a disgrace in a Christian country'.[23]

The women's evidence indicates that, as Eliot pointed out,

country men and women were not 'the idyllic swains and damsels of our chimney ornaments'.[24] Field women were not objects who were simply shaped by the discourse of pastoral. They also acted as a screen onto which urban middle-class fears about social chaos and the sexual deviancy of the mass were projected. They were engaged in an ongoing process of self-representation and negotiation within the hegemony. The women who said they aspired to service, for instance – seen as the most feminine of employments at the time, despite the common sexual abuse of servants in middle-class homes – did so for a variety of reasons. Field work was physically taxing; service carried with it the chance of financial improvement; they laid claim to working-class respectability; and they were telling their observers what they wanted to hear, shaped by the process of confession, in which the interviewer has the power to guide and shape the interview.[25] We can also see that field women refused to accept the image given them by the middle class and were prepared to use the official text to attack employers who abused their authority and working class men who tried to displace them – at this time women in Northumberland still occasionally drove carts and harrowed fields, and defended their right to do so.[26] Harriet Websdale, from Norfolk, believed that the labourers of Gissing were paid lower wages 'because they are fools',[27] a statement that attacked both employers and employed. To what extent, therefore, might these women have been able to engage in radical and alternative discourses, beyond unionisation?

Eliza Cook's Journal, established by the poet and journalist Eliza Cook in 1849, was one of the first publications to attack the dominant construction of womanhood. Cook wrote and produced the journal herself and aimed to entertain and inform her middle-class readers, discussing questions that were going to become familiar to late nineteenth-century feminists, including issues around paid and unpaid work and marital exploitation. Her treatment of the issue of ganging offers a fascinating comparison to the way that later feminists tackled women's field work, and highlights the often divergent concerns of middle- and working-class women that implicitly question the popular notion of 'sisterhood' in late Victorian feminist campaigns. In 1851 a 'remarkable' letter about gangs in *The Times* prompted *Eliza Cook's Journal* to published an article on 'The Treatment of Women'. The original correspondent had seen a group of women clearing weeds, with 'a slave driver' watching over them with a stick:

> "Imagine what was our astonishment when we actually saw the man beat one of the girls for neglect of work, and that so severely, that the poor creature fairly winced under the infliction! We could scarcely believe the evidence of our own eyes, that such a means of compelling

women to labour were used in our own country..." It certainly takes the gloss off the happy lot of the village swain, and jars harshly against our poetic ideas of rural felicity and contentment. ... [but] domestic felicity has also its hideous and revolting aspects as well as the rural. The truth is, there is an enormous amount of cruelty inflicted upon women, which is never heard of. ... We underestimate the character of woman, and keep her in a state of forced submission to man; who in all his transactions with her, treats her as an inferior. She has no legal rights. She is not supposed to exist as a citizen. Her personality is merged in that of man. She is always a minor, never reaching majority.[28]

The journal then went on to demand that the Acts on the mines and factories be extended to the countryside.[29] The conclusion to this article is worth quoting: 'Whether the law can reach the farm overlookers who belabour the field-workers with sticks, remains to be seen. But as a better public opinion prevails, the sight of women "bondagers" in the fields, spreading manure, forking sheaves, and engaged in other rural labour, may be expected to become rarer, and the beating of women by rural overlookers become a relic of a barbarous time.'[30] The language of slavery was powerful enough to allow the conflation of two very different systems of hiring. But more importantly, the gangs, like the 'white slaves', became a *metaphor* for the way that all women were treated in Victorian society.

Eliza Cook's Journal argued that women should be free and equal individuals, who could own their own property, have a legal identity and no longer be treated as 'man's goods and chattels'.[31] In an attempt to overturn the ideology of separate spheres, Eliza Cook used the languages of political economy, commerce, Englishness, slavery, domesticity, pastoral and liberalism, which were more often used to support the dominant construction of femininity. If women could not be free in the English countryside, where could they be they independent, Cook asked. The gangs may have been slave-like, but marriage was little better; in which case, marriage was represented as an unnatural, un-English and therefore uncivilised practice. This reworking of the languages normally used to construct femininity was a practice also adopted by late Victorian feminists. Eliza Cook differed from these women in one important respect, however: she perceived the laws on mine and factory work as one small step towards an improved condition for women, whereas later middle-class feminists argued that women's employment should never be restricted. The debate about whether it was better to protect working-class women or to let them have a free choice of employment paralleled wider debates over *laissez-faire* and interventionism, and remained a contested point among feminists

throughout the century. The Langham Place Group, who took up this debate in the 1850s, began by campaigning on women's right to retain their property after marriage, and widened their concerns to take in women's right to work.

The feminist project at this time was founded on the language of 'sisterhood' – the shared experience of all women as women, despite differences in class, race, religion, age, and region. It developed from the desire of single middle-class women to have more access to the public sphere, the world of paid work and, later, politics. They campaigned to gain access to the professions and better education, and in order to do so argued through the discourse of respectable femininity that women had a social duty to become carers, not just of their own families, but of children and the working class as a whole. They used the language of spirituality and morality to become teachers, nurses and factory inspectors. In other words, they expanded women's 'mission' beyond the private sphere of home and family. By 1866 these women laid claim to the right to vote using this same language; they argued that women should be consulted on moral issues that affected the nation as a whole. Much of this centred on the liberal claim to be free and equal individuals, who could be recognised as 'persons' or 'citizens' within the law, which we can already see in Eliza Cook's discourse. Feminists claimed a new identity for women within the bourgeois hegemony.

Feminism at this time, as now, took many forms and languages, and there were therefore contradictions and silences within feminism, as there were in other radical and alternative ideologies. Many of these contradictions were due to class divisions, which were especially highlighted in the campaign for the franchise. Middle-class women largely wanted the vote as a symbol of their changing status; working-class women mostly wanted it in order to change their working conditions. Other women, those who went on to use the language of white slavery, focused on changing the moral standards of Victorian society; some, like the Women's Co-operative Guild, focused on issues like maternity welfare and wider social conditions. Each of these feminisms challenged the boundaries of masculinity and femininity while also adding to their construction; some dissenting discourses were incorporated into the definition of womanhood or manhood, others were marginalised or excluded. Most were constructed within dominant definitions of race and class, which they failed to overturn.

The Langham Place Group initially addressed the issue of women's farm work in April 1867 in *The Englishwoman's Review*, founded in 1858 as *The English Woman's Journal*, and resisted the idea that field women were prostitutes, but were adamant that women's agri-

cultural employment should not be restricted. 'If deprived of this resource [gang labour], their condition would be wretched indeed, as there is absolutely no other honest employment open to them.'[32] It is probable that Jessie Boucherett, daughter of a large landowning family and a key member of the group, wrote this article. She had already given evidence to the 1867 Commission as an expert on the labouring population in Lincolnshire, and had been quoted as such in Mr John Dent MP's essay in *The Journal of the Royal Agricultural Society:*[33] 'Field work is often rough for girls, but it is ... the only means girls who have lost their character have of getting an honest living'.[34] This implies that she did not challenge the dominant representation of field women as sexually deviant, but Boucherett was also keen to pin the real blame for immorality on the women's fathers and husbands. Men were drunks, women and children were their victims: 'I believe the public-houses are the feeders of the gang system, and of half the overwork and hardships of the women and children. The men are not bad, but when the bottle is held to a man's mouth "he cannot help but drink" '. Even though she did not see the labouring population as particularly elevated or intelligent, and showed some distaste for women working on threshing machines, Boucherett argued that it was more important to have good laws to punish labouring men who 'ruined' the girls, than to have laws restricting women's employment.[35] She constantly juxtaposed prostitution with legitimate employment, in an attempt to reconstruct respectable bourgeois femininity along lines that paralleled working-class notions of morality. Field women were used as a metaphor of women's wider position here, as they were in *Eliza Cook's Journal*, and as they were in effect in the parliamentary reports.

When the Langham Place Group next referred to rural working women, in 1869, the 'First Report of the Commission on the Employment of Young Persons, Children and Women in Agriculture' was the focus of discussion. Statistics helped prove that rural women were no more immoral than other working women, including domestic servants. Immorality, such as it was, was blamed on society. And it was argued that it was better to do honest field work than to be forced into prostitution:

> A certain immorality is said to result from every employment for women that can be named, but want of employment produces far more. ... when a well paid woman is guilty of misconduct it is the individual herself, and not society, who is responsible for her misconduct, but when hundreds of poor creatures every year, as at present, driven into vice by poverty, society, and not the individuals, must be to blame.

The occasional immorality of women workers in the field, in manufactories, in domestic service and elsewhere, is preferable to the

wholesale immorality of those who have no work and consequently no honest means of earning their bread.[36]

Finally, *The Englishwoman's Review* claimed 'Any further interference would be an act of oppression towards the women.'[37] These articles, like that in *Eliza Cook's Journal*, attempted to present a major challenge to the predominant representation of women who worked in agriculture by using several dominant languages. The issue of prostitution, the discourses of political economy, objective statistical research, race and evolution appeared throughout each piece and were turned to defend rural women, but also helped reinforce femininity and definitions of deviant sexuality. Field women became signs of the oppression of women, like the white slaves, in a projection of bourgeois feminist concerns onto the countryside. In order that they have a public voice, middle-class feminists like those of the Langham Place Group and Eliza Cook had to maintain their own respectability through the use of discursive practices that were apparently antithetical to their aims. This dilemma still haunts feminists today.

By this time George Eliot knew Barbara Bodichon, a key member of the Langham Place Group, on whom the novel *Romola* (1863–3) is allegedly based, quite well. Interestingly, unlike Boucherett, Bodichon was one of the most radical members of the organisation, and accepted the right of married, as well as single, women to take paid employment, a position which most middle-class feminists found untenable at this time. It is hard to determine the extent to which Bodichon or the rest of the Group influenced Eliot, but in many respects the writing in *The Englishwoman's Review*, like the article in *Eliza Cook's Journal*, challenged aspects of pastoral in ways which parallel Eliot's concerns, despite her own ambiguity towards feminism. All of the authors saw the countryside as a site of labour, and often hardship, which challenged the idea that the towns were the only site of production based on capital. As A. S. Byatt says, this promoted a certain degree of 'realism' in Eliot's work – as we shall see when we look at *Adam Bede* – which was 'partly a moral realism, rejecting "compensation" and other consoling doctrines, and partly a related technical realism, a desire for accuracy'. Eliot's essay went on to take on board the new concepts of 'natural history', i.e. the discourse of objective, scientific research as carried out on human societies, and to focus on a discussion of Wilhelm von Riehl's work 'The Natural History of German Life'. Eliot argued that social science should never be carried out without an understanding of the specific organic, evolutionary, incarnate and natural history of a people.[38] This use of an organic metaphor is particularly interesting in reference to a discussion

of rural life. In her essay Eliot moved from a critique of idealised pastoral, which creates nothing but an artistic refuge or requiem, to a sense in which peasants exhibit the natural, organic history of their nation in their everyday language, their *'physique'* and communal life, even though that life is harsh.[39] In effect, this produced a rationalisation of the organic community, but at the same time Eliot expected that community to change gradually; she did not use the organic community nostalgically to bolster pastoral, she saw it as a stage in the evolution of European society as a whole. This was far removed from the material needs and political concerns of working-class women in the countryside.

Elizabeth Gaskell also viewed the town and industry positively in comparison to the rural and she challenged pastoral for its hiding of social ills. Using a similar system of representation to that found in Eliot's essay and *The Englishwoman's Review*, Gaskell recognised that the urban and rural environments both had their problems, and argued that they were equally backward and degraded, but that the town was the way foward. In *North and South*, published in 1854–55, just before Eliot's essay, Gaskell constructed an opposition between the fictional village of Helpstone and the new industrial town of Milton-Northern, which was paralleled in a debate between Mr Thornton, a self-made man, and Margaret Hale, the daughter of a country clergyman. Margaret originally had 'a detestation for all she had ever heard of the North of England, the manufactures, the people, the wild and black country'. However, she learns to appreciate the energy of the working classes and realises that *their* life in the country, at least, is no better than in the town. When Higgins, a working man, asks her advice about moving to the country, because he had heard that 'food is cheap and wages good, and all the folk, rich and poor, master and man, friendly like', she disabuses him. She says the country labourer earns only 9s. a week, at best; that the work is hard, carried out in all weathers and results in rheumatism; that he would no longer be able to have butcher's meat every day; that the life is inactive and dull, and the poor ground down by their work. Higgins drew the conclusion: 'God help 'em! North an' South have each gotten their own troubles'.[40] Rural idyll and urban idyll began to fight it out. Pastoral was under attack, but 'reality' also had to adjust to this changing ideology.

NOTES

1 Eliot, G., 'The Natural History of German Life' from *Westminster Review*, July 1856, in Byatt, A. S. (ed.), *George Eliot, Selected Essays, Poems and Other Writings*, Harmondsworth, 1990, p. 108.

2 Eliot, 'Natural History', p. 109.

3 Byatt, *George Eliot*, p. xiii.

4 Eliot, 'Natural History', p. 108.

5 See Benjamin, M. (ed.), *Science and Sensibility, Gender and Scientific Enquiry 1780–1945*, Oxford, 1993.

6 See Williams, R., *Cobbett*, Oxford, 1983.

7 Nead, L., *Myths of Sexuality: Representations of Women in Victorian Britain*, Oxford, 1988, pp. 110–18.

8 Somerville, A., *The Whistler at the Plough; Author of Letters 'One Who Has Whistled at the Plough' and Agricultural Customs in Most Parts of England, with Letters from Ireland: Also 'Free Trade and the League'*: A Biographic History, Manchester, 1852, p. 18.

9 Somerville, *The Whistler at the Plough*, p. 38.

10 There is a body of largely unpublished oral material at an archive in Exeter.

11 Davies, M. L. (ed.), *Life as We Have Known it, By Co-Operative Working Women*, London, 1990, 1st edn. 1931, pp. 110–12.

12 Davies, *Life as We Have Known it*, pp. 109–10, 112, 114.

13 Davies, *Life as We Have Known it*, p. 113.

14 Quoted in Davies, *Life as We Have Known it*, p. viii.

15 Quoted in Kingsley Kent, S., *Sex and Suffrage in Britain, 1860–1914*, London, 1990, p. 196.

16 'Reports From the Commissioners on the Employment of Children, Young Persons and Women in Agriculture', PP 1867–70, xvii, p. 198.

17 PP 1867–70, xvii, p. 198.

18 Foucault, M., *Power/Knowledge, Selected Interviews and Other Writings 1972–1977*, (ed.) Gordon, C. (ed.), Brighton, 1980, pp. 215–16.

19 PP 1867–70, xvii, p. 197.

20 Barret-Ducrocq, F., *Love in the Time of Victoria: Sexuality, Class and Gender in Nineteenth-Century London*, trans. Howe, J., London, 1991, pp. 7–9, 39–43.

21 Barret-Ducrocq, *Love in the Time of Victoria*, pp. 9–13.

22 PP 1867–70, xvii, p. 233.

23 *Ibid.*, pp. 233–4.

24 Eliot, 'Natural History', p. 108.

25 Barret-Ducrocq, *Love in the Time of Victoria*, p. 42.

26 PP 1867–70, xvii, p. 54.

27 *Ibid.*, p. 234.

28 *Eliza Cook's Journal*, 9 Aug 1851, p. 225.

29 *Ibid.*, p. 225–7.

30 *Ibid.*, p. 227.

31 *Ibid.*, p. 226.

32 *The Englishwoman's Review of Social and Industrial Questions*, April 1867, London, 1985, p. 195–6.

33 *Journal of the Royal Agricultural Society*, 1871, p. 356.

34 PP 1867–70, xvii, p. 80.

35 *Ibid.*, p. 285.

36 *The Englishwoman's Review*, April 1869, p. 172.

37 *Ibid.*, pp. 175–6.

38 Byatt, *George Eliot*, pp. xvi, xxi–xxiii.

39 Eliot, 'Natural History', pp. 112–23.

40 Gaskell, E., *–f*, London, 1975, 1st edn. 1855, pp. 72, 122–34, 381–2.

Girls into demons

All the Year Round, A Weekly Journal Conducted by Charles Dickens, With Which Is Incorporated Household Words powerfully summed up the arguments against field work in an article in the first half of 1867 by declaring that the work 'converts girls into demons'.[1] By implication, girls who worked in the gangs would grow up to become women who were quite literally fallen angels; not mothers, but Liliths who would destroy the nation's children. A few months later Mrs Fellows, president of the Eynsford Association in Norfolk, created a prize for the 'wife or widow of an agricultural labourer who had brought up the largest number of daughters and established them in the world without having sent them to field labour since they were ten years of age, and then only in occupations within the parish where they were residing'.[2] The wives of agricultural labourers had become wholly responsible for their children's morality and were expected to behave accordingly. Field labour had come to be seen as a corrupting influence on girls as they reached puberty. And the gangs, which took children out of the parish, were believed to be 'one of the foulest blots on the character of a civilised country which public investigation has ever brought to light'.[3] Women's field work was only represented as a respectable occupation when it was practiced in Northumberland.

The apparent power of paternalism to survey and discipline the rural poor waned in the 1860s. Field women were condemned from on high, no longer victims, but agents of contagion. The use of medical languages was much more pronounced than in the 1840s. Medical men were beginning to feel the benefits of professionalisation; at the same time as the agricultural reports were being written, they were defending the Contagious Diseases Acts, and attempting to physically restrict prostitutes in military towns through incarceration, not just limit their trade by surveillance. Definitions of deviant sexualities, which constricted the bounds of acceptable behaviour for both men and women and produced

a multiplicity of new identities, were the ideological, scientific and cultural focus of the period. The reports on women's work in agriculture, with their constant discussion of the women's uncontrolled sexuality and child mortality should be seen in this light. This was also the period in which the majority of England's population became urban. The middle and working classes now lived in the towns and were more remote from the countryside than ever before, despite the boom in agricultural production. As the population shifted, so nostalgic visions of the rural became increasingly desirable, despite critiques of the rural idyll by writers like Eliot and Gaskell. The countryside still offered an escape: literally as a site of leisure, and metaphorically as the supposed location of the perfect community, landed authority and English tradition in artistic and literary discourses, despite the break-down of pastoral in radical and official texts. The middle class simultaneously feared and desired what they supposed was contained in the garden of England.

Rural women's bodies became condensation points for these values and concerns. They were stereotyped as ideal women, fragile and beautiful; they were elevated as goddesses of harvest and fecundity in compensation; middle-class men and women colluded in the internalisation of the rural idyll, the rose-covered cottage and the sweetness of peasant women at work during haysel and in the dairy; and feminist and radical discourses were denied through the use of ever more idealised versions of rural woman's beauty, and diatribes against inverted field-working femininity which defined womanhood through what it was not. All of this was seen through the Claudean glass of pastoral and distance, physical, gendered and experiential. The ultimate form of this construction of rural femininity can be seen in the numerous pictures of girls who stand and play near cottages. Charles Wilson's *The New Arrivals* and *Feed Time*, and John Dawson Watson's pre-Raphaelite *Bubbles – A Cottage Scene with Children* (1856) (Plate 2) provide perfect examples of this state of childhood bliss in its most perfect location. Girls play with babies or kittens and feed chickens, signifying their future domestic role. However, they can also be read as an ultimate disempowerment of rural women in a process which reduced them to an ideal state – childhood, passive, innocent, pretty, and in need of protection. These pictures capture the Beau Ideal in a moment of utter inevitability; these children were destined to become paradigms of maternal duty within the organic community. There was no need to represent the adult woman, who after all might be unsexed, when the girl could be as easily painted and the scene lose any connotations of class threat or immorality.

If we start with the last point, recuperation and denial, which, as Michèle Barrett says, is a process that helps 'defuse' any critique of the

dominant construction of femininity, we can better understand the representation of female day-labourers at this time. Using the material in the official reports and debates in Parliament, most of the press took up the question of women and children's labour in agriculture in 1867. The system of ganging led to the most critical response, while other forms of women's farm work were largely passed over as supremely feminine tasks. Different papers and journals took up different aspects of ganging, but in contrast to 1843, all condemned it. Metropolitan *Punch* succinctly summed up the issues in April 1867, condemning ganging as

> a system so abominable that nothing but the intensest hypocrisy can call this a Christian nation, while such a thing exists. ... A slave driver hires a gang, chiefly children of both sexes ... and makes as much as he can by taking these creatures about the country and letting their labour to farms. The cruelty to the children is the least frightful part of the system, the demoralisation is too hideous to be more than hinted at here. But look to it gentleman philanthropists, if you have sympathies for anybody but niggers.[4]

> [Shaftesbury's speech gave] such insight into the accursed system of Agricultural Gangs as ought to make Pharisees blush with shame, and Christians with indignation.[5]

Punch represented ganging as un-English, or as Shaftesbury might have put it, 'utterly inconsistent' with English middle-class principles and values. Englishness was defined by *Punch* as honest, not hypocritical; Christian, not heathen; free, not slave-driving; kind, not cruel to children; pure and moral, not corrupt; patriotic, not just sympathetic to 'niggers'. The system was so bad even Pharisees would, apparently, be shamed by it. The languages of slavery, savagery and evangelicalism were all alluded to, forming a powerful and shocking rhetoric which legitimised intervention.

Similar languages were used in the remainder of the mainstream press, though the debate was usually more complex than that found in *Punch*. *The Times* announced the return of the subject by publishing a piece from *The Pall Mall Gazette* on 18 May 1865. This was just after Lord Shaftesbury had made his speech demanding that the Children's Employment Commission inquire into the gangs. And the paper particularly highlighted the question of the children's slave-like employment, rather than the issue of women's work, as the speech had centred on this. The paper believed that rural children were 'the great staple of British industry, the hope of England, and the parents of families destined for all kinds of employments, in the field or the factory, by land or by sea, at home or in the colonies'.[6]

Significantly, the paper also feared girls were made unsuitable for

domestic work having been in the fields. They became 'rude ... so wild and so unhandy' that they would become useless women. Girls were represented through the construction of domesticity, not just by the language of childhood. The paper finally demanded legislation on the education of rural children, linking the question of farm work to the education debates.[7] But it was to become apparent that rural children presented a particular problem within the construction of childhood as seen by anthropologists and social Darwinists like Francis Galton and Herbert Spencer. They, more than any other working-class children, held the future of the race in their hands. The countryside was increasingly seen, not just as the epitome of English freedom, but as the site of all that was physically and morally fit. Peasants not only owned vestiges of English culture which had been lost in the cities, and were naturally moral, but they also possessed the only remaining rude health. The towns were seen as sites of physical and moral corruption which destroyed children and childhood, whereas the countryside was supposed to be a haven. To find that the countryside itself was corrupt and that the children there were as sickly as those in the towns presented a peculiar dilemma for the middle-class faith in the curative effects of pastoral.

Many articles in the journals of the period, such as those in *The Fortnightly Review* of 1865 and *The Quarterly Review* in 1866, which addressed the question of women's farm work opened with a criticism of the rural idyll, or rather a sense of horror that such abuses could exist in England's countryside, and picked up on some of the critiques we looked at in the last chapter. When *The Quarterly Review*, for instance, wrote on the findings of the 'Sixth Report of the Children's Employment Commission' in 1867 it began: 'This report is one of the most painful which it has ever been our duty to pursue', because the conditions it would have expected to find in the cities had been found in the country.[8]

It feared, like many, that 'this agrarian evil ... threatens to extend itself over no inconsiderable portion of the rural districts of England'.[9] Having first established, through medico-moral language, that the whole of the countryside, and therefore the nation, was liable to be contaminated by ganging, it went on to describe the women's work in a voyeuristic mode. Those employed were:

> girls depraved by constant association with some of the worst characters of their sex; married women who prefer the rude independence of the fields to the restraints of domestic life ... [They are] ... hardened in a life of depravity ... [They wear] ... buskins on their legs [tucked up petticoats and] ... garments clinging tightly to the body ... [They return] ... weary, wet, footsore, but in spite of their wretchedness singing licentious

or blasphemous songs ... a spectacle to excite at once pity, detestation and disgust. [They cannot] ... resist the temptation of adding two or three shillings to the weekly earnings.[10]

The Quarterly Review concluded: 'Field work seems to be essentially degrading to the female character; no regulations will abate its evils in that respect'. Yet some legislation had to be introduced, otherwise – using the languages of medicine and morality together – 'it will spread like a moral leprosy over the land'. The air rural children lived in may have been pure, but they worked 'in an atmosphere of moral corruption, paralleled probably only in the interior of Africa'. They were transported by the work out of the safety of the English environment, the English garden of childhood, into the racially, physically and morally threatening natural world of the 'dark continent'. The journal did not like to interfere in the liberty of the individual, but ultimately believed that if something was not done soon, the women, men and children of the countryside would be beyond redemption.[11] These articles defined Englishness, childhood, parental duty, the duty of the government to its people, the duty of wealthy Christians to their poorer counterparts, the rural, masculinity and femininity. In this way it was possible for the mainstream press to demand interventionist legislation, which might otherwise have gone against the principle of *laissez-faire*. That fundamental contradiction – between *laissez-faire* or free individualism, and the urge to reform, and take on moral responsibility for those perceived as weak and vulnerable – which shaped so many debates from the 1840s, was overcome through the complex interweaving of values around deviant sexualities, and the construction of race and nation.

 The Quarterly Review's representation of children was particularly alarming. The languages of sexuality, medicine, race and imperialism are combined in the article to construct the countryside as vital to the nation, but as potentially alien and corrupting, like the colonies. The children, who should have been England's pure and innocent future, were described as having been warped and made into near savages; they became the Other, alien and fearful to the English bourgeoisie. The hope was that they would evolve, which according to the new anthropological theories of the day was an increasingly accepted possibility, but they had to have the right conditions in which to grow and learn, which included good mothering. This was absent in the countryside. Rural women were seen as utterly degraded, regardless of their own claims to respectability. Although they were supposed to belong to the Beau Ideal as sweet innocents, by this point they were most often described in terms of transgression. Their inability to resist the temptation of money or

independence identified them as prostitutes, while, like factory women, they were condemned for their public conduct after work, which was interpreted as licentiousness, blasphemy and rowdiness. The national press did not excuse the women's labour on the grounds of necessity. And, as in the official reports, the representation of women's farm work centred on their labour in the public, exposed and uncontrolled space of the field. The key issues raised by the press in the 1860s were therefore the need for observation and control of deviant sexualities, and the attempt to universalise middle-class constructions of gender and child-hood, which intersected with official discourse and the ongoing definition of 'race'. Field women worked and lived beyond middle-class sight and control, and were therefore supposed to behave deviantly. They did not adhere to middle-class notions of European femininity in their physical appearance and behaviour, and were therefore supposed to be immoral and savage. They were no longer innocents abroad, but were culpable in their misdemeanours. If we turn to the main stereotypes and compensatory images in the artistic and literary practices of the period, we see that three main figures emerge: the dairy/milkmaid, the haysel/harvest worker and the cottage woman. These added to the horror of field work, but also offered a counterpoint to the moral panic of the day by presenting English women with the model of domesticity and community they should aspire to. Reality had to be seen to adjust to this ideal in order for the panic to end, to reach a point of closure.

The dairywoman or milkmaid appeared throughout nineteenth-century literature and art; as we saw in the first section of this book, she was a popular image for artists and poets in the early nineteenth century and an important category of normative femininity. *Dairy*maids, who worked within the dairy, were rarely distinguished from *milk*maids, who milked the cattle. One of John Clare's later poems, 'The Milkmaid is Bonny and Fair', operates as a summary of the key signs of femininity within the body of art and literature employing representations of dairy-maids. Clare's writing conformed to middle-class literary structures and was imbued with nostalgia, especially for his lost first love Mary Joyce, who seems to have become his rural muse, though it has been read as the poetry of alienation, in which his mental breakdown played a major part, along with his incorporation into the discourse of literature, the process of enclosure before 1820 and the move from his native Helpstone.

> O the milkmaid is a beautiful flower
> And kind as a prayer book to me
> She shows me more truth in an hour
> Than the Parson and prayer book in three
>
> ...

> Her face is all rose her neck's like her milk
> And white as the daisy's snow rim
> Her bosoms as soft as the silk
> She'd beauty in every limb
>
> …
>
> O the milkmaid's a beautiful thing
> When she sits there a milking her cows.[12]

This poem represents the milkmaid as closer to nature, and therefore to God, than the local clergyman. She is described as part of nature itself, in that she can communicate with it and is an aspect of its beauty. Ultimately she is an object, observable only at certain times of day, dawn and dusk, when the boundaries of dark and light mixed, when she crosses the boundaries of the public and private. The fact that she could be seen at work proved her industriousness, while her problematic entry into the public sphere, where she became visible to the male gaze, was dealt with by the brevity of her appearance and her natural sentiment.

As the English rose, this milkmaid was seen as an element of the landscape; hidden by nature, unless you knew where or when to look. She was also part of the white, milky, smooth and therefore good side of the dichotomy which categorised women into white/dark, smooth/rough, good/bad polarities. She and her labour were ultimately natural, pure, mysterious, beautiful. Nature and femininity combined to make her both a perfect woman and the rural her most perfect location. This combination occurred whenever the dairy/milkmaid helped fill in the rural scenery, or was represented as a good, moral woman, providing one of the most common rural myths against which other women could be judged. Not all authors accepted this connotation: the milkmaid was always a little at risk morally, because she stepped into the outside world. The Nature/Culture divide could as easily damn a woman as elevate her.

It is worth considering George Eliot in this light. She overturned the vision of the ideal dairymaid within a Wordsworthian framework, but still reinforced the dominant construction of femininity.[13] *Adam Bede* was published in 1859 but was set during the Napoleonic wars. As we have already seen, Eliot was committed to social reform through the practice of literary production; she believed literary representation could replace political representation for the working class, disenfranchised by their material and social conditions. She hoped to end the 'miserable fallacy that high morality and refined sentiment can grow out of harsh social relations, ignorance, and want'.[14] This was clearly signalled by her in *Adam Bede* through Hetty Sorrel's story. Ultimately, Hetty is convicted of concealing her illegitimate child's birth and murder, despite an

initial description of her as a beautiful dairywoman – much like those praised elsewhere as naturally possessing both sentiment and high morality. Captain Arthur Donnithorne, who brings about Hetty's downfall, represents another of Eliot's convictions – that we are destroyed by self-deception, not fate. Captain Donnithorne is signified as potentially morally dangerous and reprehensible early on in the novel when he rejects Wordsworth's *Lyrical Ballads* as nonsensical 'twaddling stuff',[15] an act which clearly defines him as without natural sentiment and therefore dangerous, despite – or perhaps because of – his superior social position, age and supposed responsibility. Hetty is still culpable, however, as Eliot carefully shows us when she describes her at work:

> Hetty's cheek was like a rose-petal, dimples played about her pouting lips ... her large dark eyes *hid a soft roguishness* under their long lashes, ... her curly hair, though all pushed back under her round cap while she was at work, stole back in dark delicate rings on her forehead, and about her white shell-like ears ... how lovely was the contour of her pink-and-white neckerchief, tucked into her low plum-coloured stuff bodice ... the linen butter-making apron ... fell in such charming lines, ... her brown stockings and thick-soled buckled shoes lost all that clumsiness which they must have had when empty of her foot and ankle; ... Hetty's was a spring-tide beauty; it was the beauty of young frisking things, round-limbed, gambolling, circumventing you by a *false air of innocence* ... And they are the prettiest attitudes and movements into which a pretty girl is thrown in making up butter – tossing movements that give a charming curve to the arm, and a side-ward inclination of the round white neck; little patting and rolling movements with the palm of the hand, and nice adaptations and finishings which cannot at all be affected without a great play of the pouting mouth and the dark eyes. And then the butter itself seems to communicate a fresh charm – it is so pure, so sweet-scented ... '[16] [my italics]

This description of Hetty employs every cliché of the dairymaid myth and parodies the girl who makes the most of them to seduce her lover. Yet her prettiness is represented sexually, erotically; her milkiness is consumable, not worshipful.[17] This leads to her downfall when coupled with the innocence and naïvety which she, like other dairymaids, exhibits.

Hetty is irresponsible and careless of her morality. Hetty's failure does not lie in her femininity as such, but is due to her lack of religion. As Eliot had already stressed in her essay on the German peasantry, being part of the rural did not necessarily result in closeness to God, which could have been the only guarantor of natural sentiment. The woman who is closest to God in *Adam Bede* is the angelic Methodist preacher Dinah, who works in the mill when she is not touring the

country. This was an unusual representation of an urban woman, espe-
cially one who spoke in public. The factory worker was usually the one
who needed religious education. To some degree Eliot did try to chal-
lenge the stereotypes of her day. She questioned whether dairymaids
were really better than other women, and whether women should be
expected to be more moral just because they were naive: 'The conven-
tional countryman of the stage … represents the still lingering mistake,
that an unintelligible dialect is a guarantee for ingenuousness, and that
slouching shoulders indicate an upright disposition. … The selfish
instincts are not subdued by the sight of buttercups, nor is integrity in
the least established by that classic rural occupation, sheepwashing. To
make men moral, something more is requisite than to turn them out to
grass'.[18]

What I want to stress, though, is that both Eliot and Clare recog-
nised that there was a specific mechanism for delineating the dairymaid
or milkmaid, which was widely used in the artistic and literary discourses
of the mid-nineteenth century, and which reworked middle-class ideol-
ogy and social reality through the process of representation. The body of
woman was often likened to Nature and landscape. As Annette Kolodny
has discussed with reference to narratives on the Wild West, women's
bodies became metaphors for the land in the nineteenth century, as well
as signs of moral or social degeneration.[19] But there were particular signs
of femininity written onto the body of the dairy/milkmaid which added
to the definition of domesticity, even when inverted. The dairy- or milk-
maids' hair, eyes, cheeks or faces, skin, hands and arms were each alluded
to as the ingredients of their superior purity, sentiment or sensuality;
dairy/milkmaids were predominantly represented as young, dark-haired,
white- or pink-skinned, dark-eyed, shapely, and graceful. Their personal-
ities were referred to through a physiognomical construction of
character;[20] a technique which was so frequently used, many authors,
including Eliot, specifically disassociated Hetty's looks and character.
The dairymaids' work also added to the discourse of the body, with refer-
ences to the cleanliness, coolness and purity of butter. And, as Anthony
Trollope shows us in *The Last Chronicle of Barset* (1867), their faces con-
noted their class: '[The Archdeacon knew the] difference between
beauty of one kind and beauty of another kind in a woman's face, – the
one beauty, which comes from health and youth and animal spirits, and
which belongs to the miller's daughter, and the other beauty, which
shows itself in fine lines and a noble spirit, – the beauty which comes
from breeding'.[21]

The dairy itself was represented as supremely feminine because it
was pure, which it had to be; domestic, through its attachment to the

farmhouse; idyllic, because it was associated with pastoral. When the dairywoman was represented voyeuristically or erotically, the descriptions focused on her neck, figure, bosom and ankles.[22] Some of these descriptions allowed the woman herself to remain innocent, while others created coquettes and women whose moral fall toppled them from their pedestals of purity. But all dairy-women, both pure and impure, were objectified and added to the dominant construction of femininity, domesticity and the rural.

The second category of rural femininity which I want to discuss in some depth here is the harvest worker, or gleaner, who was largely accepted because of the communal, rather than the domestic, nature of her work. As we saw in Chapter 1, the hay and corn harvests were represented both in middle-class literature and art as joyous events for labouring men and women and as perfect examples of the organic community in action. The work was generally depicted as easy, fun, co-operative, and in the case of the corn harvest, as a completion of the agricultural year. As David Hoseason Morgan has noted, the harvest was used as a symbol of social harmony.[23] According to Richard and Caroline Brettell, this harmony was between classes, humanity and Nature, and the sexes. The harvest signalled the continuous cycle of Nature. The labourers were seen as part of both the cycle and its bounty. Occasionally the harvest was also used to show the heroic quality of rural labour, of the peasant wresting the fruits of toil from the land.[24] We can see this theme recurring in 1905 in Thomas Blinks' *Bread Winners*, a powerful evocation of masculinity in which a man in the foreground stoops to tie a sheaf of corn, while two others ride past on shire-horses which pull a reaping machine; a church and labourers fill in the background to connote the sacred nature of the work. Images like this celebrated the industry of rural men and women, which brought abundance and pleasure. The painting carefully explored all meanings of the phrase 'bread-winner': as the most sought-after wage for a man, the toil of reaping corn which would become bread, the sacred bread of Christ. Even the horses participate heroically in the act of harvest, which is almost a direct representation of muscular Christianity.

The moral and religious power inherent in the image of harvest work was used to equally great effect in 1863 by *Punch*, when John Tenniel, one of *Punch's* major contributors, who was knighted for his work on the paper, drew 'Thanksgiving'. In it a young woman – distinctly pre-Raphaelite – kneels on a sheaf of corn, hands in prayer, and looks to the sky. Beside her the symbols of Britannia, or war, are laid on the ground. In the field at her back men, women and children pray with heads lowered. One woman is looking at the baby in her arms, a

metaphor for prayer. Behind the townspeople are the outlines of facto-ries. In the right of the picture, to the rear, is a cart, full to overflowing with sheaves, on top of which are joyful peasants waving their hats, including the journal's symbol of Englishness, Mr Punch himself. All are at a distance from the pious crowd below.

This illustration emphasised the very real importance of the harvest, and therefore the rural, to the cities of Britain. The country people were represented as the agents of God, happy and well-off, and naturally religious through their work, while the townspeople had to recognise their dependency in this instance. The cartoon constructed England as a religious, rural, industrial, and united nation. The rural was used to define femininity, through peace and natural piety. Motherhood was elevated. The industrial and its classes were represented as strong, yet dependent on God and the peasantry to give them strength. This was a key representation of Englishness. The urban middle class began to show their awareness of the economic significance of the countryside in a range of texts, each of which had a different standing within their own discourses, but each of which participated in a changing definition of the countryside.

Within these images harvest and haysel were not always distinct. The representation of haysel usually involved elements of rural courtship, rather than the results of toil, but haysel and harvest could be easily exchanged, as is demonstrated by the changes made to Matthew Arnold's poem of 1864–67, 'Bacchanalia; or the New Age':

> Deserted is the *half mown plain* / New reape'd grain
> Silent the *swaths* ! the ringing wain / sheaves
> The *mower's* cry, the dog's alarms / reapers'
> All housed within the sleepy farms !
> The business of the day is done,
> The *last-left haymaker* is gone / last belated gleaner.[25]

The main difference between the two events rested on the idea that the culmination of the harvest involved a celebration which did not happen at haysel. The harvest-home was a secular event where farmers provided food and drink for their workers after the corn was finally gathered in. It probably originated as a form of payment in kind, but was declining by the middle of the century, due to the cost and increasing bourgeois concerns about working-class men's public drink-ing, violence and sexuality. The second form of celebration after the harvest, which also led to a clash of working- and middle-class values, was the custom of largesse. The ideal of this was represented in William Maw Egley's *Hullo Largesse! A Harvest Scene in Norfolk* (c.1860), in

which labouring men, women and children, watched by their employer and his family, dance in a field of partially cut and bound corn, in sight of the village church. Largesse by this time actually meant that male labourers collected cash to be spent on food and drink at the pub.[26] But despite these conflicts, both largesse and harvest-home were regularly represented positively, as times of communal enjoyment and *Gemeinschaft*, or as Raymond Williams would have put it, as representative events of the knowable community and the face-to-face relationships of the village. As urbanisation apparently destroyed the 'community', so it became an increasingly important part of the rural idyll. Pastoral novels offered their readers knowable communities in themselves, and presented their readers with a vision of face-to-face relations in action, even if the neighbours in the books were closer in class terms than geography.[27] Again, distance between urban and rural, and middle and working class, in literary and artistic pictures of the harvest-home and haysel meant that a site of class contest could be reworked through the values adopted by the bourgeoisie as a site of naïve gaiety, safe and consumable. As Williams said, even when the rural working class were the focus of attention, as in *Adam Bede*, the class of the author could still be heard in their speech, values and concerns. The reality of the rural labouring community was always changed in this way, through the very process of production and representation, by even the most socially aware of authors.[28]

Haymakers and gleaners abound in nineteenth-century art and show us how countrywomen were selectively represented at this particularly meaningful time of year. They were depicted as individuals or grouped figures, or as elements of general harvest scenes making up the industrious, communal landscape. Harvest and haysel offered a chance to show the heroic aspect of women's work, as well as joy and playfulness; it was a particularly malleable subject and offered a perfect opportunity for metaphor in the form of Ruth, as noted in Chapter 1. Arthur Foord Hughes' *Gleaning* (Plate 3) offers us a particularly dramatic vision of this labour, but there are many more from this period of High Farming.

Hughes' gleaner is positioned in the foreground of a vast and empty field; a windmill on the horizon gives an indication of scale. The spectator would be looking up to the woman if she were standing, but in her stooping position her head is level with us. In her right arm she grasps some stalks of corn, with her left she reaches out to clutch another ear, looking intently at her work. She walks from the left to the right of the canvas, actively getting on with her labour. Her clothes are worn, her sleeves are rolled up and her boots are sturdy. Young and pretty, she

also has strong arms and hands, and her hair is tied up in a bun, connoting her separateness from her middle-class audience, but also her morality. This powerful image of a rural working woman crossed the boundaries of the idyllic, with its use of the rural as ideological vehicle, and social realism, which stressed the hardships of rural life. Like most representations of gleaning, it celebrated the values of thrift and industry; despite her presence in the public sphere, her activity within a rural paternalistic and organic tradition meant she could be recuperated. She grasps at the last of nature's bounty. The rural is greater than her, than humanity, and she clutches at whatever it will give her for her survival. Though it is a summer landscape, her work reminds us that the time of nature's felicity is about to end; she takes what she can while she can. Unlike George Vicat Cole's *Harvest Time* (1860) (Plate 4), which shows the harvest and harvest workers as distant elements of the landscape, but which hides the effort of their labour, *Gleaning* dwarfs the labourer but emphasises the work. It represents one gleaner, but focuses on gleaning and the significance of that work in the countryside. The woman is heroic and unreachable because she is a metaphor for toil, not just because she is distanced by class.

Hay and corn harvest scenes were equally popular and variable in literature. They often provided the only literary representations of women at work in the countryside, outside of the domestic sphere. In *North and South*, Mrs Gaskell describes a servant at an inn as 'a flushed-looking country girl, who had evidently been finding some variety from her usual occupation of waiter, in assisting in the hay-field'.[29] This is the only agricultural work done by women in the book, one of the asides typical of these representations. Through it, Gaskell presents the woman's hay-making work as one of her normal if occasional, tasks. The 'girl' is hot, it is early summer and so she must logically have been in the hay-field; this was an accepted part of working-class women's employment and was widely used to signify respectable working-class femininity. Though she was hot, the girl was not tired, and the work gave her some 'variety'. Haymakers were normal, not deviant women, and as such helped define both identities.

As Leonore Davidoff *et al.* have said in 'Landscape with figures', the ideals of the community, the domestic and femininity came together in a particularly powerful way when set in the village, where harvest and haysel were usually situated. These ideals were reinforced through the culture of the period and were a constant judgement on the urban. The village was the perfect community, the cottage was the perfect home within that space and the rural woman the perfect female set in that domestic sphere. It should not surprise us to see these ideals repeatedly

evoked in high art and literature, as in Joseph Clark's painting *The Labourer's Welcome* (n.d.) – a perfect representation of domestic bliss and unity, which is what the middle class wanted to see in the homes of the working class. *The Labourer's Welcome* is an image of prosperity, thrift, modesty within the working class. The wife sitting mending, waiting for her husband – who we can see reflected in a mirror above her – reassures her audience that rural labourers are well off, content and respectable, as connoted by her tidy dress, and do not exhibit the discontent of the industrial poor. The cottage woman was intrinsically part of this domestic and economic idyll and a paragon of working-class femininity. The cottage woman became the ideal for all women by the 1860s, an ideal which only a few could fulfil, but which offered a particular way of seeing to the middle-class publicists and officials who went to observe the women of the fields, reinforced by social, gendered and spatial distance. Field women did not usually fit this ideal, hence their demonisation. They could only be elevated if they were strong and healthy, able to bring up physically fit children. Even then, only the new theories of evolution within the interlocking discourses of science, social investigation and race enabled this process of compensation to take place.

At the same time that the moral panic about women's field work was beginning to gain momentum in the 1860s, author and civil servant Arthur Munby went to Northumberland to carry out his own research into women 's field work and recorded his findings meticulously in his diaries. At first Munby was disappointed because he could not find the large number of bondagers he had expected. Moreover, at a distance they looked much the same as any other women fieldworkers – a telling disappointment. On his previous visits to the north of England, Munby had encountered women who not only did field and harvest work but also ploughed, and he gave these women a voice in his diaries, by questioning them about their work. One, a Mrs Blackshaw's mother-in-law, was given a guinea by a squire who was surprised to see her driving a plough in 1811 at Knutsford.[30] The other, Hester Burdon, whom he interviewed in 1862, and who used to plough regularly near Osgodby, was also given money by a shocked gentleman, after winning a ploughing race against a man in 1859. This kind of reaction by upper-class men, sudden praise through spending, is unsurprising. Most of their relationships with working-class women were bounded by cash, either as wages for legitimate labour, or payment for sexual favours. Orgasm itself was described as a form of commerce – to be spent.

But Munby noted 'there was nothing in any of these "larks", or in her manner of telling them, which implied the least immodesty of speech or act. Unconventional intercourse, free and homely, between

the sexes no doubt: but this, with a young woman who owns a shrewd wit and a strong arm may not be very dangerous! [She] was not coarsened by the work either: on the contrary …'.[31] Munby saw farm women's apparent physical strength positively, in the same way that Henley saw the bondagers' fitness as a good thing. Neither man, like Eliot, wanted rural women be 'rustic heroines … of the Dresden China kind'.[32] They both wanted working women to be 'hardy and lusty'. They glorified physical strength like Arthur Foord Hughes, and did not categorise field women as prostitutes.

It is doubtful whether Munby and Henley ever met, but it is noted in Munby's diary that he agreed wholeheartedly with Henley's perspective. On 23 February 1869 Munby spent an hour in Hansard's, Abingdon Street, looking at the evidence in the first report of the Commission established in 1867. He recorded: 'Would that I had been one of these commissioners! But the Northumberland Cmr, Mr. Henley, does full justice to those splendid lasses; the Bondagers. It is a comfort to me also, sitting here fastbound, to know that women so vigorous and so picturesque exist, and are at work, though far away.'[33] Where most observers watched the women from afar and were afraid of them, Munby and Henley waded in with interviews and quotes. They openly looked for physically strong women whom they could admire, while other authors translated their physical observations into moralising sermons. They had a different way of seeing across the distances of class, gender and location, possibly coloured by the pleasure of confession for the interviewer, rather than the interviewee. Munby – who regularly met with Barbara Bodichon, despite a distinct distaste for feminism – in particular has left us with a fine record of working women's lives as a result of this desire to scientifically *collect* working women as specimens of physical prowess, nobility through labour, toil and competition. If all the women did occasionally look the same to him, this was due to the process of homogenisation that takes place within the practice of the case study.

Munby and Henley believed that strong women bred strong children and that this was important for the future of the nation and race. The more able the women were to compete, the fitter they were. Survival of the fittest in this case meant that women might surprise their observers; for Munby and Henley this brought pleasure, where to others it brought pain. They saw the countryside as supremely healthy, as long as the closure between working women's bodies and middle-class definitions of femininity was accepted in the way that it had been earlier in the century. Both men had a nearly eugenic vision of the physical superiority of northern rural women, and this was not as exceptional a point of view as we might at first think. Both seem to have been influenced by

the new ideas of social Darwinism, which became increasingly impor-
tant in representations of the rural as empire, femininity as associated
with the race and motherhood as a social rather than biological func-
tion. Evolutionary languages, as well as the construction of respectable
working-class femininity, legitimised Munby and Henley's desire for
strong physical women; eugenic discourse informed the reports on the
opium-drenched children of East Anglia. The countryside was seen as
the repository of a healthy working class, uncorrupted by factory labour
and overcrowded urban conditions. This vision persisted and, in fact,
increased in popularity through the nineteenth century, despite the
moral panic around women's agricultural work and rural infant mortality
in the 1860s. This had been caused by the temporary inability of the
bourgeois hegemony to recuperate the field women within pastoral, as
urban social issues were projected onto the rural but was solved by the
intervention of legislative discipline and official surveillance in the form
of the Agricultural Gangs Act, which adapted the 'reality' of rural life to
fit the myth. Rude health became a national concern as the rural was
once again tamed.

NOTES

1 *All the Year Round, A Weekly Journal Conducted by Charles Dickens, With Which is Incorporated Household Words*, Dec 1866–June 1867, p. 588.
2 *Norfolk News*, 2 Nov 1867, p. 9.
3 *Quarterly Review*, 123, July–Oct 1867, p. 190.
4 *Punch, or the London Charivari*, 13 April 1867, p. 146.
5 *Punch*, 20 April 1867, p. 155.
6 *The Times*, 20 July 1867, p. 9.
7 *Ibid.*, p. 9.
8 *Quarterly Review*, 123, July–Oct. 1867. p. 174.
9 *Ibid.*, p. 175.
10 *Ibid.*, pp. 178–84.
11 *Ibid.*, pp. 187–90.
12 Robinson, E. (ed.), *The Later Poems of John Clare 1837–1864*, Oxford, 1984.
13 Eliot, G., *Adam Bede*, London, 1873, introduction Gill, S., pp. 29–39.
14 Eliot, G., 'The Natural History of German life' from *Westminster Review*, July 1856, in Byatt, A. S. (ed.), *George Eliot, Selected Essays, Poems and Other Writings*, Harmondsworth, 1990, p. 111.
15 Eliot, G., *Adam Bede*, p. 109.
16 *Ibid.*, pp. 69–70.
17 See Pearl, C., *The Girl With The Swansdown Seat*, London, 1955; Nochlin, L., *Women, Art, and Power and Other Essays*, London, 1988; Nead, L., *Myths of Sexuality: Representations of Women in Victorian Britain*, Oxford, 1988.
18 Eliot, G., *Adam Bede*, pp. 109–10.
19 Kolodny, A., *The Land Before Her*, Chapel Hill, 1984, and *The Lay of the Land*, Chapel Hill, 1985.

20 Gough, B., *Songs for British Workmen*, London, 1876, p. 10.
21 Trollope, A., *The Last Chronicle of Barset*, ii, London, 1927, 1st edn. 1867, p. 179.
22 For example see Jefferies, R., *Amaryllis at the Fair*, London, 1939, 1st edn. 1886, pp. 202, 207, 229–30, 239, 337.
23 Morgan, D. H., *Harvesters and Harvesting 1840–1900, A Study of The Rural Proletariat*, London, 1982, p. 140.
24 Brettell, R. R., and C. R., *Painters and Peasants in the Nineteenth Century*, Geneva, 1983, pp. 80–5.
25 In Allott, K. (ed.), *The Poems of Matthew Arnold*, London, 1979.
26 Howkins, A., *Reshaping Rural England, A Social History 1850–1925*, London, 1991, pp. 70–1.
27 Williams, R., *The Country and the City*, London, 1985, pp. 165–6.
28 *Ibid.*, pp. 168–81.
29 Gaskell, E., *North and South*, London, 1975, 1st edn. 1855, p. 482.
30 Munby, A. J., diaries, held at Trinity College Library, Cambridge, 1860, p. 16.
31 Munby diary, 1862, pp. 91–118.
32 Munby, A. J., *Dorothy, A Country Story in Elegiac Verse*, Boston, 1882, 1st edn., 1880, p. 218.
33 Quoted in Hudson, H., *Munby, Man of Two Worlds: The Life and Diaries of Arthur J. Munby, 1828–1910*, London, 1974, p. 266.

1 *Little Bo-Peep*,
Margaret Thompson
and William Rowe

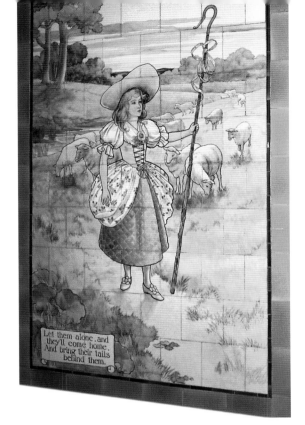

2 *Bubbles – A Cottage Scene with Children*, John Dawson Watson

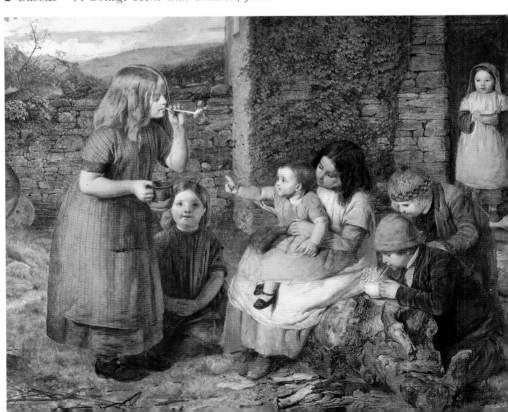

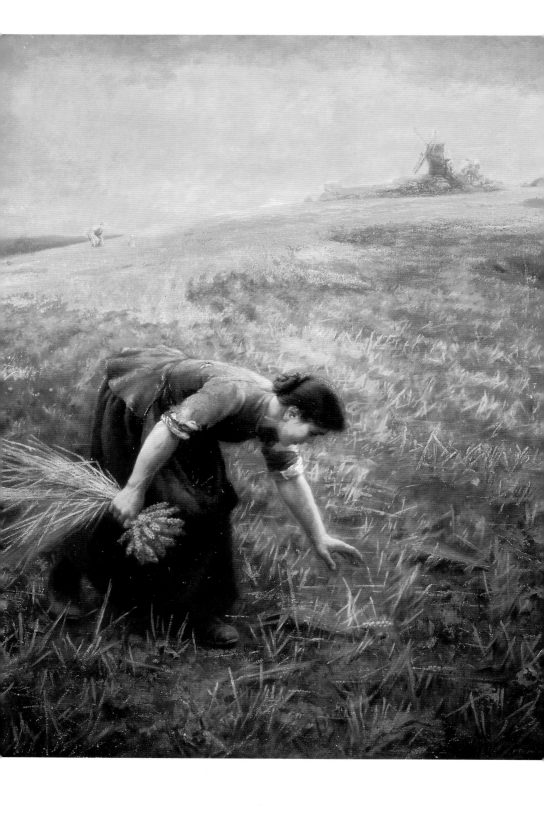

3 [*facing*] *Gleaning*, Arthur Foord Hughes

4 *Harvest Time*, George Vicat Cole (detail)

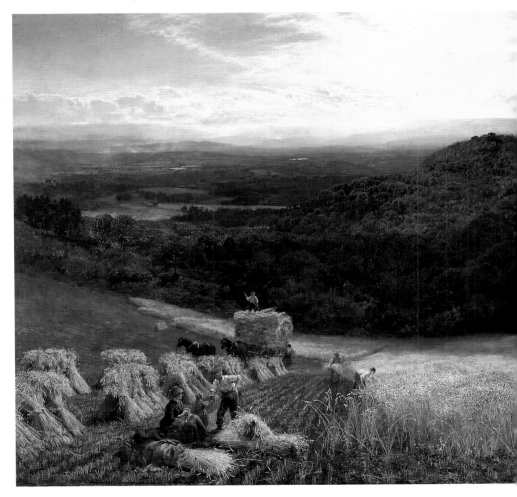

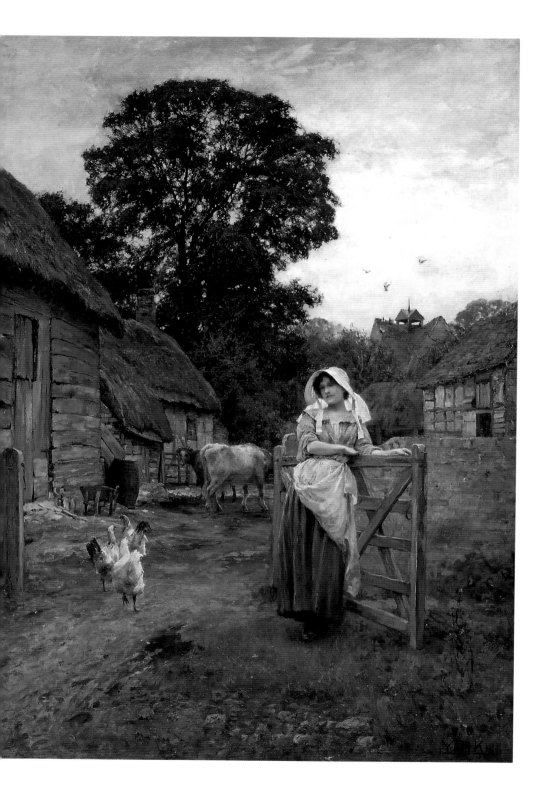

5 [*facing*] *By the Farm Gate*, Henry John Yeend King

6 *One of the Family*, F. G. Cotman

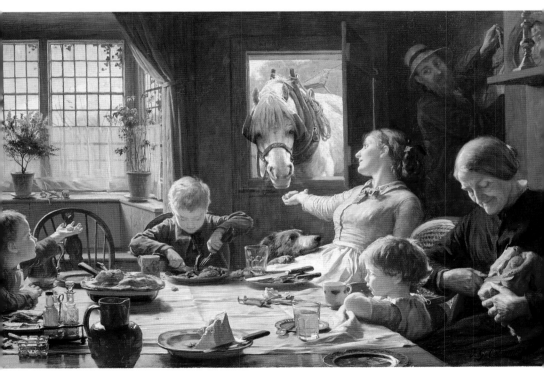

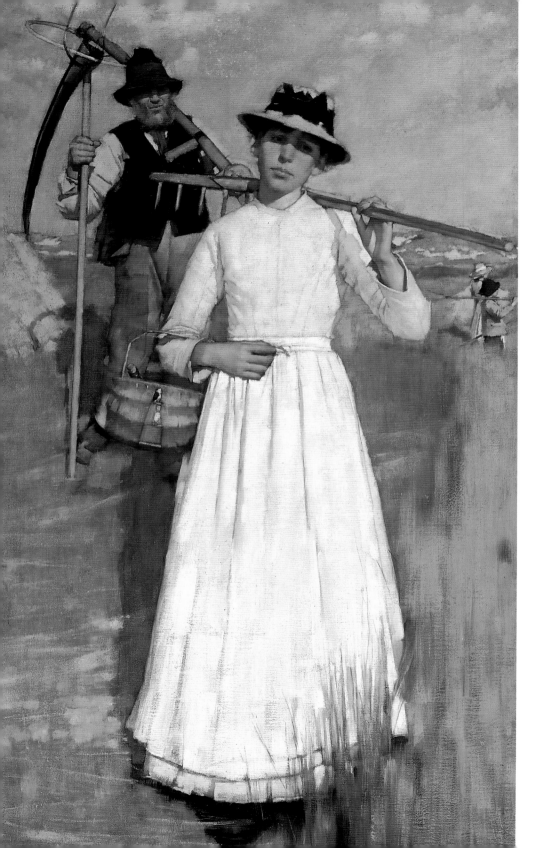

7 [*facing*] *Return of the Reapers*, Henry La Thangue

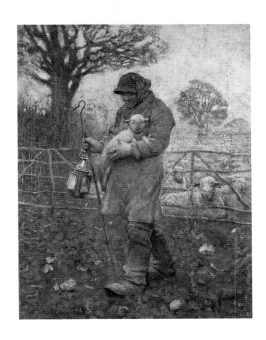

8 *Shepherd with a Lamb*,
George Clausen

9 *Milking Time*, William Mark Fisher

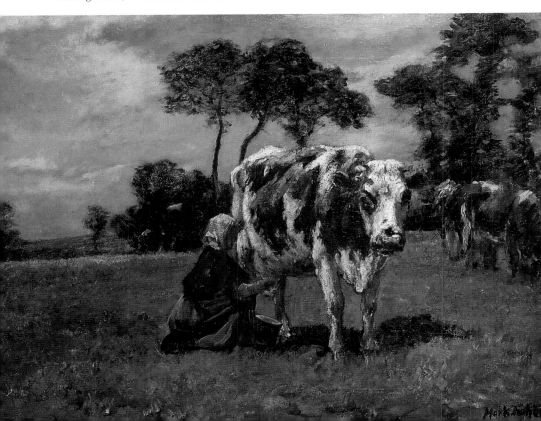

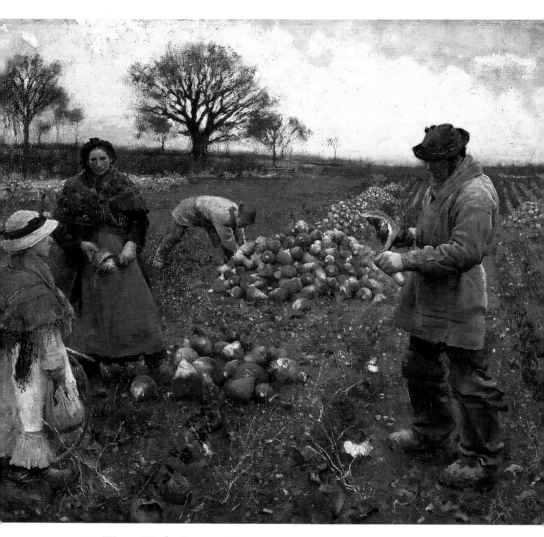

10 *Winter Work*, George Clausen

Depression

1873–1901

Neither a wise
nor a womanly thing

C. Whitehead's *Agricultural Labourers* was published in 1870 with the aim of improving conditions in the countryside by encouraging co-operation between classes. He included a whole chapter on women's work and said, 'even in these very days of the nineteenth century ... the position and condition of women is not any means what it should be ... many of them still slave and toil, and perform work altogether unsuited to their nature. ... very many perform work which hardens their hands and their feelings'.[1] Unlike Munby and Henley, he did not want women to show their labour on their bodies; strong hands 'unsexed' a woman, and removed feminine sentiment from their hearts. Whitehead, principally influenced by the debates on the gangs at the end of the 1860s, focused the full force of his attack on women's field work. 'Field work is particularly unsuited to women. ... A woman who works constantly in the fields cannot fulfil her social duties; she cannot attend properly to the wants of her husband; she cannot do her duty by her children. These are the first grand objects of a wife's care; upon the proper execution of these hinges the welfare of society.'[2]

By this time, of course, field women signified a wider social ill than mere rural poverty. They were caught up within mid-nineteenth-century constructions of femininity which had been widened to include all women, regardless of class. And women's duties had shifted within these constructions, so that by the 1870s they were supposed to serve their society and their race, not just their husbands and families. If they failed to fulfil their given role because they were distracted by paid work, then they put the wider social community at risk. Women had become agents of social change in parallel to the new construction of children as a national asset. Whitehead's aim was to spread the 'ably collated ... [and] industriously collected' evidence, in the official inquiries, to those

who would not otherwise have had access to it. In other words he, like many others at this time, was actively engaged in the dissemination and universalisation of ideologically constructed 'facts' in order to achieve 'the gradual influence of public opinion' to improve rural conditions, and therefore English society as a whole. The 'man should be the bread-winner, the sole supporter of the house'; it was vital that 'public opinion, and an average rate of higher wages ... keep women in their proper sphere'. For Whitehead and the whole of the middle class the stakes surrounding the new concept of separate spheres – a term which had first been used in the 1860s – were high.[3] And increasingly the same language could be found in working class demands for a bread-winning wage, as we began to see in Chapter 5. The effect of this 'improving' language was to elevate femininity across the classes, to create an ever-more refined and universalised construction of gender, in which the categories of 'wife' and 'mother' became of paramount importance in the maintenance of social stability and order.

In the 1870s supporters of the National Agricultural Labourers' Union mirrored earlier concerns that married women should to be able to fulfil their domestic and 'social' duties, as part of the definition of working-class respectability. Whitehead was not the only man to write a critique of rural social relations based on the evidence and ideology that informed the official texts. George Mitchell, a NALU organiser, whose credentials within the labour movement were impeccable, very clearly used the women's work to prove that rural conditions were genuinely bad.[4] Mitchell adopted the pseudonym 'One from the Plough', which, like Somerville's 'One Who Has Whistled at the Plough', highlighted his masculine working-class identity and gave him the authority of experience required by his target audience, the rural upper working class. George Mitchell's speech to a union meeting in Somerset in June 1873 had established his views on the subject of women's paid work. He argued for a male bread-winning wage so that women would not have to go to the fields 'three weeks after their confinement' for 7d. a day, and used evidence from the government reports to link immorality to women's employment.[5] In his semi-autobiographical *The Skeleton At The Plough*, published in 1874, Mitchell continued to accept the representations of rural working women found in the official texts, and to rework them through radical discourse. The title of his book is also worth remark as it connoted, especially in comparison to Somerville's book, an image of death stalking Old England. Labourers were now dying at their work, rather than whistling – an image which is at once full of pathos, and which would cause alarm in the context of wider fears about the state of the nation and the race. By this time economic competition

with Europe and the United States was growing, older industries in Britain and agriculture itself were showing declining profits, and as a result there was an increased concern with national efficiency, including physical efficiency and changes in the division of labour. There was not a universal slump. Finance capital was growing and wealth became increasingly concentrated in the south of England, which prompted new urban bourgeois developments and acted as a spur to the growth of a new consumer industry. Economic pressure on the domestic market did add to the expansion of empire, however, while the newly-mature working class began to look for its own representatives in Parliament, both of which impulses contributed to a restructuring of cultural, social and political relations. This was a time of flux. The boundaries of masculinity and femininity were subject to debate as new, often radical, discourses like feminism proliferated.

Mitchell believed that respectable rural women were now exceptions, somehow divinely saved from the 'flood of degradation and demoralization around them.' But Mitchell's main complaint was that under the bondage system 'if she be an amazon … the master will obtain as good as two men's labour for 2s. a day'.[6] Mitchell saw women – if unfeminine enough to be un-English 'amazons' – as being capable of undercutting men's wages and taking their jobs. Women's strength was not in itself bad, but their employment was. This was a view held by most unions, not just the NALU; working-class respectability, the breadwinning wage, were key components within the discourse of the labour movement. What is unusual within rural radicalism is that these values were couched in a version of the language of national efficiency that separated the rural working class from their urban counterparts.

Francis George Heath, who wrote *The English Peasantry* in the same year as Mitchell's *Skeleton*, explicitly aimed, like Whitehead, to make the evidence in the official inquiries more widely available to the public, and more readable. He used his own empirical evidence, based on his own objective research, undertaken as a journalist in the West Country, to give extra authority to his book. For Heath, like Whitehead, his subject – in this case rural depopulation – was one of 'national importance'. Again, the title is noteworthy. In Heath's view the rural, the mainstay of Englishness and the English race, was beginning to vanish, and this was far more important than the individual suffering of men, women and children. He used the pastoral term 'peasantry' as a way of highlighting the fact that the rural working class belonged to a specific, identifiable category different from the urban proletariat. He collected his evidence, his facts and information as a colonial explorer might have done, in a way which belonged to the imperial, patriotic, scientific,

rational and 'masterly' masculinity of the day, highlighting the image of the rural working class as somehow distinct and separate from the rest of the mass.[7] Within this discourse, Heath used women's agricultural work as a sign of rural poverty. He expected the level of women's labour to fall as wages rose, even though at the time of writing he presented their work as vital to their family's income.[8]

'Where mothers of families are employed in agricultural labour, the work has of course to be performed to the almost total neglect of domestic duties. The employment too of young girls in agricultural work has been the fruitful cause of immorality.'[9] Women were again represented as a barometer of rural working-class oppression and essentially as wives and mothers. Though doing their duty to some extent by helping raise the family wage, their sphere was ultimately the home, and their domestic duties were no longer their own business.

In his later book, *Peasant Life in the West of England* (1880), Heath reiterated the representations he had used before and the use of pastoral and racial languages by which he defined the rural poor as distinct from the city poor. He used the 1843 report this time to say that the rural idyll was a myth; the labourer's wife and children went out to work, they did not stay 'at home in rose-bound cottages.' He went on to describe how the children were left untended and how husbands turned to the local pub as a result of the women's bad housekeeping. Men were still drunk, while women and children were still victims in this reading of the official text. The Royal Commission on the Employment of Women in Agriculture 1867–70 was then employed by Heath to show how little things had improved. In conclusion he blamed women's work for the poor mental state of the rural working class.[10]

Heath's reading of the reports represented women's work as both cause and effect of poor rural conditions and depopulation, which with hindsight showed that the rural poor had 'lived and toiled almost ... in a world apart'. For him, good women were neatly, but not showily dressed, thrifty managers of the household, caring of their children's appearance and education, religious, sober, and literate. Heath's division of country and city helped define the rural through opposition, just as middle-class feminists helped define femininity through the use, even the inversion, of dominant ideology. His definition of the rural was of a separate land that was remote, its people historically 'uncared for and forgotten', which was only just becoming civilised as social reformers began to explore its depths, and as the state began to legislate for it.[11] For the urban working and middle classes the rural was a mini-empire within the borders of England, which had to be explored.

It was not all doom and gloom within the construction of the

rural. Like the middle class at this time, labourers had an equally compensatory image of pastoral and rural femininity to offer their wives and daughters. Benjamin Gough's 'Katey Lee', published in *Songs for British Workmen* (1876), clearly and erotically depicts a man working in the harvest field, falling in love with a woman labouring beside him:

> Out at harvest, reaping,
> At Hobb's, on the weald,
> Quick stroke with sickle keeping,
> Like others in the field,
> I couldn't help a-minding
> One lass that followed me,
> My corn-sheaves nimbly binding,
> And that was Katey Lee.
>
> Soon I was in a pickle,
> With feelings new and strange;
> I couldn't work my sickle,
> Or understand the change.
> And when Katey overtook me,
> Bright, beautiful, and free
> A sudden tremor shook me,
> And all through Katey Lee.
>
> ...
>
> That night I lay a dreaming,
> Such dreams as fancy weaves;
> Katey's eyes were sweetly smiling
> As she was binding sheaves ...
>
> ...
>
> So I popped the question – stating
> All my hopes and fears.
> My Katey listened, blushing,
> But lisped consent to me;
> And while the tears were gushing
> I kissed my Katey Lee.
>
> ...
>
> Ten years and more have vanished,
> Since that my brightest day;
> And daily love has banished
> And driven care and strife away.
> Six girls and boys rejoicing,
> Ring out their mirth and glee;
> I shall never leave off voicing
> The praise of Katey Lee.[12]

Katey Lee, like the Northumbrian bondagers, is seductively beautiful while at work, to the extent that she emasculates her observer by making him fall ecstatically in love. But Katey Lee is also a perfect woman, so passive and silent that she can barely articulate her consent to marriage, who as a good wife and mother is able to rear a bevy of happy, healthy children. Within the preferred reading of the poem Katey Lee is a stereotypical representation of working-class respectability. She is industrious, a good worker while single, but gives up her independence to devote herself to her family. She is all that is light, bright and good. The representation of this woman is complex, though, and gives rise to alternative meanings. She, like other representations of women, is not wholly determined by her author's intent. She is sexual, alluring and therefore has the power to corrupt or bewitch, to make her observer shudder in pleasure, stop work and fantasise about her all night; whether good or bad she could disempower her man, so that masculinity is defined as subject to female sexuality in this reading. This ambiguity reflected the wider division or opposition within the construction of femininity, of women as virgins and whores. Her borderland existence in the public space of the field as she works under the supervision of her community is also emphasised by her transitional state between girlhood, connoted by her lisping speech, and her womanhood, denoted by her work. Finally, Katey Lee also exists at the intersection of two powerful discourses, pastoral and femininity, which reinforce each other so that her apparent ambiguity is resolved through elevation, rather than inversion, which equally enables her husband's masculinity to be recuperated. He becomes a successful husband and father, in a position to judge and to voice his praise for his wife. This kind resolution was not always feasible, as the NALU was all too aware.

The National Agricultural Labourer's Union was established in 1872 by Joseph Arch. It was the first national union for farm workers, despite some local attempts at organisation in the 1850s. From 1872 until 1874 it was very successful, but having reached a membership of 16,000, or 12 per cent of male farm labourers, in 1874, numbers declined to around 5 per cent by 1891. There were regional variations in this, and a revival in 1889, but in 1896 it was brought to a close. Officially, as in many unions, women were not permitted to be members, but they and their work were still widely discussed in *The Labourers' Union Chronicle*, and women did have a political role in the countryside as we will see[13] The NALU, unsurprisingly, argued that women should not work in agriculture as it took them away from their homes and children, kept men's wages down and reduced the number of jobs available to male labourers. We can see this response to women's paid work in a speech in June 1873,

headlined 'A Monster Meeting in Somersetshire', by Joseph Arch, who told labourers to demand higher wages so that their wives could stay at home, at which point England would see them 'living and acting like men'. Masculinity and national identity were threatened by women's work as much as femininity in this case. Mr Smith, from Gloucester, similarly said that labourers should keep their wives at home: 'A woman's place was in her home and her proper work was to keep it comfortable and happy'. If she did not 'the consequence was a row'. Smith, using an old argument, told the farmers to send their own wives and daughters out, if they really needed women in the fields. Mr Ball, from Lincolnshire, said that field work stopped girls learning their domestic skills, so there were no good wives for the labourers to marry. During his speech several women reputedly spoke up: 'We won't do it no more sir !' He commented that he hoped they would not, for really they lost money by working.[14]

Each comment was typical of the union's ideas on women, reiterated throughout its life. There was, in fact, a union campaign in August 1873 against women's work in Northumberland, a county officially supposed to provide good conditions for all labourers. The delegate from Newcastle, Mr W. Gardner said of it:

> dung-spreading and such like work unsexes a woman; it is degrading … We ask you, the women of Northumberland, to respect yourselves and keep your native delicacy intact, unsullied and pure. You may be free if you will, and you may free your husbands, brothers and sweethearts; also, you will gain additional respect and money by so doing, for, if the women break away from the bondage system next hiring day, the supply of labour will be short in proportion to the demand, and the wages will advance in consequence. Be determined then ye men and women to unite and break your bonds.[15]

Using the discourses of race, domesticity, and Englishness as freedom, Gardner argued that women were actively corrupted, and therefore 'unsexed' and un-civilised, by their paid work. Though Gardner believed English women should have some spirit, and urged the women to end 'this liberty-killing bondage system' through an appeal to their economic needs, he still assumed they were inverted and corrupted by it when he was not speaking to them directly. Later in the month he was reported as arguing from the more usual footing that the men should keep their wives and daughters at home. *The Labourers' Union Chronicle* similarly celebrated a vision of the day 'when clothing clubs will be things of the past, because each labourer's wife, being no longer a drudge in the fields, but a managing, economical housewife, will be enabled by

her husband's earnings to provide all that is necessary in clothing and otherwise for decency and comfort'.[16] According to *The Labourers' Union Chronicle*, women's paid work was one of the most 'disgraceful things in this country'.[17] These extracts show that there was much more at stake for the NALU than higher wages and better working conditions. The constant reference to national and racial discourses of freedom, civilisation and the welfare of society by the NALU worked to support their demands, but also constructed new definitions of gender, class and race. Through the development of working-class respectability, the gendered radical economic discourse of a bread-winning wage, and new constructions of national identity, especially those linked to Englishness as represented through rural well-being and freedom, working women were constructed as a threat to English labouring men's jobs, wages, and liberty, in other words, as a threat to their masculinity.

As noted at the start of this chapter, masculinity was as much in flux as femininity at this time, and was constantly subject to debate. In the 1850s masculinity had begun to take on connotations of the muscular Christianity espoused in Charles Kingsley's texts; by the 1890s it had incorporated notions of leadership, courage, honour, respect for feminine women, 'team spirit', nation, the free and equal individual within the market – whose character was formed through social Darwinist values of struggle – and heterosexuality. This process of reconstruction took place within a variety of discourses and social practices. For the middle class this included the public school and the sciences which helped define 'normal' and 'deviant' male sexualities. For the working class new social venues like pubs, clubs and volunteer forces such as the territorial army, elementary schools where children were regularly drilled, the new youth movement, designed to discipline the 'street Arab' – a new category within the representation of childhood – and boys' papers all contributed to the construction of manhood.[18] The NALU and other unions were part of this process.

The construction of a new working-class masculinity and femininity involved the radical reworking and intersection of dominant ideologies, and at times the NALU appeared to be adhering to middle-class values in the way that working-class women seemed to do when interviewed. But there was a clear divergence from bourgeois constructions of gender difference when women were asked to take effective political action by withdrawing their labour on their own account. There was also a clear recognition that women had some economic worth, if not skill. It is also important to recognise here that women did take political action in their own right, often to the horror of the NALU. The ambiguous situation of rural women in this case was very

similar to those who worked in industry. Mine women never entered a union in the nineteenth century, though they campaigned with their men on several occasions and took unofficial action against employers to raise their own wages.[19] But rural women were particularly isolated, unless they worked in a gang, so their opportunities to unionise were even more restricted than these of women in the towns.

We should first of all be clear that agricultural women, as well as men, were involved in direct political activity before the establishment of the national union in the 1870s. Women day labourers went on strike in Oxfordshire in May 1867 over their wages. The men's wages had risen by 1s. a week and they did not see why theirs should not go up by the same amount. In support of their cause, which they won, they issued an articulate account of their demands. These women were represented by *The Norfolk News* on 11 May 1867 in patronisingly ironic language as 'the "gentler" sex' and as 'ladies'. Their political assertiveness doubly damned them; they were neither gentle nor ladies. They therefore lost all pretence to femininity and respectability. But their dispute was not widely reported, thanks to the ongoing debate about the gangs at the time; indeed the need to show that labouring women were not ladylike may well have informed *The Norfolk News*'s decision to run the story as an implicit critique of official observers who were trying to protect the sensibilities of poor labouring women. The women themselves recognised this issue in their 'manifesto', which criticised complaints about ganging while they were being just as badly exploited.[20] They used the languages employed to denounce the gang women within their own discourse. They did not want paternalistic protection, they wanted higher wages: 'Farmers may talk at their monthly meetings about labour being well remunerated; conservative journals may comment on, and lament over, the evils of the "gang system" practised in the fens of Lincolnshire; but will the public believe them? Is 1s. 6d per day a fair remuneration for a woman to toil in the fields and unsex herself?'[21]

The paper went on to note that women in neighbouring villages were also intending to strike.[22] In May 1873 *The Fife Herald* reported that several women field-workers were on strike over wages. They were paid 1s. 2d., the average wage for that area, but wanted a raise.[23] Women also went on strike over that year's harvest payments at Haydon Bridge in Northumberland.[24] And later, in 1894, *The Eastern Weekly Leader* covered the involvement of women in a dispute at St Faiths in Norfolk where women led men in a demonstration of rough music and violence, one of several similar events in which women played a central part that year.[25] There is also evidence to show that rural women were concerned with wider issues than pay.

We have already seen how labouring women's memoirs and testimonies reveal the development of alternative respectabilities and an emphasis on working conditions in the first half of the nineteenth century, and the same is true if we look at their testimony after the 1870s. As Jenny Kitteringham says, this can help explain the criticism of them from above,[26] but it also shows how working-class women's concerns and actions could diverge from those working-class men. Some country women, like Mrs Burrows, the woman who wrote of her work in a gang as an eight-year-old, were members of the Women's Co-operative Guild. Hannah Mitchell, the prominent suffragist, came from a farm in rural Derbyshire and Susan Silvester's mother was 'a keen suffragette' in Leicestershire.[27] Both Mary Luty and Gladys Otterspoor resented the advantages that the boys and men of the family had, even if they did not act on this perception in the way that Hannah Mitchell had.[28] Lucretia Cromwell believed that country women had not been involved in the campaign for suffrage in the Fens. However, she remembered: 'We liked to know women had got the voting. That the women were considered as fine as were the men. They could see more really, being women, couldn't they?'[29] The feminist campaigner Margaret Bondfield also came from the countryside.[30]

Rural women did not only interpret their experiences through class, but also through an awareness of the power relations between the sexes. Women like Lucretia Cromwell gave women gendered authority, while others became actively involved in feminist campaigns. Most of this political action and thought has remained unexplored by historians, who have focused on urban unrest and organisations, or male trade unions, to the exclusion of countrywomen's involvement in either class- or gender-based action.

Patricia Hollis, who is one of the few historians to have looked at rural women's political action, concentrates on women who became Poor Law guardians or were elected to local government.[31] Much of this silence can be seen to be due to the problematic relationship between poor labouring women and the NALU. Because they could not belong to the union, any action women took remained very largely hidden. Only on one occasion was their resistance, on behalf of their men, widely discussed. This was in 1873, during the Chipping Norton case, which provides a valuable example of the response of the public to women as political actors. It also reveals the complex relationship between labouring women, working-class men, the NALU and middle-class feminists.

In mid-May 1873 thirty or so women from Ascott in Oxfordshire attempted to stop two men acting as scabs in a strike by their husbands.

A policeman had finally been called to protect the labourers while they worked and sixteen of the women were convicted, without defence, for threatening and assaulting the men with sticks and abusive language. The women were sentenced to hard labour under the Criminal Law Amendment Act for 'having used violence, threats and intimidation to prevent ... [two] men from working'. A riot followed their conviction.[32] This resulted in a widespread outcry, because the public believed that women, even working-class women, should not have been treated so harshly.[33] The real issue here was the crossing of the boundaries of class, femininity and pastoral. *The Times* wrote a special report on the case and published a letter from the union on it. Local papers, like *The Hexham Courant*, used the case to criticise the employment of clergymen as magistrates; *The North of England Farmer* and *The Eastern Weekly Press* both reported it and used an interview with the women from the *Daily News*. *The Englishwoman's Review* discussed replies to the parliamentary questions.

As their husbands were agricultural labourers, it seems reasonable to suppose that these women had themselves undertaken casual farm work at some point in their lives, but this was never referred to in the press or by Parliament. Rather, the femininity of the women involved was constantly emphasised by the repeated descriptions of them as wives and mothers: 'Two of the unfortunate prisoners had infants at the breast.' The idea that they could really have been a threat to the two men was also ridiculed: 'though very abusive and threatening language was used, the fright and peril which a few girls and middle aged women had occasioned to the two stalwart labourers could not have been very serious'.[34] The *North of England Farmer* represented all women as naturally garrulous and the men involved, both husbands and scabs, as cowards.[35] Clearly, the dominant definitions of masculinity and femininity were called into question by the episode, as were the supposed organic class relations in the countryside and wider perceptions of the rural as a haven of peace, solitude and harmony, which were already under threat from the agricultural depression and fears of racial degeneration caused by the exodus to the cities.

The case was raised in the Commons as a question on criminal law, in response to the article of the 23 May in *The Times*. Mr Mundella, who spoke of 'sixteen women, *wives* of agricultural labourers' [my emphasis], asked the Secretary of State for the Home Department, Mr Bruce, if he could intervene in the case. The simple reply was that the magistrates had been written to. Their answer came in the form of a local newspaper cutting, which was said to cover all the facts of the incident.[36] The cutting was one of the few accounts to emphasise the

violence of the women, who threatened the men physically and morally. They 'were armed with sticks', 'waylaid' the men, were 'threatening [that] ... they would beat them', then 'hustled them, pushed them into a hedge, and declared they would duck them'; later they 'asked them [the two men] to go to the public house to have beer,' and 'tried to get them to join the union'.[37] This account shows that the women's action came from the tradition of rough music, singing and other forms of disorder aimed at demonstrating disapproval, in which women and children in the countryside participated throughout the nineteenth century, often in connection with union activity, but it contravened respectable femininity in the same way as women's field work.

Bruce then emphasised that the women had broken the law, even if they did not realise that they had done so. He 'could hardly believe that their ignorance was so barbarous as to lead them to suppose that any person, whether man or woman, had the right to interfere with men in that way and endeavour ... to prevent them from working.' Bruce believed that if men had done this to women the outcry would have been as bad; men and women had to be treated equally in criminal law. However, he went on to say that their punishment had been excessive and that as a result the public had become too sympathetic to women who were otherwise guilty. The magistrates would be chastised.[38]

The Ascott women had transgressed gender boundaries and inverted femininity on several levels. But what is particularly interesting is that the incident was discussed through the language of free individualism, men's right to sell their labour was legally enshrined, and the acceptance within penal discourse that women were 'persons' who could transgress the law. Of course, the dominant definition of femininity did not allow women to be represented as threatening, and the level of punishment meted out to the Ascott women was unacceptable exactly because of this. It resulted in a public condemnation of the conviction, despite the women's transgression of the law, as 'persons', and of gender, as women with babies at their breasts. There was widespread agreement on this, so that MPs and the mainstream, farming and radical press converged in their criticism and definition of working-class respectability, though each belonged to a different discourse.

The radical *Daily News* provided one of the most sympathetic views of the Ascott women, and highlights the issues of class and national identity raised by the case. When they were released the paper interviewed four of them: 'They would, in appearance and in behaviour be taken as good specimens of lower middle class Englishwomen. ... I think the easy going British public would be a trifle amazed if they could see the description of women who have been receiving felon's treatment

for an action ... [without] malicious [intent].'³⁹ *The Daily News* was at
pains to emphasise how innocent the whole event had been, how good
the women were really and how British justice had failed them, so that
the public should be shocked. The women's story gave evidence of this,
as did the representation of them as respectable 'lower middle class
Englishwomen'; they fulfilled the highest ideal of femininity. They sud-
denly became paragons of English womanhood.

In their account, the women said no weapons or strong words had
been used, and that the two strike breakers had agreed not to work after
the situation had been carefully explained to them. They had even
laughed together while waiting for the employer to return. However, the
farmer's wife called for a constable, who then escorted the men to the
field while the women talked to him. They felt the sixteen, out of
around twenty-one women involved, had been chosen unfairly for trial,
and emphasised that the riot afterwards had been caused by the sense of
outrage felt by the local labourers. This story, it was stressed, was not told
in a 'vindictive spirit [but] clearly, openly and with a variety of corrobo-
rative details'.⁴⁰ Again, the women were represented as respectably
feminine, educated and English. The paper denied that the women had
really stepped over the bounds of gender, not by redefining femininity,
but by stressing that the women had not been violent or intimidating
during the event, and that now they were honest, articulate and forgiv-
ing.

The Labourers' Union Chronicle reported on the Ascott women in
much the same way as *The Daily News*. The women were represented as
respectably dressed, well-behaved and of good character; it also denied
that they had ever acted violently. Their support of a just cause was
emphasised and they were used within the wider debate about justice in
the countryside as signs of resistance to the practices of penal discourse.
But most significantly, the Ascott women were described as
'martyrs.'⁴¹ The use of this word is important because a martyr is passive
in the face of hostility, though the result of their passivity and resistance
is powerful: they are blessed by God in a just cause. This aspect of self-
sacrifice was seen as a supremely feminine quality. The women of Ascott
can be read as powerful figures, but they were represented as not seeking
that power. They were said to be defending their husbands and following
their conscience, which was acceptable, even praiseworthy, within the
bounds of respectability.

The Ascott women's action, otherwise unfeminine because it was
directly political and public, was therefore rescued and recuperated by
the radical press. Both the mainstream and radical media accepted the
women through the emphasis on their femininity. But this solution was

as problematic and inherently unstable for the union as it was for the remainder of the press and Parliament. When the women were presented with 5 pounds each at a meeting to celebrate their release, Mr Attenborough, co-opted onto the union's executive committee, said:

> he had at the outset to give expression to the conviction which might be unpleasant to some, but which duty obliged him to utter, viz. that neither he, nor the leaders of the Union thought that the sixteen women had done either a wise or a womanly thing in attempting to influence the two lads ... they would have been far better at home minding their families, and he trusted that the lesson they had received would not be lost upon them. He believed, however, that they had no idea they were doing an illegal thing, that they did not know of the law they were accused of breaking, and had only intended a piece of by-play.[42]

Attenborough also hoped that they would not spend the money at the pub.[43] He patronised the women's action in order to disempower it. Women's place was in the home looking after their children, not out fighting men who broke strikes. And even if they did the latter, they could not be expected to know the law, nor would they intend to take serious action. Further, as unwomanly women, they were also potentially immoral enough to drink away their compensation.

We can put this reaction to the women's protest in the context not just of the cultural hegemony or penal discourse, but also the contemporary challenges to definitions of femininity by feminists. 'Womanliness' was at a premium due to this, and as John Goode has argued, it was women's only marketable commodity. Womanhood, or femininity, had an economic, not just ideological definition. Marriage was women's only legitimate mode of production, therefore they needed to be able to sell themselves within this, not their labour. The phrase neither 'a wise nor a womanly thing' can be interpreted as meaning neither good masculine (wise) nor appropriately feminine (womanly). The women had fallen between two ideological stools.[44] Because similar definitions of femininity were used by the union and the middle class, both the radical and mainstream press had the same problems in dealing with what these women had done. *The Labourers' Union Chronicle* was more sympathetic only because it was supposed to believe in the cause the women had fought for. The women had taken political action that the union had to support, but in trying to define working-class respectability, it could not fully condone their behaviour because they were women.

The Englishwoman's Review found the case problematic in a different way. It, like the rest of the press, stressed the femininity of the

women as wives and mothers and then provided a standard account of the event. The evidence used in Parliament that the women had sticks and 'used such threats as to place the men in bodily fear', was accepted. The journal believed the women were guilty. However, it also thought that 'the punishment has been disproportionate to the offence'.[45] At this point the parliamentary discussion of the issue was taken up. On Bruce's speech the *Review* said: 'There seems to be some want of logic in the right honourable gentleman's answer. Without a doubt seventeen, or as some say, thirty, women could use intimidation towards only two men; but if, as he suggests, we alter the case, and figure to ourselves seventeen men using intimidation to two women, the offence would have been altogether of a deeper character'.[46]

The *Review* recognised that women could threaten men, which most of the other papers tried deny through the process of recuperation, but it also represented men as more threatening to women because it recognised the inherently gendered power relations of the day. The case still presented a problem for the Langham Place feminists, though. The publication did not discuss the reason for the women's action, which was class, not gender based, and in the end even seemed unsure as to whether an injustice had really been done. 'We are no advocates for women, if they are guilty, being let off because they are women, but it is needful to ascertain that the punishment has not been greater than the offence.'[47] The *Review* was almost as threatened by the women's actions as the farmer's wife who had called the police.

Much of this ambiguity was due to the distancing effect of class. The *Review* felt much more able to deal with the gender politics of rural life when tackling issues raised by farmers. The journal noted that one woman had written to *The Field* in 1871 to complain that she was not allowed the benefits of joining the Royal Agricultural Society of England – (RASE) because she was a woman, and it was quite able to criticise this, based on the ideology of liberal individualism. The *Review* also argued that farmers' widows be allowed to keep their husbands' property to protect themselves from poverty. Middle-class farming women suffered discrimination in law and practice and the journal was determined to support their cause. It began to list the prizes won by women for farming at agricultural shows, and Jessie Boucherett campaigned steadily to get more women to take up farming as a career. The closest that the journal came to fighting for rural working-class women's rights after the 1860s was its demand in 1881 that dairying be professionalised through official dairy schools, and its belief that only women should be allowed to do this work.

At this point farming was represented by *The Englishwoman's*

Review as something that middle-class, not working-class, women should know about; though it did suggest that women farmers ought to know of and be able to carry out all the heavy, manual tasks on a farm, before they began to manage it. Even the call to professionalise dairying was part of the journal's wider campaign to expand women's involvement in skilled trades, and to increase their access to specialised education.[48] This focused on middle-class women's need for respectable employment, and therefore ignored the need of working-class women for paid work, in jobs which were seen as 'unskilled', especially after the restriction of their employment by the Agricultural Gangs Act. There was a shift in focus away from the rights of the socially distant working-class female labourer to the needs of the wealthy and lower middle-class woman. The Ascott women presented the *Review* with something of a dilemma.

Because the liberal and desperately respectable *Review* could not advocate breaking the law and did not believe in strikes, its representation of the Ascott women, the event, the crime and the punishment became ambivalent. The different power relations between men and women were emphasised in the journal, but to a certain extent it also reinforced dominant definitions of gender. Its resolution, a reasoned effort to say that women should be legally punished, but that this seemed to have been over-done because women were inherently less threatening than men, oscillated between a radical support for the women as women who had made a stand, and the need to maintain respectability in order to preserve a public voice. This predicament was constant throughout the journal's existence and was exacerbated by the issue of class. Its answer to this gap, which, like *The Daily News,* was to reconstruct the women as unthreatening, only succeeded in further confusion of the issue.

The Chipping Norton case highlights the intersection of wider concerns connected with the clash between middle-class and working-class respectability, challenges to the dominant discourse of femininity as passive and apolitical, and the destruction of pastoral and English liberty and justice. The supremely problematic nature of these women and their action can be seen in the ambiguous reporting of the case, where each of the identities offered remained inherently unstable. If the women were deserving of the punishment meted out to them, then they denied the universality of passive womanhood and rural contentment; if they had acted rationally, like middle-class women, then English law was unjust. Above all, surely a group of mere women could not have threatened two stalwart English labourers.

The NALU had a particular problem with the Ascott women centred on its own definition of respectability, which it used to legit-

imise its wage demands. It appealed to women's solidarity by asking them to withdraw their labour in Northumberland, and it asked them to persuade their men to join the union when they could not. One woman did so, and encouraged her husband to become branch secretary; she did all the real campaigning through him, while she claimed that she was just helping.[49] But this was the exception, not the rule. More typically, in 1891 Norfolk women were praised for making a tea that 'reflected great credit upon the ladies who prepared it.'[50] It was far better that rural women sustain their men and families through domesticity, than that they emerge from their homes and threaten men's jobs, wages and masculinity. The Ascott women had managed to show their solidarity with the union, had acted in support of their husbands and sweethearts as asked, but had stepped over the mark, so that the union both had to praise them and warn them that they had endangered their only valuable commodity – their respectability and their womanhood. It would not stand for this again.

NOTES

1 Whitehead, C., *Agricultural Labourers*, London, 1870, pp. iii, 48–9.
2 *Ibid.*, pp. 50–1.
3 *Ibid.*, pp. 52–3, 73.
4 Mitchell, G., *The Skeleton at the Plough, Or the Poor Farm Labourers of the West; with the Autobiography and Reminiscences of George Mitchell, 'One from the Plough,'* London, 1874, pp. 44, 62–9.
5 *Labourer's Union Chronicle*, 28 June 1873, p. 4.
6 Mitchell, *The Skeleton at the Plough*, pp. 64, 47.
7 Bristow, J., *Empire Boys: Adventures in a Man's World*, London, 1991, pp. 38–41.
8 Heath, F. G., *The English Peasantry*, London, 1874, pp. vii–x, 259–64.
9 *Ibid.*, p. 264.
10 Heath, F. G., *Peasant Life in the West of England*, London, 1880, pp. 39–43, 63.
11 *Ibid.*, pp. 296–302, 376–9, 386.
12 Gough, B., *Songs for British Workmen*, London, 1876.
13 Howkins, A., *Reshaping Rural England: A Social History 1850–1925*, London, 1991, pp. 185–92.
14 *Labourer's Union Chronicle*, 28 June 1873, pp. 4–5; 16 Aug. 1873, p. 7.
15 *Ibid.*, 16 Aug 1873, p. 7.
16 *Ibid.*, 23 Aug 1873, p. 6; 20 Sept 1873, p. 7; 27 Sept 1873, p. 7.
17 Seccombe, W., 'Patriarchy stabilized: the construction of the male breadwinner wage norm in nineteenth century Britain' in *Social History*, 11, 1986, pp. 54–6, 61–74.
18 See J. Bristow, *Empire Boys: Adventures in a Man's World* for a thoroughgoing discussion of this area; see also H. Cunningham, *The Children of the Poor – Representations of Childhood since the Seventeenth Century*, London 1991.
19 John, A., *By the Sweat of their Brow, Women Workers at Victorian Coal Mines*, London, 1984, pp. 124–6.
20 *Norfolk News*, 11 May 1867, p. 7.

21 *Ibid.*, p. 7.
22 *Ibid.*, p. 7.
23 *Fife Herald*, 22 May 1873, p. 3.
24 Howkins, A., *Reshaping Rural England, A Social History 1850–1925*, London, 1991, p. 190.
25 *The Eastern Weekly Leader*, 27 Oct 1894; Howkins, A., *Poor Labouring Men, Rural Radicalism in Norfolk 1870–1923*, London, 1985, pp. 98–9.
26 Kitteringham, J., 'Country work girls in nineteenth century England' in Samuel, R. (ed.), *Village Life and Labour*, London, 1975, p. 77.
27 Silvester, S., *In A World That Has Gone*, Leicester, 1968, p. 10.
28 Luty, M., *A Penniless Globe Trotter*, Accrington, 1937, p. 35; Chamberlain, M., *Fenwomen, A Portrait of Women in an English Village*, London, 1975, pp. 34–6; Mitchell, G. (ed.), *The Hard Way Up: The Autobiography of Hannah Mitchell, Suffragette and Rebel*, London, 1968, p. 43.
29 Chamberlain, *Fenwomen*, p. 132.
30 Godwin, A., 'Early years in the trade unions' in Middleton, L. (ed.), *Women in the Labour Movement, the British Experience*, London, 1977, pp. 97, 62.
31 Hollis, P., *Ladies Elect, Women in English Local Government 1865–1914*, Oxford, 1987.
32 *Hansard*, ccxvi, May–July 1873, pp. 548–9.
33 *The Times*, 23 May 1873, p. 5.
34 *The Times*, 26 May 1873, p. 12.
35 *The North of England Farmer and Northern Counties Gazette*, 31 May 1873, p. 344.
36 *Hansard*, ccxvi, May–July 1873, pp. 429, 548.
37 *Ibid.*, p. 548.
38 *Ibid.*, *pp.* 549–50.
39 Quoted in the *The Eastern Weekly Press*, 31 May 1873, p. 1.
40 *Ibid.*, p. 1.
41 *Labourer's Union Chronicle*, 7 June 1873, p. 2.
42 *Ibid.*, 28 June 1873, p. 6.
43 *Ibid*, 28 June 1873, p. 6.
44 Goode, J., 'Woman and the literary text', in Mitchell, J. and Oakley, A., *The Rights and Wrongs of Women*, Harmondsworth, 1986, pp. 220–2.
45 *The Englishwoman's Review of Social and Industrial Questions*, July 1873, p. 243.
46 *Ibid*, p. 244.
47 *Ibid.*, p. 244.
48 *Ibid.*, Jan 1870, pp. 11–12; Jan 1871, pp. 66–7; April 1873, p. 156; April 1874, pp. 87, 144; Aug 1877, p. 376; Sept 1877, p. 426; Nov 1879, p. 48; Nov 1879, p. 484; Feb 1880, p. 85 and March 1880, pp. 101–2, 116; July 1880, p. 332.
49 *Labourer's Union Chronicle*, 16 Aug 1873, p. 7; 27 Sept 1873 p. 7; 15 Nov 1873, pp. 2–3.
50 *Ibid.*, 10 Jan 1891, p. 2.

A passing notice

By 1900 women had largely passed from view as casual farm labourers. The state had intervened, they had been disciplined and now they were seen to have returned to the domestic sphere. Instead, as wives they were blamed for 'one of the causes of the rural exodus [failing] ... to make the home attractive'.[1] Occasionally the women who remained in the fields were described as pathetic remnants of country femininity, 'mostly either single women or widows who have been wrecked in life and have no other means of picking up a slight livelihood. ... [who are] hardly worth mentioning'.[2] By 1910, *The Edinburgh Review* felt able to treat the whole subject of women's agricultural labour retrospectively, even nostalgically, within a wider celebration of England's rural working class as part of the nation's root-stock: 'The true peasant seems almost a part of the vegetation.'[3]

The Royal Commission on Labour, the last official text I want to look at, was established in 1892 after a long period of unrest to 'inquire into the questions affecting the relations between employer and employed, the combinations of employers and employed, and the conditions of labour which have been raised during the recent trade disputes in the United Kingdom'. Three committees interviewed expert witnesses from three different trade groups. However, relations in the countryside 'appeared to present special difficulties', so that Special Assistant Commissioners had to be appointed in this case to carry out local surveys. The countryside required special investigation, as if it was a foreign land. Each reporter certainly belonged to that imperial world of mastering the facts, the literal and mental accumulation of data, which mirrored the collection of zoological specimens and which schoolboys across the land had to emulate.[4] Wilson Fox, who reported on Norfolk and Northumberland, was certainly imbued with the discourse of science. He was a member of the Royal Statistical Society, and was Comptroller General of the Commercial, Labour and Statistical Departments of the Board of Trade by 1906.

The Special Assistant Commissioners were told to look at the supply of labour, conditions of engagement, earnings, cottages, gardens and allotments, benefit societies, trades unions, general relations between employers and employed, and the wider condition of the agricultural labourer. Each of these areas were then broken down into more detailed questions, including the issue of women and children's work where relevant.[5] This was also the first Royal Commission to employ women as Special Assistant Commissioners. Women's employment similarly constituted a 'special difficulty', though the government had initially resisted the idea that women should be taken on to observe women when Mr Summers MP had first proposed it.[6] Regrettably, these commissioners only looked at industrial relations. Though they tended to share the ideology of their male counterparts, their representation of rural women would have made interesting reading.

The exodus from the land, which was already causing increasing alarm within the ruling class, who saw the countryside as the last bastion of a physically fit nation, was the main focus of concern when the Royal Commission on Labour looked at the countryside. Because of this, and because there had also been many disputes with the NALU since its inception in 1872 and revival in 1889, women's labour did not constitute an area for concern. Rather, it was discussed as a factor within these wider issues. Field women were already seen to be numerically inconsequential by this time. Witnesses to the 1880–82 Royal Commission on the Depressed State of the Agricultural Interest – which also shared some commissioners with the later enquiry – said that women were withdrawing from farm work. One employer in Bridgwater, Somerset complained, 'We have great difficulty in getting any women to do outdoor work'. And the reporter on Norfolk, Mr Druce, surmised that 'very few women are now employed upon farm work in Norfolk'. There was evidence that women were still taking paid outdoor work in these areas, but apparently few did so.[7] In this fashion, women were briefly described purely as agricultural labourers. Their wages, hours and level of employment were discussed, not their morality, health or fitness as mothers. Following the main concern of the Commission, namely the interests of arable agriculture,[8] as most of the witnesses were arable farmers from the south and east, women's supposed withdrawal was presented as only one of many problems farmers were facing; for example, children had also been removed from the fields because of state intervention via The Education Act, which had 'taken children from agricultural employment, ... [and] obliges the women to remain at home on account, perhaps of an elder daughter ... being compelled to go to school ... [This] has had a great effect ... in depriving the farmers of female labour'.[9]

The one exception to this decline was Northumberland, where the reporter on the county, Mr Coleman, said 'With regard to the women workers, there can be no doubt that they are an essential and integral feature of farm economy, and this being so it is important to consider how far their employment is desirable or otherwise from a higher point of view.' Coleman had apparently read the previous debates on female labourers' morality, but quickly concurred with the 1867–70 report, that in this case there was no problem. Northumbrian women were acceptable both in base economic terms, and from an elevated moral and ideological viewpoint, which is an interesting juxtaposition.[10]

> They are as a rule either the wives or children of labourers and more *under control* in their parents' houses than when in domestic service, or in factories. That during working hours they are *under the charge* of the woman steward, and are usually employed in a gang, and that they seldom work with the men, and that fact, the only reliable guide, proved their respectability. … they enjoyed excellent health, a fact my personal observation confirmed. Those who follow the itinerary will find many illustrations of the extraordinary efficiency of women workers.'[11][my italics]

As in 1867 and 1843, the women labourers of Northumberland were praised because they appeared to remain within the control of their families, or within the sight of acceptable supervisors, and to fulfil the codes of domesticity. In this case, the gang, now a legal labour system, had become accepted as a suitable means of supervision. As members of the working class the women were industrious, but when they left the domestic sphere to do their work they also remained within the bounds of femininity. Of course, although these women were acceptable to him, Coleman still found many working women problematic. He defined Northumbrian women as superior to urban servants and factory hands through the use of the relatively new language of national efficiency. He also believed parental control in the cottage to be superior to middle-class supervision in the home, a complete reversal of what had been said forty years earlier. Sexual transgression of moral codes did occur in middle-class families; there was a tacit acceptance that the middle-class men of a household had physical access to the women working in it,[12] but this was not usually publicly acknowledged within dominant discourses. Domestic service was supposed to be the highest form of employment that a working-class girl could aspire to; it reputedly promoted bourgeois moral standards and taught the girls household skills in preparation for marriage. Pastoral, coupled with ideal femininity in the cottage, and a concern for the fitness of the race, though, began to super-

sede the idyll of the middle-class home in the 1880s, and was backed up with evidence obtained by objective observation, collected on an official itinerary.

To return to the issue of the farm women's vanishing act, this was very much grounded within the discourse of farming itself, and the ongoing acceptance of and need for their labour within agricultural practice. Throughout the century, farmers had maintained a constant defence of the women who worked in the fields in an attempt to prevent legislative interference. Economically, farmers had too much to lose if women were removed from their labour force, while they were also close enough to those women, as members of the agricultural community, to avoid some of the distorting effects of pastoral. Clare Sewell Read MP had said in his address to the Agricultural Association at North Walsham in Norfolk, November 1867, 'If I were a farm labourer, nothing would give me greater pain than being compelled to send my girls to field labour', but he still recognised that the work was financially vital to the labourer's family and, like Boucherett, argued that it was better than 'idleness or vice at home'. Some were only capable of 'the plain and sturdy labour of the field, [and] it is far preferable that they should work on the farm than have silly notions put into their heads that field-labour is not fitted for females'.[13] This is not to say that the accounts of farmers, or feminists, are any more 'real' than other texts. It was just that they operated through a different mode of representation, which brought into focus different aspects of the women's lives. Farmers saw women as labourers first, wives and mothers second, and it is not surprising that a report which focused on the problems of agriculturists should conform to this. What is important here is that this became the dominant representation of rural women within a much more general official report. The clergyman was replaced by the farmer as expert witness on the countryside in the 1890s.

Aside from the agricultural depression, it was the loss of the organic community that increasingly preyed upon the minds of the official observers and publicists; things had changed since the era of High Farming: England now had to compete to maintain its domestic and foreign markets, and sustain an ever-increasing empire. The general and county reports of the 1892 Royal Commission on Labour began, like the Royal Commission on the Depressed State of the Agricultural Interest, by emphasising that women's farm employment was greatly diminished: 'One very marked feature distinguishing this inquiry from any of the previous investigations of a similar character is the lessened employment of women in farm work'. Again, only in Northumberland had they 'stayed at roughly the same ratio to all agricultural labourers'. The wages, hours

and labour of women in other counties were represented as inconsequential: 'A passing notice may be given to the wages of women, though in most districts they form a very insignificant part (numerically) of the wage-earners in agriculture.' Any contrary evidence was given as the exception which proved the rule: 'there has been a great decline in female employment ... except in Glendale and in those districts where certain crops for which they have a special aptitude are largely grown.' Where women did take paid employment, they took on jobs that could be accepted as women's work, that fitted conventional notions of skill and femininity. Farm work was still clearly gendered. In the conclusion to the report it was stated that: 'The universal withdrawal of women from field work is an evidence of an improvement in the circumstances of the labourers.'[14] Rural women were used as signs of social well-being, and it was this that came to be of primary importance as pastoral, the concern to promote national efficiency and the need to redefine masculinity and femininity continued to rework the observations of publicists and official reporters alike.

The county reports of 1893–94 had little to say about women in agriculture. Wilson Fox followed the lead of the 1867 inquiry, and did a follow-up on the gangs in Norfolk, which he noted had been criticised as demoralising for girls. But like the farmers and feminists, he decided gangs were acceptable forms of employment; they offered work to widows and wives who had no other income. What Fox was worried about was the work hurting the women's health and their families' welfare when it was casualised; 'the children, the household duties and the husband's comforts are neglected, the women's strength is exhausted and in time she becomes prematurely old.'[15] The role of women in the home, and the reproduction of a healthy population became the focus of Fox's concern.

Elsewhere the women's invisibility in agriculture was taken to be a sign of rural well-being, though the location of their work, not their economic activity, was all that had changed. Mr Aubrey Spencer decided that in Somerset 'women are practically not now employed at all in agriculture', because their husbands were earning more, but he also said they had 'opportunities of earning money in other ways [which] ... can be done by the wife at home without the neglect of domestic duties'. Increasingly, rather than do field labour, those who needed to supplement their husbands' wages, or earn their own, went into other kinds of work, such as glove-making, which paid up to 12s. a week.[16] No figures were given for field women's wages, so we cannot make a direct comparison, but it is interesting to note that 2s. – 2s. 6d. a day was offered to persuade local women to join the Land Army in 1917, and they were still

reluctant to sign up – possibly they had internalised the middle-class ideology that had been the cause of the Agricultural Gangs Act, having felt the pleasure of adhering to the ideal it would seem that rural women became reluctant to visibly opt out of it.[17] The ambiguity arose in Spencer's report because of the dominant definition of 'work' that centred on public economic activity as opposed to domesticity. It meant that all productive employment carried out in the home became invisible, especially if that work was unpaid, and this added to the haziness of vision that official observers suffered when looking at rural women. The walls of the cottage or farm increasingly obscured their sight, as the cottage emerged as the ideal home. The women farm servants, farmers' wives and dairywomen; the wives of shepherds who worked with sheep in the hill country; the labourers' wives and daughters who worked on the cottage allotments provided in Somerset, or who looked after the family pig, all went uncounted and unwatched.

This invisibility was challenged by some publicists. Richard Heath, inspired by the reports of the 1860s, determined to do his own research into the condition of the rural population, which he published in *The English Peasant, Studies: Historical, Local and Biographic* (1893). He classified the details of rural life, attacked agricultural employers, and looked to a recently extended democracy and improved education to reinstate pastoral bliss. Part of Heath's study involved the careful weighing up of evidence on the issue of women's field work. After looking at the arguments for and against, he decided that the labour was acceptable where it was used properly by the farmers. But the women had to remain capable of their domestic duties, in which case Northumbrian women were once again taken as paragons. Heath, like other writers by this time, saw no need to panic.[18] Wilson Fox implicitly agreed. He represented field women as cheap supplementary labour for farmers, and as part of the traditional agriculture of the area.[19] Wilson Fox presented women's farm work as not only acceptable, but as ideal and desirable through a series of signs connoting health and beauty:

> Certainly the splendid healthy and cheerful spirits of the women of Glendale bear a very practical testimony to the beneficent results of an active out-door life. … Those who have seen them in their useful and becoming attire looking the picture of health, and working actively and cheerfully, must be impressed with the fact that their employment is considered no hardship, and that it has made them physically a race of which Northumberland may be proud. It is also a matter of congratulation to them and to the county, that their standard of morality is so high.[20]

Wilson Fox agreed with Doyle, Henley, Munby and Coleman that

the physique of the Northumbrian women was not to be surpassed, which elevation came directly from anthropological and evolutionary languages. Notions of pastoral, Englishness and national strength converged. Wilson Fox also concurred with the other observers when he said that the women's morals, now that the bondage system was supposedly gone, were perfect. They fulfilled their domestic duties, and so he accepted their labour. He represented field women in this way because he, like the others, adhered to a vision of separate spheres that coincided with the dominant definition of culture, which labelled a civilised society and race as one in which women were passive and domestic, while men were active and participated in the world of paid work. As he said, the loss of women from agricultural employment 'may possibly be a sign of progress in civilisation'.[21]

Statements like this need to be placed within the context of the growth of imperial languages in science, politics, art, literature and popular culture at this time, as well as in the polarity of Nature/Culture. From the early 1870s, when Britain renewed its interest in empire through exploration and then colonisation, there was an increase in the popularity and production of imperialist imagery. At this time literacy was becoming the norm rather than the exception, and by the 1880s the popular press as we know it was beginning to develop. Papers reported on the dangers and excitements of life in the colonies, provided coverage of imperial battles and disseminated new scientific theories of race. Some, like *The Illustrated London News*, even provided illustrations to add spice to their stories. In literature, writers like Rider Haggard and Kipling were gaining in popularity and it was at this time that the so-called 'penny dreadfuls' appeared – cheap paperback editions of romantic and adventure fiction. Another area of written culture was the children's paper and magazine, such as *The Boy's Own*. which also increasingly published stories about heroic exploits in far-flung lands, and colonised the past as much as the present.[22] The high culture of the period also reworked imperial ideology in a variety of visual forms, including scenes of emigration, colonial life and orientalism. In addition to the literary and visual images, imperialism was also promoted through clubs and leagues. As noted in Chapter 7, this culture added to the reconstruction of masculinity as well as femininity through definitions of physical and moral fitness, predicated on a eugenicist and social Darwinist discourse which placed white European men at the top of the evolutionary tree. What we can see from the Royal Commissions and in the work of publicists is that within these different practices the rural was essential as the last bastion of health, but also as an alien land in itself that required exploration and classification, and which provided a

safe environment in which to practice these imperial skills. It became simultaneously alien and English, and this shaped the representation of rural men, women and children at this time.

Wilson Fox was obviously engaged with the discourse of imperialism. However, he also appears to have digressed from the bourgeois hegemony on one key issue: he felt able to say that farm labour was better work than 'the drudgery, confinement and constant supervision which domestic service often entails'. The quote, like Coleman's reference, can probably be placed within the context of the 'servant problem', as it was widely known. In other words, the ongoing problem of getting servants who were reliable, moral, industrious, and who would stay with one employer. This had contributed to the proliferation of prizes for loyalty within Agricultural Societies earlier in the century, as both working-class men and women were required to fulfil these criteria on farms. The rise of feminism, coupled with a wider range of paid employment for women at the end of the nineteenth century, then exacerbated the issue in the case of domestic servants, and made it a key question of the day. It was at once a 'real' practical problem for the middle class, and an ideological issue connected with the changing definition of femininity at this time. Domestic service was, of course, normally held to be the most worthwhile form of employment for working-class women, because they were constantly watched, were doing feminine work and remained in the domestic sphere. Even Coleman's critique did not suggest that service was a bad thing *because* it was closely observed. Either this shows a dramatic shift in the dominant ideology, or, as is more likely, Wilson Fox had spawned a dissident reading of the issue in trying to understand the women's viewpoint. He was able to applaud agricultural work because 'I venture to think that work in the fields is freedom compared ... to the life of a maid-of-all-work in a town'.[23] He had ventured across the borders of class and gender in this case. The women he wrote about became subjects, capable of rational – masculine – decision-making, from the basis of middle-class liberal individualism. Regardless of authorial intention, this can be read as a clear challenge to the dominant vision of respectable working-class femininity. This is a fascinating statement, especially because it appears in an officially sanctioned document.

Arthur Munby's texts, published and unpublished, exhibit a similar instability of meaning, where the woman he represents becomes an independent actor. Arthur Munby published *Dorothy – A Country Story in Elegiac Verse*, a long poem supposedly based upon actual 'English life', thirteen years before the Royal Commission on Labour. The poem, which provides a valuable comparison to the official texts, used Munby's

own research and was positively reviewed in Britain and America by *The Academy*, *The Pall Mall Gazette*, *The Spectator*, *The Guardian*, *The Chicago Standard* and *The New York Critic*,[24] and was applauded by Robert Browning.[25]

The heroine of *Dorothy* was a farm servant who was fashioned both for beauty and for work, unlike Jane Eyre, who believed she was 'formed for labour, not for love'.[26]

> 'Often and often she winds at the mighty
> old windlass,
> Still with her strong red arms landing the
> bucket: aright
> Then, her beechen yoke press'd down on her
> broad square shoulders,
> Stately, erect like a queen, she with her burden
> returns:
> Stalwart and tall as a man, strong as a heifer
> to work:
> Built for beauty, indeed, but certainly built for
> labour
> Witness her muscular arm, witness the grip of
> her hand!'[27]

Munby represented Dorothy as proud of her work and as enjoying her freedom. She revealed bare arms, reddened by work, strong shoulders, muscular hands and was described as an animal. Yet she was also queenly and beautiful. When she met two upper-class men while ploughing, Munby described a lack of comprehension of the Other on both sides. They, like the middle class in the 1860s, wanted to legislate against field women; she found the idea laughable.

> 'Gad, though, look there!' cried the youth; – a
> woman, by George! – and she's ploughing –
> 'What, do they train them, out here – women
> – to follow the plough?
> 'Uncle, we'll ask her the way – she's a social
> phenomenon, surely;
> 'Which you can quote with effect, next time you
> bring in your Bill!
> 'P'r'aps she has heard of your *Bill to Regulate
> Female Employment* –
> "Women and children', you know – *won't* she
> adore you for that! –
> Here were the quality folks, standing and staring
> at *her*!

What could she do? She was trapp'd – she could
 but go nearer and nearer,
Red though her face might be; redder than ever,
 just now: ...
Swiftly she came to her doom – and the younger
 stranger address'd her
('Jove! she's a beauty', he thought, 'Fancy a
 beauty at plough!')
'So you are ploughing, my lass? Warm work, in
 such weather as this is!'
'Woa, horse!' Dolly replied, pulling her best
 at the rein,
'Woa!' And the plough stood still; and she, as
 she stood in the furrow,
Dropp'd him a curtsey, and said, 'Yes, Sir, it
 is very warm.' ...
She, in the midst of her work – so unfit for her
 betters to talk to –
Wish'd they would both go away; wish'd they
 had never come near. ...
'Are you a servant? Indeed! And why do they
 send you out ploughing?
'*Men* should do that, don't you know? *You*
 should be indoors!'
Dolly could almost have laughed, but she knew it
 would not be respectful;
Therefore she gravely replied, 'Well, Sir, I'm
 used to the fields:
'And there is only me, and Master, and this little
 lad here:
'I should be ashamed indeed, not to be able
 to plough!"[28]

Munby challenged the dominant definition of femininity, as we have already seen in his diaries; he liked women to be fit and strong. He placed Dorothy, possibly modelled on his servant and wife Hannah Cullwick, from Shropshire, on the dark side of the racial polarities which defined femininity as light, white, smooth, small, weak, passive and domestic, and celebrated her strength and independence. However, Munby made it perfectly clear that Dorothy was working class in both the form and the content of his poem. He represents her as knowing her place and liking it, as the story goes on, while her plain speaking and dialect marks her out as a rural woman, especially in contrast to the language of the men who observe her, to whom she is respectful in her utterances and body-language. Munby represented the power relations

within the process of interview very well here, and through this Dorothy becomes subject, with her own consciousness, as well as object; she is not wholly determined by the men who see her as a 'phenomenon' – including Munby, who, despite his different reading of 'reality', carried out exactly this kind of process in order to write his poem. Dorothy becomes an ambiguous figure, as so many field women do in middle-class discursive practice. Though she is shaped by her work – she becomes 'strong as a heifer' – she is still not as strong as a labouring man.[29] And though she retains an aspect of demure femininity, she is still able to order her own language and thoughts for her observers. In *Dorothy* Munby made visible the boundaries of class and gender that he tried to cross in his own life,[30] but the poem also shows us how one text could rework the facts of rural life to produce many readings. Though in the end Dorothy marries and settles down to a quiet cottage life, so that her subjectivity collapses back into domesticity, not all of the meanings in the text can be reduced down to the intention of the author.

The women who worked in agriculture were largely invisible in the Royal Commission on Labour. Officially they were no longer problematic physically, morally or economically, in any county. The message from above was that they were to be forgotten. Women in rural society became firmly represented as housewives and mothers, choosing to stay in their cottages, thanks to the higher wages their men were receiving. The images from the 1892 Commission were reiterated in the 1894–97 Royal Commission on the Agricultural Depression, which again gives us some insight into the discourse of late nineteenth-century farming. Wilson Fox summarised the points he had made in the previous Commission and Clare Sewell Read, by 1894 the ex-MP for Norfolk, gave evidence that:

> 'The women's labour is almost entirely extinct with us. We hardly get any women to come into the fields; not only that, but they do not even care about gleaning now-a-days, they do not come out to glean. Last year we had an enormous crop of acorns, which could be sold at a shilling a bushel, and they were not all picked up. Then we had flints on our lands which are extremely useful for the purposes of road-making, and we cannot get them gathered. Then, generally speaking, I might say that *you do not see a woman outside her cottage at all now-a-days*.'
>
> 'Has there been a change in that respect? – 'Yes, a great change, and *it is a good change* in a great number of ways.'
>
> 'Do you think that it is a symptom that the labourers are better off as a whole? – 'I think it must be.' ...
>
> 'You think, notwithstanding the loss of the women's earnings, that

the labourers are better off? – 'They must be better off or they could not dress and look so well as they do ... '[31](my italics)

Women had stepped back inside their cottages, indeed they seemed reluctant to emerge, and this was taken to be proof of, or rather the accepted metaphor for, the improvement of rural life.

By the 1890s the mainstream periodicals and newspapers had equally little to say on women who worked in the countryside. *The Times* disseminated the findings and images of farm women in the 1892 Commission; women did 'a *little* hay-making', (my italics) which meant that 'there is less drunkenness, less immorality, less disease, less distress. Young women are at service instead of wandering about the fields and lanes'.[32] Obviously, things had improved immeasurably since the passing of the Agricultural Gangs Act; women could no longer be seen in public space, travelling country lanes and indiscriminately contaminating passers-by. This vision, based upon the earlier use of field women as signs of social disease spreading throughout the land, elevated domestic service and celebrated a newly cleansed and disciplined rural environment. As the stereotype of the cottage woman gained ascendancy, the periodicals of the late nineteenth century concentrated on the question of depopulation. Publications such as *All the Year Round*, *Macmillan's Magazine*, and *The Contemporary Review* wrote about the countryside generally. *All the Year Round*, in particular, explained rural depopulation in terms of the failure of the idyll, but also published articles on quaint rural characters, based on old eighteenth-century constructions of the peasant, so that the working-class became an element within a middle-class spectator-sport situated in the park-like English countryside.[33] Labouring men and women vanished from sight to be replaced by figures in the landscape once more.

By the end of the century rural women were important signs within the debate on England's physical condition and the construction of the rural as the essentially English bastion of old values. They became metaphors for the state of the race, as can be seen in Thomas Hardy's essay 'The Dorsetshire Labourer', (1883), published in *Longman's Magazine*. Largely a descriptive report, and a critique of the stereotyping of male agricultural labourers as 'Hodge' – the nearest female equivalent was Polly, as used in S. Baring Gould's *Old Country Life* (1890) – Hardy attempted to provide an accurate account of rural life through close observation. The details that he went on to give, prove that he was as capable as any parliamentary reporter of collecting the 'facts'. But these details, juxtaposed with idyllic descriptions of old-fashioned harvests, were used to criticise current practice and the increased use of machin-

ery in farming. 'The Dorsetshire Labourer' combined social science with literary practice and essays like it became increasingly popular towards the beginning of the twentieth century. Richard Jefferies, author of *Hodge and His Masters* (1880) and *The Toilers of the Field* (1881), emerged at this point as one of the leading experts on the rural, and is still often used as such. Using his own experience as a farmer's son, he wrote in London for a predominantly urban readership and effectively developed *the* dominant descriptive mode of writing on the countryside.[34]

Jefferies used images of women to rescue the old values that Hardy lamented. In *Hodge and His Masters* he wrote of his regret at the industrialisation of agriculture, which had removed the 'romance' from farm work. Significantly, the dairymaid, rather than the fieldworker, was the rural woman he chose as his sign of a lost ideal.[35] The dairy had become a distant realm belonging to a golden age. With increased mechanisation, the dairy was no longer part of every farmhouse, and was therefore constructed in opposition to the advance of industry as a naturally feminine sphere. The women in *Hodge* were represented through the polarities of Nature/Culture, sentimentality/rationality, country/industry, nostalgia/progress; they were romantic images of a pre-industrial, unscientific rural past. Jefferies used rural women as idealised signs and metaphors for English pastoral, founded on nostalgia and the invisibility of poverty, in a very similar way to late eighteenth-century authors, keen to distance the aristocracy from the causes of rural poverty, but he worked within a very different context.

Jefferies was clearly equally engaged with the late nineteenth-century discourse of race. He suggested that rural women no longer did dairy work because they had gone to the towns: 'Those that remain are slow-witted, or those who are tied in a measure by family difficulties. ... or perhaps an illegitimate child of her own may fetter the cottage girl'.[36] These stragglers were the ones who took field labour. The fear of racial degeneration is clear here, coupled with a concern to provide accurate and sympathetic details of rural life and work. Perhaps, he implies, if the rural had been left in the hands of his forebears, honest, simple farmers who cared for and understood the rural poor, then the country – nation and countryside – and its people would not be in such a tragic condition, but now it was too late. In *The Toilers of the Field*, left alone after a life of toil in the fields, the women become naturalised metaphors of Englishness: 'In their later days these women resemble the pollard oaks, which linger year after year, and finally fall from sheer decay.'[37]

This heroic mode of representation continued up until the First World War at least. The Bettesworth books, biographies written by

George Bourne (the pseudonym of George Sturt, born in Farnham, Surrey) from 1901 to 1913, were the most popular books written in this genre and they have been widely used as sympathetic accounts of the rural and its people ever since. Bourne was critical of the way the poor were treated by the rural upper classes and scathing of urban visitors who moved to the countryside to regain a lost golden age. Because of these progressive politics, most of his books have been taken to be some of the most authentic accounts of the period. On closer inspection, though, it appears that Bettesworth, the object of Bourne's study, was far more in sympathy with the countryside and labouring class than his author.

The social distance between Bettesworth and rural men and women was much less than that between Bourne and his country case studies, therefore the gardener constantly pointed out things to his employer that the latter had missed entirely. Also, as Marsh notes, it was a simple matter for an account in dialect to be read as heroic by its audience. Bourne easily slipped into a pastoral mode regardless of his intentions.[38] Bettesworth saw rural women in terms of their experience, while Bourne turned them into signs. This was despite Bourne's criticism of urban middle-class authors who helped to add to the rural idyll,[39] a process which continued despite an increased focus on the city as a source of pleasure, morality, inspiration and model of culture by modernist artists and writers The significant shift here in terms of pastoral was that the rural came to be linked to a medieval past, or utopian future; it no longer belonged to the present. By the 1890s the city was increasingly elevated above the country. A book like this offered its readers only a temporary excursion into a rural world that was seen to be, and described, as long gone. Sometimes this was regretted, sometimes it was seen as a good thing, sometimes it was just seen as as an historical account of the formation of English identity.

The descriptions of the gardener's wife, in *Lucy Bettesworth*, provide some of the best examples of these alternate readings. Bourne began the book by describing how it would be very difficult to imagine Lucy Bettesworth being loved. She was a completely alien figure for the author, utterly Other:

> She is a strange looking figure … some piece of antiquity resuming forgotten life. An odd slate-coloured and dishevelled, not quite human, apparition, even on a summer's day … [She gives an] impression of unattractive strangeness … .[there is] something suggestive of bats wings or of old cobwebs. … [Her face], though placid and kindly, is somehow hardly in keeping with our modern times. … It is short and broad; the eyes in it have a dark and unspeculative gleam; the teeth have gone and the lips have fallen in … [40]

This was a woman who had worked in the fields most of her life, probably while the parliamentary reports were being written in the 1860s. In a fashion, according to the reports of the 1890s, she was a figure of the past, a ghost. In the form of the book she is represented as if she were already dead, though when it was written she was still alive. She was certainly not an angel of the home, nor a nubile dairymaid. Her body was criss-crossed with the marks of work and time; she was dark, tanned, and had a strange visage as if she were from another race, not just a different period.

Bettesworth, when asked about her, commented on the harshness of her life, how she used to rush to her mother's aid when her drunken father went into one of his many rages, how she worked with him doing the harvest round, as able as any man. As he said, 'She 'ave worked 'ard, no mistake. So did her mother and her sisters. Never no gals worked 'arder than them – and their mother too. They 'ad to to keep the home together.'[41] Bettesworth was proud of his wife's strength and in many ways Lucy Bettesworth was typical of most rural women:

> as strong as a little donkey. See her out with the sheep fold liftin' they great hurdles, and then go out and cut up a bushel o' swedes, and out with it for 'em. Strong as any man! ... I've knowed my wife ... since we bin married, come 'ome with daglets of ice's big's yer thumb hangin' from her skirts. Yes, daglets of ice. That was trimmin' swedes, with men goin' in front of her to sweep the snow away from 'em. Well somebody got to do it.[42]

Bettesworth appreciated his wife's hard labour, was proud of it and saw her as an individual. Bourne went on to use this testimony and objectified Lucy Bettesworth as a metaphor for the history of the English race. She could be any:

> worn out working woman Her face is a face of the fields: it is unhomely, undomesticated. Swarthiest of the swarthy, that she must have been in her younger days ... Yet it cannot be all swarthiness that darkens the old woman's withered features ... Perhaps it is only the stain and sun-tan of many years spent in the fields ...
>
> For she is of the fields one of their unvalued products; and the fields have ... overlaid her humanity with an enigmatic and half-dreadful composure like their own. ... But you must not judge Dartmoor as though it were a lawn in a suburban garden ... The labours that have claimed so ruthlessly and have so cruelly marred this old woman ... rank among the great things for which our race has lived. Unrecognised, unrecorded, their place is beside our Armada conflict, our occupation of India, our mastery of the seas; viewed in the large, they are not less

splendid, and they are more venerable than these …. On pleasant hill-
sides, or by quiet-flowing rivers, taking her share in the immemorial
duties of the fields, Mrs. Bettesworth has played her infinitesimal, yet
vital part in the doings of the English … [43]

The work had not only defeminised her, it dehumanised her for
Bourne. His representation of Lucy Bettesworth is complex. Bourne is
sympathetic to her to the extent that he appears to be in awe of her. But
she is the antithesis of domesticity, and is described as a member of an
uncivilised race, as part of wild uncultivated Nature. Bourne aims
neither to 'overdramatize', nor to sentimentalise her life, 'in a romantic,
Wordsworthian way'.[44] But as with his portrayal of Bettesworth, Bourne's
description slips into the heroic, aided by the fact that she never speaks
for herself in the book. Unlike Dorothy, Lucy Bettesworth, as an indi-
vidual woman, disappears altogether into the landscape, so that she
becomes quite literally part of England's great colonial history. She
becomes part of the construction of Englishness and empire, despite her
alien form which belongs to awful Nature – now seen as a violent, often
destructive force. Her individuality or subjectivity becomes inherently
unstable. She is Dartmoor – untamed Nature – *and* a 'fair English land-
scape such as Constable might have painted. … It is as though our
choicest English weather had burned itself into the fabric of the old
woman. She is a part of the magnificent land – as much a part of it as the
cattle in our valleys'.[45] But Lucy Bettesworth the woman, like the
women in the official texts, vanishes from sight. Bourne saw the coun-
tryside that had shaped her as part of the past, something to be valorized,
but also, something dead and gone. He and his audience lived in a dif-
ferent world, a world of mechanisation, constant transition and change.
These were the values that were now fêted.

The field women in all of these texts – official, literary, press and
poetry – are alien, all Other in some respect, but none of them are
threatening viragos or prostitutes. Like the dairymaids, field women
were judged by their clothes, bodies and features as much as by their skill
as wives and mothers, or the paid work they did. This objectification still
marked them as inversions of respectable femininity. Field women were
still placed on the wrong side of the light/dark, smooth/rough, good/bad
polarities, but were increasingly used as signs of social decay if deplored,
or signs of racial stamina if praised. This was because, rather than focus
on moral/sexual deviancy, a new system of representation evolved
through the projection of fears about national efficiency onto the coun-
tryside. During this period all rural women became metaphors, not just
for the land, but also for the race. Motherhood, idealised as cottage

motherhood, became vital to the maintenance of empire,[46] and this shaped the representation of all rural women at this time.

Books like those by Jefferies and Bourne on the rural, both positive and negative, proliferated, especially at the turn of the century. By 1880 these acted as one of the most popular forums in which to define difference, and became a much more important public platform on which to discuss the issues of the day than the official texts they had originally mimicked. As both cause and consequence of this process the countryside itself became an alien land, subject to repeated investigation and exploration, which served to produce new codes of behaviour. But the city was now the focus of cultural and artistic attention. Writers no longer looked to country dialects to offer them a linguistic or moral exemplar. Within this construction, having been disciplined by legislation so that they were no longer a threat, field women – like country men – became the carriers of a new set of values adopted within middle-class ideology. The danger their work had once posed to the bourgeois hegemony had been contained through a cultural, ideological and actual reworking of their lives and surroundings. Hence their apparent invisibility, which meant that they could now be safely represented as mothers or figures of health, and used as metaphors for the nation, the past, the race. But as C. F. G. Masterman put it in *The Condition of England* (1909): 'The landlord, the farmer, the clergyman, the newspaper correspondent primed with casual conversation in the village inn, think they know the labourer. They probably know nothing whatever about him'.[47]

NOTES

1 'Reports of the Inter-Departmental Committee on Physical Deterioration', PP 1904, i, p. 42.
2 *Country Life: The Journal for All Interested in Country Life and Country Pursuits*, 17 Jan 1914, p. 74.
3 *Edinburgh Review or Critical Journal*, ccxi, pp. 338–40.
4 See Bristow, J., *Empire Boys, Adventures in a Man's World*, London, 1991, for further discussion.
5 'Reports From the Royal Commission on Labour', PP 1892–94, 'Commission', p. 11.
6 *Hansard*, ccchli, pp. 437–8, 1065–6.
7 'Reports of the Royal Commission on the Depressed State of the Agricultural Interest', PP 1880–82, Mr Little, pp. 232, 244–5, Mr Druce, p. 387.
8 See Fletcher, T. W., 'The great depression of English agriculture 1873–1896' in Minchinton, W. E. (ed.), *Essays in Agrarian History*, ii, Newton Abbot, 1968.
9 PP 1880–82, Digest, p. 23.
10 PP 1880–82, Mr Coleman, p. 699.
11 *Ibid.*, p. 699.
12 Davidoff, L., 'Class and gender in Victorian England' in Newton, J.L. *et al.*, *Sex and Class in Women's History: Essays from Feminist Studies*, London, 1985, pp. 23–9.

13 'Reports From the Commissioners on the Employment of Children, Young Persons and Women in Agriculture', *PP* 1867–70, xvii, p. 171.

14 'Reports From the Royal Commission on Labour', *PP* 1892–94, Senior Assistant Commissioner's report, pp. 54, 56, 62, 163.

15 *PP* 1892–94, Fox, pp. 336–7.

16 *PP* 1892–94, Spencer, pp. 686, 687.

17 'Reports on the Wages and Conditions of Employment in Agriculture', *PP* 1919, p. 129.

18 Heath, R., *The English Peasant; Studies: Historical, Local and Biographic*, London, 1893, pp. v–viii, 50, 85–6, 209–18.

19 *PP* 1892–94, Fox, p. 337.

20 *Ibid.*, p. 432.

21 *Ibid.*, pp. 337, 432.

22 Bristow, *Empire Boys*, pp. 38–48.

23 *PP* 1892–94, Fox, p. 396.

24 *Saturday Review of Politics, Literature, Science and Art*, 18 Nov 1882, p. 15.

25 Hudson, H., *Munby, Man of Two Worlds: The Life and Diaries of Arthur J.Munby 1828–1910*, London, 1974, pp. 402–04.

26 Bronte, C., *Jane Eyre*, Penguin, 1960, 1st edn. 1847, p. 398.

27 Munby, A., *Dorothy, A Country Story in Elegiac Verse*, Boston, 1882, pp. 9–10.

28 *Ibid.*, pp. 95–8.

29 *Ibid.*, pp. 70–1, 41–3.

30 Davidoff, 'Class and gender', pp. 41, 60–2.

31 'Reports of the Royal Commissioners on the Agricultural Depression', *PP* 1894–97, Mr Read's evidence, p. 71.

32 *The Times*, 20 May 1893, p. 11.

33 *All the Year Round, A Weekly Journal Conducted by Charles Dickens, With Which is Incorporated Household Words*, 17 June 1893, p. 558; 10 May 1890, pp. 445–8; 14 April 1894, pp. 343–50.

34 Marsh, J., *Back to The Land, The Pastoral Impulse in Victorian England From 1880–1914*, London, 1982, p. 33.

35 Jefferies, R., *Hodge and His Masters*, i, London, 1966, 1st edn. 1880, p. 78.

36 Jefferies, *Hodge*, ii, pp. 61–68.

37 Jefferies, R., *The Toilers of the Field*, London, 1981, 1st edn. 1892, p. 106.

38 Marsh, *Back to The Land*, pp. 61–4.

39 Bourne, G., *Lucy Bettesworth*, Firle, 1978, 1st edn. 1913, p. 10.

40 *Ibid.*, pp. 1–3

41 *Ibid.*, pp. 11, 17–19, 23, 81.

42 *Ibid.*, p. 24.

43 *Ibid.*, pp. 3–5.

44 *Ibid.*, pp. 9–10.

45 *Ibid.*, p. 21

46 Davin, A., 'Imperialism and motherhood' in *History Workshop*, 1978.

47 Masterman, C. F. G., *The Condition of England*, London, 1910, 1st edn. 1909, p. 194.

Unstrained dialect
a speciality

On 7 May 1892 *Punch* published a satirical comment on Thomas Hardy, 'Mr. Punch's Agricultural Novel. Bo And The Blacksheep. A Story Of The Sex,'[1] in which the idea that rural women could be seen as anything more than figures of fun and earthiness was ridiculed, alongside Hardy's narratology and style. It was said to be written 'By Thomas of Wessex, Author of "Guess how a Murder feels", "The Cornet Minor", "The Horse that Cast a Shoe", "One in a Turret", "The Foot of Ethel hurt her", "The Flight of the Bivalve", "Hard on the Gadding Crowd", "A Lay o' Deceivers",&c.,' which succinctly established that Hardy was the author in question. *Punch* goes on to say, in the author's voice: 'It is well known, of course, that although I often write agricultural novels, I invariably call a spade a spade, and not an agricultural implement. Thus I am led to speak in plain language of women, their misdoings, and their undoings. Unstrained dialect is a speciality'. Here, the periodical copied Hardy's disclaimer to the first edition of *Tess of the D'Urbervilles*, published in November 1891, in which he stated that he did not believe in disguising reality for the sake of appearances.

Punch then proceeds with a story which reflects Hardy's style, themes and message. The tale begins with a precise, topographic description of the countryside and the intertwining of its people and history. The character Bonduca/Tess is introduced after a careful description of her parents as typical peasants. They show the rigours of their history on their bodies and speak an imitation of dialect. '"Where be Bonduca?" said Abraham, shifting his body upon his chair ... "Like enough she's met in with that slack-twisted 'hor's bird of a feller, Tom Tatters. And she'll let the sheep draggle round the hills. My soul, but I'd like to baste 'en for a poor slammick of a chap."' In the final scene, Bo sees a procession of ladies who put babies at her feet. Finally, Thomas

Tatters appears: '"I know you, I know you!" was all she could gasp, as she bowed herself submissive before him. "I detest you, and shall therefore marry you. Trample upon me!" And he trampled upon her.'

This piece captured and simplified all the elements of Hardy's writing. From his use of the historic Wessex landscape, dialect, and nature as a metaphor for the human condition, to his characterisation of Tess as an archetype. Tess was given an ancient, aristocratic history by Hardy, was represented as a physically blooming country maid, and as a woman trampled by men and fate. Here the image of the country bumpkin met the image of the normally masculine peasant as 'Lob', carrier of the essence of English history.[2]

As we have seen, by the end of the nineteenth century it was a widely accepted literary and artistic convention that the countryside represented health, stability and community within a period of economic and social flux. There was criticism of this in journals and by influential authors such as George Bourne, but instead of pastoral being abandoned, it was adapted to include aspects of that criticism. If we look at the literature of this period we can see a new genre emerging, which focused entirely on the rural community, peopled by quaint characters of times gone by, who stand as metaphors for values that have been lost. They are part of the mechanism which aided the rescue and reconstruction of ideology from the past in the present.[3] But they were not the same jovial peasants that Eliot had attacked in 1856; they were presented to readers with much more complexity than the happy bumpkins of late eighteenth-century pastoral, though they were still seen as the contented carriers of ancient English folklore and bearers of national history. The men and women of the countryside were now written about as metaphors for the land, the nation, the race as a whole, by authors who claimed expert knowledge of their lives. Distance still existed between author and subject, but for readers that distance was hidden by a fantasy of little details, such as dialect and dress.

By the 1890s peasants had become collectors' items within the discourse of imperialism, which reconstructed the countryside, not just as a site of leisure, but as an adventure playground for the urban population as a whole. Waifs and strays from the towns were sent on country holidays to improve their moral and physical health; Scouts and Guides went on camps to learn survival skills on mock colonial ventures. Few of these children were destined to leave England, but the rural was seen as the perfect environment in which to train future bureaucrats and good mothers. Rescued prostitutes were also sent to country homes to re-learn the skills of femininity in order that they would have a more acceptable commodity to sell – their labour rather than their bodies. Having legis-

lated on the gangs, it was assumed that there was no longer any contaminating influence which might lead a visitor astray. The countryside had effectively become a tamed, safe, mini-empire in England's backyard. Country women were now officially paragons, who lived and worked solely within their cottages. Yet rural conditions were giving social commentators and publicists as much cause for concern as those urban environs which led General Booth to write *In Darkest England and the Way Out* in 1890, and prompted William Morris to create a rural utopia in *News From Nowhere* in 1891. The urban middle class may have attempted to escape to the organic community, but long-term economic depression, falling agricultural wages and the resulting rural exodus meant that there was very little of that community left, if it had ever existed. The rural became the supreme metaphor of Englishness, and was seen as the most beneficent influence by those who supported nurture over nature, at the very time that the countryside was declining in economic and political import and when its people were abandoning it like a sinking ship. Books which catalogued the lost peasantry of England, like Richard Jefferies *The Toilers of the Field* (1881), attempted to resolve this paradox, and in so doing often intersected with changing notions of femininity when they came to write about rural women.

There was widespread nostalgia, not just for the lost peasantry, but also for lost femininity, as feminists, the 'surplus woman' issue, and medical men increasingly challenged accepted notions of how girls and women should behave from the mid-nineteenth century. There was a growing acceptance that single women should be able to take more responsibility for themselves, but still a belief in the destiny of marriage and motherhood, especially as imperial discourse emphasised the need for middle-class women in particular to have physically and morally fit children for the benefit of the race. Motherhood took on a social role, which legitimised increased intervention by scientists and the state into this supposedly 'natural' duty. Girls had to negotiate these new forms of femininity. The contradiction between the self-sufficient independence of the middle class and the goal of motherhood was paralleled by the need to engage in the active pursuits of asexual childhood, which were in opposition to the obligation of becoming good passive and patriotic women. As Kimberly Reynolds says in *Girls Only*, this created an inherent instability between the discourses of childhood and femininity which new publications, like *The Girl's Own Paper*, attempted to rationalise and channel. Girls' literature constantly denied the changing role of women at this time, and other contentious discourses, by incorporating elements of resistance with the sting taken out.[4] The same can be said of the new rural literature, which incorporated tempting details

of rustic life, without signifying resistance, poverty or depression. Together the discourses of race, gender and the rural combined to re-create a new form of English idyll, parallel to, but subtly different from those we have already looked at in the late eighteenth century.

It was, of course, at this point that the most powerful literary image of rural femininity was presented to the public. Whenever I mention rural women, I am inevitably asked 'Have you looked at *Tess*?' Why? Perhaps it is because Hardy is supposed to be a 'great' author. He certainly combines the themes, impulses, and ideas of his time in a way which moves far beyond the work of other writers. Hardy was also one of the most popular authors of the 1870s, though the critics of his day were less complimentary. Or maybe it is because Tess is *the* most *accurate* liter-ary representation of a rural woman. *Tess of the D'Urbervilles* does seem uncanny in its detail and we know that Hardy was a countryman himself, born and bred in 'Wessex' where the book is set. Certainly, his-torians such as Pamela Horn, Raphael Samuel and Jenny Kitteringham, to mention just a few, quote his novels as if they were literal, not literary, reports on the condition of rural life, and as if his characters were real people, regardless of the distance of class between him and his subjects.[5] Or is it because Tess herself combines all aspects of the *stereotype* of rural femininity? The schema of the novel does place Tess within each of the images of rural womanhood, specific to each stage of her life, with a backdrop of appropriate scenery; she becomes in turn innocent maiden, harvest worker, dairymaid and field woman. Tess metamorphoses in moon-like 'phases' – maiden, maiden-no-more, woman – always trying to maintain her 'purity' at every stage.

All of these answers are 'true'; there are, of course, many readings of *Tess*, literary and historical. But we can only really answer the ques-tion of why Tess is constantly offered up as the archetypal peasant woman if we look more closely at the novel, its production and recep-tion in terms of the wider representations of farm women. Is *Tess* the exception or the rule? Does the book belong to nostalgic visions of a lost organic community, or does it stand out as a critique of that vision? In order to begin to answer this question, we need to know what 'the rule' was, to consider the representation of Tess in her historical and cultural context.

Tess of the D'Urbervilles – A Pure Woman was not well received by the critics when it was first published in its complete form in 1891. It was widely attacked because of its degenerate and immoral content, and the direct challenge that it presented to late nineteenth-century ideology. Hardy himself recognised this reception of the book. Even in its early stages it was turned down as a serial for moral reasons, by Tillotson and

Son, *Murray's Magazine* and *Macmillan's Magazine,* so that it finally had to be edited before *The Graphic* would take it.[6] But *Tess* was one of the most popular books Hardy ever wrote; it placed him on the literary map for the first time, and is still widely read. It is familiar to us in many forms, which goes part way to explaining why it is so regularly brought up in conversations about my work – very few people have heard of Hardy's contemporaries, for they did not generate the lasting appeal that Hardy achieved, despite their popularity in the late nineteenth century. Yet Hardy used many of the dominant representations of rural women in *Tess* that less substantial writers, like Jefferies and Bourne, employed and followed the same practice of providing interesting little details of rural life. To take one example, Hardy described rural women as part of nature when afield, while labouring men managed to maintain their identity: 'A field-man is a personality afield; a field-woman is a portion of the field; she has somehow imbibed the essence of her surroundings, and assimilated herself with it.'[7]

Here Hardy used the well-worn polarity Nature/Culture; his likening of Tess's progress through the novel to the phases of the moon was an equally common metaphor in the literary circles of his day. Hardy used Tess's body as a canvas on which to paint the accumulation of experience. At the beginning of the novel Tess is described as a young and innocent country maid through the eroticised signs of her lips, eyes, cheeks and torso, much like the archetypal 'girl at the gate'. The farm gate was a metaphor for the obstructions that stood between innocence and carnal knowledge; 'the girl at the gate' invited her audience to step across the bounds of morality. She was a liminal figure who also frequently stood at the boundary between adulthood and childhood. The *plein air,* rustic artist Henry John Yeend King's *By the Farm Gate* (c. 1890) (Plate 5) provides a good example of one such solitary seductress. Presumably a farm servant, the woman in the picture is young and pretty, there to be observed and consumed. She leans on an open farm gate, complicit in her audience's observation, but not quite looking us in the eye. She is pale, her hair is covered, which normally signified purity, but her body and dress also connote her sexuality – bare arms, a shapely neck, a pronounced bosom, an untied bonnet, a hitched-up skirt – while in the background, in the private space of the farmyard, animals can be seen roaming about, barely contained. She denotes an easy rural life and free, earthy pleasures, but belonged to a myth which enabled her audience to speculate upon those pleasures through a voyeuristic gaze.

Solitary farm women did not have to be sexual, which is partly why they were liminal. Sir George Clausen, one of the major artists of English rural life in the late nineteenth century, was a naturalist who

painted outdoors and aimed to reproduce his subject as literally as possible, a technique influenced by the French salon artist Jules Bastien-Lepage. By the 1890s Clausen was aiming to encapsulate movement in his figures and link them to their setting, and it was during this period that Clausen produced some of his best-known images of country men and women. He painted a hardworking rural population realistically, but somewhat like Hardy, to whom he has often been compared,[8] he increasingly represented them as part of the landscape they worked in. By the Edwardian period Clausen intentionally used rural labourers as symbols. The women he represented ranged from young to old, pretty to tough, and were never picturesque for its own sake. He always carefully chose good examples, or types, as his models to carry the messages he wanted to get across. His technique was often praised, though the critics who did not like his subject matter claimed they could not find any social critique behind his harsh images. In their view it appeared that there was no reason for him to paint such ugly scenes.[9]

Clausen's painting of Polly, the family nurse-maid, as *The Girl At The Gate* (1889) depicts a pensive young woman standing in a gateway to a farmyard, like King's seductive lass, looking out past the audience. In the background an old woman gazes at her, hand to face in an expression of worry while an old man looks on. Similar in theme to King's painting, Clausen's subject was very different. The light is overcast, even though it is summer, and the woman is not concerned with seducing her audience; she appears to have her own worries and concerns. Clausen represented a rural woman like Tess, who has a life of her own, and who was not just a pretty object to be desired. Like Tess, she was also unreachable for the middle and urban class audience who watched her, part of a remote world geographically and socially. Even Clausen did not distinguish between a nurse-maid and farm servant, though their work and social standing in the country were very different.

Tess was also liminal, a woman who stood at the boundary of girlhood and womanhood, who used country dialect and educated language.

> She was a fine and handsome girl ... her mobile peony mouth and large innocent eyes added eloquence to colour and shape. ... a slow heat seemed to rise ... and the colour upon her cheeks spread over her face and neck. ... Phases of her childhood lurked in her aspect still. As she walked along to-day, for all her bouncing handsome womanliness, you could sometimes see her twelfth year in her cheeks, or her ninth sparkling from her eyes; and even her fifth would flit over the curves of her mouth now and then ... to almost everybody she was a fine and picturesque country girl, and no more.[10]

This is a clue to Hardy's own vision of her. It is a hint to us that he at least sees her as higher than the average country maid, whose body became a metaphor for the land and moral condition of the community. But the distance between Hardy and his subject matter remained constant, as it did for Clausen. We can see this in Hardy's description of Tess's religious distress at the possible loss of her child – when she is just a child herself – in which he points both to her quaint peasant belief in Hell and her closeness to God. He does not present his readers with an insight into the psychic world of a woman who has been raped and is then presented with the likelihood that her child, the product of that rape, will die. He could not do this. Hardy sees Tess erotically, he presents her naturalistically, he admires her and gives her identity; in other words, as John Goode has said, Hardy objectifies Tess, so that 'at various points she is the object of consumption ... and the object of fascination ... and she is even the emancipated woman', who uses her education and resists Alec D'Urberville and Angel Clare.[11] She is given a more complex substance than other rural women in literature, but still Hardy could never move beyond the use of Tess as a symbol for the moral inequalities of his day; it is a mistake to suppose that he could do otherwise, but we can read much more into the text than Hardy wrote. Though Hardy uses childhood as a metaphor for innocence, Tess is more than she appears to be, and this is what we need to remember when looking at the other images of rural womanhood as they apply to her. When she baptises her baby she takes on the signs of divinity in a foreshadowing of her appearance as a goddess in the dawn. She is a split personality, divided between 'her conventional aspect and her innate sensations'.[12] And, like Dorothy, she escapes the author's control.

The novel was set in the period of the agricultural revolution. Because of this it contained elements of nostalgia, but there was also a danger for readers who may have remembered the period in question, who hoped to read a conventional account of the rural. *Tess* existed somewhere between continuity and change, at the point where the plough turned the furrow and the memory was broken, as Raymond Williams might have put it, and was the exception, not the rule.[13] After her child is born Tess works in the harvest field with the other village women. It was here that they are described as part of nature. Tess, among these figures in the landscape, was represented as 'the most flexous and finely-drawn *figure* of them all' (my emphasis). Though she works with the other women in the harvest field, Tess is represented as different to them; her body is more refined, she is therefore somehow superior, our eye is drawn to her, rather than the others; it is her work which is described in detail, her arm which loses 'its feminine smoothness' as it is

'scarified by the stubble and bleeds'. We are asked to note that 'The cheeks are paler, the teeth more regular, the red lips thinner than is usual in a country-bred girl', and that she had become 'a stranger and an alien here, though it was no strange land that she was in.'[14] Tess had begun to change, she had left her community, and therefore she stood out, even while working within it. She had been raped, and had had a child. Her smooth child-like body had been scarred. She began to exist in a border-land at this point, where she started to develop a complex identity that isolated her from all other women – rural working women, urban middle-class women, her home, and the men that she meets. The remaining working women continued to be largely represented in the background via the conventional images of the harvest field as a site of toil, community and some pleasure. Tess's femininity may have been sac-rificed/scarified by this point, but Hardy continued to work towards her elevation above the accepted images of rural women. The very scars on her wrists become Christ-like signs of sacrifice as she anoints her baby.[15] Hardy did not condemn her for her sexuality, for having had a child. She remained 'a pure woman' as the subtitle to the novel said – purity did not equate with virginity in the narrative, though it did in the bourgeois hegemony.

Haymakers and gleaners were widely employed by artists and writers at this time to construct a mythic fitness in the freshly re-colonised countryside. Both continued to be equally useful in illustrations, connoting co-operation, industriousness, an English land-scape, and accessible leisure, as they had through the century. *The Gleaners*, an illustration from L. G. Seguin's *Rural England* of 1885, is typical of scenes on this theme. Young women, virtually children, are shown working in a field gathering stray ears in a haphazard way, as if it were easy work; a group in the foreground are talking and resting. The eldest has a sheaf on her head, like a classic goddess. In the far back-ground ships sail across a calm sea and a cart of corn leaves the field. Many illustrations of harvest work used girls rather than women by this time. Percy Tarrant's *Gathering the Corn*, (c. 1900) for example, shows two girls with their gleanings, standing amongst poppies as a laden cart in the background leaves a distant field, which still has stooks waiting to be collected. Children did still participate in the harvest, but their labour was represented as more of a game than a necessary employment. The children in these pieces often carry the signs of innocence on their bodies: rosy cheeks and daisy chains. They became metaphors for country leisure, community and national well-being. Labouring children were therefore represented as being like middle-class children – playful, happy, healthy – but they remained distant from them. In this way, the

country children's work was legitimised and re-presented for consumption by the adult gaze. More commonly, such children were depicted in or near the family home, the cottage.

F. G. Cotman presented his audience with a perfect vision of one of these organic communities in *One of the Family* in 1880 (Plate 6). The painting shows a family meal, with its connotations of contentment, plenty, generosity, thrift and industry. This picture, like many others, reworked the dominant ideology of separate spheres in visual form, within a rustic setting. The father has just returned from work, the mother, grandmother and children are already eating within the idealised cottage interior. Outside the window we can glimpse a dovecote – sign of peace and felicity – while the horse, who is the family member mentioned in the title, partially intrudes into the domestic sphere for a treat from the table after his day's labour, and a dog leans on his mistress in the hope of similar largesse. Here the family are categorised as 'peasants' through signs of rusticity and their closeness to their animals, beasts of burden, domesticated, tamed and happy. The mother fulfils her natural role by her act of kindness and her obvious capability as a housewife and mother, as her husband – somewhat marginalised in this sphere – looks on benignly. Both he and his horse have come home, both have returned to the haven of domesticity. By this time, though, these dominant allegorical and idealistic images of the rural were regularly challenged, or at least reworked into a celebration of labour, rather than the organic community. Many artists and writers, as noted in the last chapter, were becoming ambivalent about the rural and began to fête transition instead of stability, newness rather than oldness, despite a widespread desire to cling to what was known and knowable as the end of the century drew near.

Henry La Thangue, like Clausen, was influenced by the French *plein air* school and was a member of the New English Art Club. His *Return of the Reapers* (1886) (Plate 7) presents an heroic image of haysel, akin to Clausen's *Haytime* (1882). La Thangue's picture does not connote community fun and frolics in the sun. It is set in the gentle afternoon, but clearly depicts the results of a hard day's labour in the full sun. The woman at the centre of the picture is not represented as an ideal, but as one who has to work. She is feminine, but shows the signs of her employment. The old man who walks behind, watching her, makes sure that she is at least within the range of parental male protection, therefore her work does not make her free to dally with lovers. Further, he stalks her like the grim reaper, reminding the audience of the effects time will have on her. Clausen's *Haytime* similarly shows the act of labour, the strength needed in lifting and turning hay. The woman, who

is the central figure in the piece, is pretty, but is represented more as a skilled labourer than as a decorative object. Clausen and La Thangue show women who are closer to one of Munby or Henley's field women than Percy Tarrant's children, but we should not confuse realism with reality in either case. It is the process of representation that we need to watch, not the degree of 'truth'. The artists in every case were as removed from their subject as Hardy, Jefferies, Bourne, Munby and Henley, and all of their images carried the connotations of celebrated health and moral welfare, in order to reveal the true strength of the nation. By this a time celebration of the rural could not be separated from the celebration of Englishness, nation and empire, and in the case of harvest and haysel this celebration was also gendered because of the depiction of women's work and wider references to the figures' family ties. Pastoral continued to capture the middle-class urban imagination as a metaphor of the state of the nation.

Nostalgic tales, like Matilda Betham-Edwards' *The Lord of the Harvest* (1899), recuperated the rural from the resistance located there in the late nineteenth century by evoking a domestic, rural English idyll from the outset of her novel, which began with a clearly nostalgic statement of intent 'When Queen Victoria was a maiden, harvestmen of East Anglia chose for their chief the best among them. Greater honour could befall none. ... This Suffolk usage [The Lord of the Harvest] dating from the olden time recalled Homeric story. ... Bad language, brawls, unseemly behaviour when women-folk were about, he must keep in check and punish'. Betham-Edwards – a farmer herself and a friend of Barbara Bodichon – then went on to celebrate masculinity, as well as pastoral, as something which could be dated back to the days of Homer – casting reflected heroic glory from the discourse of a classic education upon the uneducated men of the story.

> [Elisha/Master Sage/Lord of the Harvest] stood five feet eleven inches in his well-greased high-lows. He possessed the brawny limbs of the able-bodied man, of him who could shoulder a comb of corn and claim his full ten shillings a week. Heavy-faced, dull-eyed, no one would guess that he carried off kettle after kettle at the yearly ploughing match, and although unable to read or write, was first-rate at reckoning up.
>
> Elisha's career as a son of the soil had begun forty years before. From rook-scaring and stone-picking, when barely breeched, to the position of head horseman, was certainly a stride, but a stride that meant the same routine. To sow and to reap for old age, for thus it seemed good to the Almighty.[16]

Like Clausen's *Shepherd with a Lamb* (1883), (Plate 7), this carried connotations of godliness in farm-work. Rural men, like women, were

described through a discourse of the body that often tied them to the soil, but the strength of male bodies did not become a metaphor for the land as Nature, or signs of social decay, as was the case when women became 'brawny'. Men's bodies, even when they were likened to beasts of burden, or when their relationship to capital was emphasised – as here in the reference to 'able-bodied' and 'full ten shillings' – were represented as metaphors of strength and honest toil, farming as Culture. The emphasis on the collective nature of harvest work for men and women, where the men elected their own overseer, whose patriarchal control policed the community at work, made it an acceptable subject throughout the century, even when the connotation of these images subtly shifted from simple pastoral to the celebration of the physical fitness of the race through the process of representation. By 1891 Hardy was willing and able to pick up on these images for women and men.

The milkmaid was less important to the discourse of empire, but continued to figure widely in the myth of rural femininity, and of course became an integral part of the development of Tess's character. Myles Birket Foster's *The Milkmaid* (c. 1880) and William Mark Fisher's *Milking Time* (Plate 9) for example, could be transposed with John Clare's earlier poem 'The Milkmaid is Bonny and Fair' and *Tess*, as if the image was continuous, unchanging and unchallenged, despite George Eliot's Hetty, and parallel images of comic rather than fair maids. The discourse of domesticity served to close the debate about the paid work of the dairymaid before it had managed to emerge; both the representation and the 'reality' of the work remained largely unchallenged. Hardy himself worked at providing accurate details about their labour, without raising the social concerns he evinced in his evocation of field work. Dairying and the image of the dairymaid appear to never have come into opposition and therefore never challenged each other.

To return to Foster and Fisher, we can see the ongoing production of the myth of the milkmaid at work. Both pictures were painted in the late nineteenth century and each has a young woman set amid the summer countryside, going about her task unaware of any observer – the one a goddess, the other a part of Nature, both akin to Tess. Foster's maid is captured as she walks over a bridge. She balances her milk pail on her head with one hand, the other she holds to her bosom in a classical pose, ostensibly holding a scarf, but also signifying modesty, propriety, and her own potential fecundity. Fisher's woman is milking a cow out in the open field but only the animal itself appears to be aware of the audience; the woman's face is hidden by a hood and she has her back to us. The maid is so intent on her work, she merges into the cow and the surrounding countryside. Though involved in labour, both milkmaids carried the

graces which were praised most highly in rural femininity. They were hard-working, but young, pretty and decorous. They were white, pure Englishwomen and it is this context which has changed since Clare's poem. Foster and Fisher worked within the discourse of empire, as well as femininity, art, and Nature. The dairymaid came to be a metaphor for the entire range of feminine virtues, and to stand at the border between virginity and motherhood, Culture and Nature, within which class was hidden and gender made universal.

The milkmaids in *Tess* were therefore based on the most common of images: 'They were blooming young women', who lived at the farm 'comfortably, placidly, even merrily. Their position was perhaps the happiest of all positions in the social scale'. Each of the dairymaids was different, but they were predominantly described as 'pretty' or 'fresh-looking' and interested in love. When dressed up for church, they 'went forth to coquette with flesh' and were 'rosy-cheeked, bright-eyed ... charming in their light summer attire.' As Hardy notes, *en masse* at work 'Differing one from another in natures and moods so greatly as they did, they yet formed, bending, a curiously uniform row – automatic, noiseless; and an alien observer passing down the neighbouring lane might well have been excused for massing them as "Hodge".' But Tess is transcendent. In the eyes of Angel Clare, middle class, educated, urban 'alien', she is Artemis and Demeter at the dawn of the day, even though, still of the border, she becomes Tess once more when the day has broken.[17]

'She was no longer the milkmaid, but a visionary essence of woman – a whole sex condensed into one typical form.' Tess is deified by Clare, and for Hardy's readers, so that he feels compelled to consume her – her body becomes likened to the milk, curds and butter she works with, – he must marry her, despite her protests. In order to do this she must mimic his 'vocabulary, his accent, and fragments of his knowledge', and he must make her his child-like 'Tessy',[18] although when she first refused his proposal he had already recognised that in this process of consumption he would change her:

> She went out towards the mead, joining the other milkmaids with a bound, as if trying to make the open air drive away her sad constraint. All the girls drew onward to the spot where the cows were grazing in the farther mead, the bevy advancing with the bold grace of wild animals – the reckless unchastened motion of women accustomed to unlimited space – in which they abandoned themselves to the air as a swimmer to the wave. It seemed natural enough to him now that Tess was again in sight to choose a mate from unconstrained Nature, and not from the abodes of Art.[19]

To Clare, and to Hardy's audience, Tess was like any rural woman, free, unchaste, bold, wild, independent due to her class, though like any dairy woman, she remained respectably feminine. She was a figure in the distance, worthy of closer study, ripe for the middle-class gaze. But the very process of observation transformed her into an idealised figure of femininity, equally distant and unobtainable. If consumed, she would no longer be what Clare and Hardy's readers desired, she would be bounded by the limits of art and the dream of distance would be shattered. This is what happens when she finally marries Clare and naively confesses her actual impurity.

Clare suddenly discovers that the image of the pure dairymaid is not a reality. She takes on a new, equally distant identity: the fallen woman. Though she is innocent of middle-class morality, Tess is not seen to be innocent by those who believe in it. She is suddenly pitched from the pedestal of natural beauty into the mire of sexuality. In this way, Hardy showed his audience how women were wronged by the standards, or rather the polarities, of the period. She is not culpable in her actual moral fall, nor does it detract from her real character and femininity; only the values adopted by the middle class make her suffer. She is the exception that he creates to prove the rule.

Tess therefore leaves her idyll to work on an arable farm, the only possible place for a disgraced rural maid to go. The work she has to do there is described by Hardy as utterly exhausting and unfeminine. Hardy again uses dominant representations, this time of field-women, to describe the awful world into which Tess enters, as she becomes yet another form of rural woman: 'she ended with the heavy and coarse pursuits which she liked least – work on arable land: work of such roughness, indeed as she would never have deliberately volunteered for.'[20]

In the case of Tess's friend Marian, no other work is available, because she drinks. Two other field-women, described as 'Two Amazonian sisters', fight, and also drink. 'They did all kinds of men's work by preference.'[21] Like Bourne, Clausen or La Thangue, Hardy described the work the women do in sympathetic detail, in heroic terms, and used these images of immoral, masculine women to signify the true horror of the setting. Hardy happily employed the image of the field woman as one who could get no other work, or who was masculinised to develop his plot. Tess was rejected by Art or Culture and therefore had to return across the border to Nature; in this case debased animal nature, as a woman, not a goddess. Only very rarely did women's field work ever slip into the heroism associated with men's field work. In 1879, John Robertson Reid, a rural landscape painter who often tended to sentimentalism, used field work to highlight the social criticism of *Toil and*

Pleasure, in which the hard work of the labouring class, of all ages and both sexes, is contrasted with the leisure of the wealthy as a group of men, women and children stop work in a wintry turnip field to watch a hunt go by.

The social divisions in the image are intentional; however, there are also gender divisions in the picture which are probably assumed, rather than meant as commentary. The hunting group are all men (though women did ride to hounds none did so in this case); the working group, on the other hand, includes girls and women, despite the 1870 Education Act and the Gangs Act which were supposed to have removed children from this kind of labour – or so disgruntled farmers were complaining at the time. The labouring boys are active and want to hunt, the girls are passive spectators. The women's presence and toughness adds to the poignancy of the picture, the apparent hardship of working-class, as compared to upper-class, life. Thus the women's and girls' exertion is represented as something which ought to be condemned. They signify difference, distance, the need for pity.

This social realism was rare. Clausen painted some of the best-known pictures of field work, but as in his representations of harvest and haysel, his art tended toward the monumental, rather than the social. In *Winter Work* (1883) (Plate 10) a couple work in a barren landscape. The man stands alone, hacking turnips, while the woman pauses to concentrate on a girl who is visiting them, rather than the job in hand. The girl herself has been rescued from field labour by the Education Acts, as her hoop and lunch-bag indicate. *Winter Work* is gendered by the presence of this girl who signifies the old woman's motherhood. What is revealed is the ongoing rural paradox of continuity and change. The girl becomes a metaphor here for the changes of the period, the desire to provide the children of the poor with the pleasures and rights of childhood – the hoop and an education – whereas the cold, hard work that her parents are doing seems timeless. Clausen's middle-class, urban audience are invited to speculate on this tension, and if they engage in this process then nostalgia and childhood are brought into question. Is the past really better than the present? Will an education really enable this girl to escape the destiny of her forebears? This reflects some of the wider tensions of the period, and the wider unease about the vision of the peasantry as constantly hardworking, honest and healthy; a tension which Hardy went on to use to equally great effect. But the gendered roles in the picture and the class position of the figures in relation to their audience are never intentionally addressed. The category 'rural labouring woman' or 'rural labouring man' was never challenged. As Lynda Nead suggests, these images are not a manipulation of reality, they

are the site where a range of identities were constructed; these pictures of single women, dairymaids, harvest and field workers visually reworked or re-presented dominant ideologies. Through them, femininity was defined, separate spheres legitimised as universal and 'natural', urban fears about the working class were displaced and the agonies of the agricultural depression removed, all of which added to the national identity.[22] What we are able to see if we compare the representation of the experience of rural women with what is supposed to have been their actual experience, according to a range of documents, is the distance between observers and observed that enabled the process of construction to take place, and the result of this process. We can also see – from our own distance – the changes that took place over time in that process and in the resulting constructions, despite the rhetoric of continuity inherent within them.

The women and men Hardy depicted were signs of nature, the land and of Englishness, in that they were given ancient histories, which could be found in the churches which surrounded them. Christianity, history, the countryside and its people were linked, like morality, the landscape and work. But *Tess* is not simply a nostalgic text lamenting a bygone past. It is also revolutionary. Tess can be seen to have been each form or category of rural womanhood, but she was also more than an image. She was more than people saw her to be when a young girl, finer than other countrywomen in the harvest field, could become a goddess as a dairymaid, and was not so debased as the others on the arable farm. Many of Tess's problems stemmed from being torn between the complex, cultural, more urban side of femininity, and the simpler, rural part of herself. She lived on the border between Nature and Culture. Hence, Clare says of her: 'You almost make me say you are an unapprehending peasant woman, who have never been initiated into the proportions of social things'; but she answers him: 'I am only a peasant by position, not by nature!'[23]

More to the point, she was only a peasant in his fantasies. Both Hardy and Tess resist the stereotype, though Hardy does this through compensation, while the character Tess does so through an act – potentially revolutionary – of murder, and is sacrificed on the altar of Englishness for her trouble. Hardy may have tried to claim ownership of Tess, 'My Tess', but she finally escapes his ideological grasp.[24] The distance between author, audience and subject that we see in most other texts representing rural women remained, but Tess is the exception to most other rural women; in this case distance means that she can break out of the normal bounds of representation, so that *Tess* as a novel is also the exception, not the rule. Where other rural women who become

subject rather than object fall back within the disciplining bounds of domesticity, she makes by far the cleanest break, which is why she stands out in our memory.

Hardy's representations of women were complex. Often more heroic and sympathetic than many of his contemporaries' constructions, rather than challenging images of femininity he intended that they remained vehicles of an attack on the morals of his day. Therefore he did not challenge representations of rural women, so much as add detail to them and make them more real, an increasingly popular approach to the rural in his time, as it was tamed by the urban middle class as a site of leisure and a backyard empire in which to engage in adventures. The desire to collect rural specimens and to read about them came about as the rural came under threat from external competition, depression and depopulation. Authors like Jefferies and painters like Clausen provided a catalogue of a seemingly genuine peasantry which assured their readers that there was still continuity with the English past, despite the ostensible motivation to record as many of these specimens as possible before they disappeared. Hardy also used this approach to make his readers feel at home in his descriptions of the rural. But he could not give completely 'accurate' representations of rural women, and we should not expect him to. He was reworking their 'reality' within the discourse of literature, which reflected and created the codes by which he and his middle-class audience lived. We need not look for accuracy, but the process by which the discourses of the rural, femininity, nation, and then race intersected in the late nineteenth century and re-colonised the countryside after the horror of the 1860s and 1870s. The 'reality' of rural life was reinstated, disciplined and controlled through the dominant representations of the countryside as the site of natural domesticity, natural childhood, natural community, natural health.

NOTES

1 *Punch, or the London Charivari*, 7 May 1892, p. 226.
2 Weissman, J., *Half Savage and Hardy and Free: Women and Rural Radicalism in the Nineteenth Century Novel*, Connecticut, 1987, pp. 238-61; Howkins, A., 'From Hodge to Lob: reconstructing the English farm labourer 1870–1914', unpublished, 1986.
3 Sales, R., *English Literature in History 1750–1830, Pastoral and Politics*, London, 1983, pp. 15-18.
4 Reynolds, K., *Girls Only? Gender and Popular Children's Fiction in Britain, 1880–1910*, London, 1990, pp. 108–09, 138–50.
5 Horn, P., *The Victorian Country Child*, Stroud, 1990, pp. 21, 44, 85, 202. For example, when discussing superstition in the countryside she says: 'Readers of Thomas Hardy's novel, *The Return of the Native*, will likewise remember that

Susan Nunsuch, one of the villagers, believed that her child's sickness was due to witchcraft, and she sought by the same means to effect a cure. Perhaps fortunately, such extreme examples as these were rare.'; Samuel, R. (ed.) *Village Life and Labour*, London, 1975, p. 14; Kitteringham in Samuel (ed.), pp. 77–81, 93, 95, 114.

6 Hardy, T., *Tess of the D'Urbervilles – A Pure Woman*, London, 1978, pp. 37–9, 497.

7 Hardy, *Tess*, p. 138.

8 For example see Wood, C., *Paradise Lost, Paintings of English Country Life and Landscape 1830–1914*, London, 1988, p. 62.

9 Bradford Art Galleries and Museums and Tyne and Wear County Council Museums, *Sir George Clausen R.A., 1852–1944*, Bradford, 1980; Treble, R., 'The Victorian picture of the country' in Mingay, G. E., *The Victorian Countryside*, London, 1981; Rodee, H. D., 'Scenes of rural and urban poverty in Victorian painting and their development 1850 to 1890', unpublished PhD thesis, Columbia University, 1975.

10 Hardy, *Tess*, pp. 51–2.

11 Goode, J., 'Woman and the literary text', in Mitchell, J. and Oakley, A. (eds.), *The Rights and Wrongs of Women*, Harmondsworth, 1986, pp. 253–4.

12 Hardy, *Tess*, p. 141.

13 Goode, 'Woman and the literary text', p. 255; and Williams, R., *The Country and the City*, London, 1985, p. 203.

14 Hardy, *Tess*, pp. 138–9

15 *Ibid.*, p. 144.

16 Betham Edwards, M., *The Lord of the Harvest*, London, 1913, 1st edn. 1899, p. 2.

17 Hardy, *Tess*, pp. 185–96.

18 *Ibid.*, pp. 238-40.

19 *Ibid.*, p. 236.

20 *Ibid.*, p. 355.

21 *Ibid.*, *Tess*, p. 366.

22 Nead, L., *Myths of Sexuality: Representations of Women in Victorian Britain*, Oxford, 1988, p. 42.

23 Hardy, *Tess*, p. 302.

24 Goode, 'Woman and the literary text', pp. 251–5.

☙ CONCLUSION

Authors like Richard Jefferies used rural women as signs of freedom and animal nature. His description of a farmer's daughter in *The Dewy Morn* (1884) is powerfully voyeuristic in its naturalistic use of the woman's body:

> Her strong heart beating, the pulses throbbing, her bosom rising and regularly sinking with the rich waves of life; her supple limbs and roundness filled with the plenty of ripe youth; her white, soft, roseate skin, the surface where the sun touched her hand glistening with the dew of the pore; the bloom upon her – that glow of the morn of life – the hair more lovely than the sunlight; the grace unwritten of perfect form.

Running up a hill she is

> like a hare, or a beeher sinews, strung and strong, lifted her easily ... her deep chest opened, the pliant ribs, like opening fingers made room for cubic feet of purest atmosphere. ... Her limbs grew stronger, her bounds more powerful ... the labour increased her strength; her appetite for the work grew as she went. ... she would have dropped like a hunted animal before she would have yielded. ... She triumphed; she was full of her own life.[1]

Jefferies describes her skin, bosom, limbs, and hair in minute detail, and even her heart, pulse, lungs, and sinews. He likens her to a hare, a bee and a hunted animal and links her to nature through the air she breathes, and her very essence: 'Her natural body had been further perfected by a purely natural life. The wind, the sun, the fields, the hills' freedom and the spirit which dwells among these, had made her a natural woman; ... beauty and strength – strength and beauty.'[2]

This is an objectified image akin to those used for native African women by this period.[3] She is utterly unlike the passive, weak, civilised femininity celebrated in middle-class women. She is sensuous, strong, an animal; ripe, round and pulsing with energy, glistening with sweat. If she had not been innocent of observation, in love with life not men, and passive when she later meets her lover,[4] she would have been a temptress, corrupt and fallen. Rural women were almost as alien as black women to their observers, and their bodies carried very similar signs. But

in the case of English women their boundless health and fecundity boded well for the nation, where their African sisters were seen as a threat for the very same reason. By this time, the discourse of empire looked to young women to provide fit and healthy children for the race as a social duty. The countryside was still expected to nurture that health, despite the rural exodus, unionisation, and the individual labour of men, women and children. The discourses of gender, Englishness and eugenics intersected so that these women did not just add to the myth of sexuality, but also offered an equally attractive vision of physical well-being, which stood in stark contrast to the supposed deterioration of the urban masses.

By 1880 William Howitt could write *The Boy's Country Book*, in which he set out a semi-autobiographical menu of country pursuits for boys, and offered the middle-class urban adult and child reader an escape into a world of adventure and pastoral boyhood. He even included a chapter on 'Employments of the Children of the Poor' in which he quite clearly reminded his readers of their place, in a way that echoed the rise and fall of concerns about country childhood:

> The thing in the county which, next to one's own busy schemes, interests one, is observing the different employments of other children. ... I used to pity those [village] lads, and think how hard it was, when we might have been strolling a good way off birds'-nesting, that they must be confined to a field picking stones off the grass, or looking after the lambs; but I don't pity any such lads now. I have seen and heard a little more of the world, and the life of village children seems to me quite heavenly, compared to that of thousands of town children.[5]

Poor labouring women were initially seen as children; then as prostitutes, a disease, witches, murderers, viragos; and finally, as mothers. When thinking about the myth of poor labouring women, I have not aimed to compare 'reality' with 'fiction'; there is no simple mirroring of the one by the other. I have looked at the public re-presentation of 'reality', the official, visual and literary reworking of ideology. I have done this in order to understand how rural women's experience was interpreted by those at a social, economic and literal distance from them, and what effect this might have had on the women themselves and for those who helped create and recreate the myth. The representation of rural women in the nineteenth century, as prompted by the intersection of key discourses at specific moments in time, effected a very real delineation and policing of their lives. In other words, there was a two-way process going on.

When reality did not fit what was represented, then reality was

made to change – through legislation, for example – and when the representation did not fit the reality, then the representation was made to change – through the use of the new imperial discourse, for example. Reality and representation did not simply reflect each other, they were equally involved in a process of production; the production of new identities, partly worked through the social, economic, and literal distances between those who were observed, and those who watched. Distance remained constant in all of the texts I have considered, in that rural women always belonged to a different class to their bourgeois, urban audience, even when authors, like Hardy, came from the countryside, or, like George Eliot, were women. Authors like Harriet Martineau, Charlotte Yonge, Mary Russell Mitford, Mary Linskill, Matilda Betham-Edwards, Beatrix Potter, and artists like Margaret Thompson, Ada Shripton, Margaret Tarrant, Mrs Alexander Farmer, Katherine L. Beard and Helen Allingham – only some of whom have been discussed – created idealised rural images that were as stereotypical and compensatory as those created by their male counterparts. Equally, others, like Elizabeth Stanhope Forbes, created work that was as challenging as that of some male authors and artists. This should not surprise us, for women were as embroiled by capitalism, patriarchy and imperialism as men. There was a degree of collusion even when women had an overt political agenda of resistance, such as feminism. Middle-class women were bound by the conventions of respectability in the very act of resistance, and they were constrained by the relations of capital. Men and women therefore internalised the representations I have considered, and were bound to reproduce them through the axes of class, gender and pastoral, even when challenging aspects of these discourses. We can read these texts suspiciously, but we belong to a different historical context.

The representation of rural women metamorphosed through the nineteenth century thanks to economic, social and cultural changes in the form of deskilling, unemployment and unionisation; the growth of agri-business as an industry, even in depression; and the development of a rural idyll based on pastoral, then social realism and wider concerns about race, nation and empire. Women's work in agriculture was surveyed by Parliament in 1843, the 1860s and the 1890s. Social commentators and the local and national press disseminated the findings of the parliamentary reports and added to the available body of evidence through independent research, based on the same ideology of expert objectivity and growing belief in domesticity. The only dissenting voices that were heard were those of farmers, a few partial men – like Arthur Munby – and the feminists of Langham Place, who evinced sympathy rather than fear, when confronted by the 'facts'.

The farm work that women did varied by region, season and over time, but changes in the sexual division of agricultural labour were constant throughout the nineteenth century, as new technologies, including new methods of farming, were introduced. Sometimes the introduction of a new crop would mean an increase in women's employment; for example, when turnip farming became widespread more women were needed to hoe and harvest. However, by the end of the period, women had lost most of their well-paid, skilled farm work, even in the dairy. During the first half of the nineteenth century the women worked beside the men at cutting the corn and hay with sickles, but this better paid work became the exclusive province of the male labourers when the scythe was introduced. It was said that the new tool was too heavy and unwieldy for women to use.[6] Fewer and fewer women were employed in any kind of farm work at all. This contraction occurred during the last half of the century, because of the new technologies and the agricultural depression of the 1880s, and paralleled the reduction in the number of men employed, while children were removed from farm work for most of the agricultural year by the Education Acts. The economic context of the texts I have looked at therefore changed dramatically, not just in terms of their own production and consumption, but also in terms of the wider needs of capital in the countryside.

Paid farm work was never a major employment for women in the nineteenth century, despite an initial increase in their numbers while the new labour-intensive methods of capitalist agriculture spread. But it had always been available as an option for village women who could not go into domestic service, take in outwork, or enter a factory. In their parliamentary evidence, the women themselves apparently said that they had many reasons for becoming farm labourers, including the need to earn a wage and the freedom it gave them. It was these two factors, pay and independence, which became most detestable in the eyes of the middle class in the 1860s, as femininity was universalised, and as agriculture began to need fewer labourers.

The countryside had been largely seen as an economic or picturesque arena until the beginning of the nineteenth century. Even then, the middle class maintained an image of the rural as a healthy, moral environment – even if the inhabitants might be a little stupid now and again, they were pure and simple – based on a Romantic notion of nature, and pastoral. This belief in the rural idyll was reflected in the expansion of suburban middle-class housing during the nineteenth century, which supposedly combined the benefits of both worlds: rural innocence with urban sophistication. Spatially and socially the countryside was at an increasing distance from the middle class, however, even

in the provinces; they went there to enjoy their leisure time, but were ultimately urban, particularly after 1861, when nature began to be seen as terrific, rather than beneficent. The rural was a site of traditional power, to be both desired and feared.

Women were placed at the heart of this social and cultural stage. The perfect rustic scene was of a woman playing with her children, outside the rose-smothered door of a thatched cottage. This image came from the intersection of two ideals that were central to middle-class ideology and reinforced each other. One concept, the dominant construction of femininity, defined women as innately domestic and moral. The other, the rural idyll, presented the countryside as the site of the perfect, natural community. The purest, most contented wife and mother therefore lived an exemplary life in a country cottage beside a village green.[7] This conjunction of ideals can be seen in numerous oil and water-colour paintings of the period, which also constructed the countryside as the perfect site of childhood and helped define English national identity.

Culturally, the Romantic construction of childhood as a garden was added to by the use of peasants as carriers of middle-class values in art, literature and prose. Representations of rural children, like those of women, became the platform on which both the rural idyll and childhood were defined. Visual images of the country child at play in a field or outside a cottage became a paradigm and a metaphor for innocence and stability. Reality was manipulated so that conflict of any kind vanished in these images; distances were negated and the identity 'rural child' was defined for urban middle-class consumption.

We can see this process at work, in the late nineteenth century, in Charles Wilson's *The New Arrivals*, in which a poor country child is shown playing near a picturesque – decaying – cottage. A small girl in a white pinafore holds and plays with some kittens, who have just had a saucer of milk. This picture connotes a simple, peaceful country life. But like many similar texts, the child's playthings, her proximity to her cottage and other signs of and metaphors for rustic domesticity – sunshine, roses, a broom, a basket of onions, a caged bird, a discarded sunbonnet, the act of caring and feeding – signify her future adult, gendered role, and help construct a supremely picturesque vision of children as passive, innocent, pretty, and in need of protection. At this point, rural children were objectified for the adult gaze.

But these images of rural women and children were not fixed. They were adapted in the same way as reality was altered in the traffic between 'truth' and 'fiction'. Flora Thompson's *Lark Rise*, published in 1939, shows how the image of the field woman, for instance, could still

be problematic in the early twentieth century, but also how this image had shifted and been tamed by the distance of time. The book probably recounts Thompson's memories of her Oxfordshire childhood in the 1880s, but exists somewhere between autobiography and fiction.[8] However, though she came from the countryside, she was still at a social distance from her subjects, as her father was a mason, rather than a farm labourer.

Thompson remembered six '*respectable* women' (my emphasis) who did field work in the 1880s. Their children had left home, which meant that they had some spare time, and they liked the extra money earned in the fresh air:

> A few women still did field work, not with the men, or even in the same field as a rule, but at their own special tasks, weeding and hoeing, picking up stones, and topping and tailing turnips and mangolds ... Formerly, it was said, there had been a large gang of field women, lawless, slatternly creatures, some of whom had thought nothing of having four or five children out of wedlock. Their day was over; but the reputation they had left behind them had given most country-women a distaste for 'goin' afield'. ...
>
> [They] worked in sun-bonnets, hobnailed boots and men's coats, with coarse aprons of sacking enveloping the lower parts of their bodies. One ... was a pioneer in the wearing of trousers ... the others had compromised with ends of old trouser legs worn as gaiters. Strong, healthy, weather-beaten, hard as nails, they worked through all but the very worst weathers and declared they would go 'stark, staring mad' if they had to be shut up in a house all day.
>
> To a passer-by, seeing them bent over their work in a row, they might have appeared as alike as peas in a pod. They were not.[9]

Thompson went on to describe the characters of three of them, invoking their physical appearance to do so. One was 'ingrained with field mould and the smell of earth about her, even indoors'. She had reared a child she had had after a man deserted her, refusing to marry until she had done so, though she was 'really ugly'. The one who wore the trousers, kept a spotless home, was 'a rough tongued old body, but independent and upright ... Her gentle, hen-pecked little husband adored her.' The last was 'comfortable, pink-cheeked' and loved children.[10]

Closer to the women than many authors who wrote of them, Thompson still felt bound to re-create them for her audience via the discourses of the body and sexuality. Thompson accepted the definitions of gang women as immoral, but said that these women were long gone. Field women could be seen sympathetically, by the end of the century, as

the exception rather than the rule. Thompson then attempted to bridge the gap between observer and observed by including tantalising details, drawn from her own experience, so that the women she described in the 1880s were represented through the imperial discourse of types, rather than the medico-moral discourse of prostitution.

The representation of field women in the mid-nineteenth century centred on the crucial definition of class, domesticity and sexuality. Their existence questioned and threatened the construction of femininity in the 1860s, while they also offered a platform on which to discuss contemporary urban social questions, especially prostitution. In many respects, especially the ideological divisions of good/bad, white/black, clean/dirty, asexual/sensuous, the representation of and responses to poor labouring women were very similar to those around urban working-class women. Similarly, as members of the rural working class, country women could be used as vehicles of middle-class values in the same way as countrymen, who came to be metaphors for honesty, diligence, hard work, and loyalty – except when they were drunk. However, it can be seen that there was also something different at stake here. Farm women came from the countryside, and were therefore meant to embody the absolute ideals of Englishness and community, while as white women they should also have supported the ideal vision of femininity and domesticity. But farm women did none of these things – except in the dairy or at harvest-time. Instead, they earned a wage; worked outside, beyond home, family and community; and did hard physical labour. The farmers may have called it women's work, but it was far from being feminine. Their tough, masculine, practical clothes, tanned or dirty skin, bare arms, and powerful limbs also crossed the boundaries of race. They therefore moved into the realm of alien, dark, sensual, sexual womanhood.

Like native women, poor labouring women at this point, could have become either heroic symbols, or degraded remnants, of humanity. New boundaries were therefore constructed, literally in terms of legislation, which disciplined them and limited their supposed freedom, while the limits of the myth of rural womanhood were also stretched to include new tamed, racial images, which fitted the newly discovered reality of an alien world beyond the city. This was then reworked through a concern to promote physical as well as moral fitness into a new ideal based on empire.

Mary Russell Mitford's *Our Village* (1824–32) summarised many of the wider images of rural femininity that became available in the late nineteenth century. Most of the women in the book did not take paid work, but lived in their cottages or were seen within the village, on a

road which was not nearly as threatening as the urban street. One, for example was 'a plump, merry, bustling dame.' The publican had 'a stirring wife', the carpenter an 'excellent wife'. There were some 'squabbling women', and 'the prettiest, merriest lass in the country', and 'a tall, ...stately ... dark ... gypsy-looking, bonneted and gowned ... perfectly honest, industrious, painstaking' washerwoman.

Later, Mitford described 'approaching so slowly and majestically, [a] bundle of petticoat and cloak, [a] road-wagon of a woman ... the completest specimen within my knowledge of farmeresses as they were', while Mrs Allen '[sat] feeding her poultry, with her three little grand-daughters from London, pretty fairies ... playing round her feet.'[11] Mitford's representations of rural women were of mothers, cottage women and pretty girls. They were seen at a distance, different from middle class and urban women, but quaint and interesting because of it; having been tamed rural women could be collected from any period for the delectation of Mitford's readers.

The countryside became a place where people holidayed in the summer, and country books themselves became vacations for their readers. They provided an escape from the crowded, unnatural, uncommunal landscape of the urban everyday world. These images also provided a vision of what England should be: unpolluted by industry, without conflict, crime, or violence, an organic society. By the 1890s, publicists like Richard Heath, F. E. Green, William Morris, and General Booth, despite their diverse political backgrounds, became increasingly critical of the industrial environment in which the English race was supposed to have degenerated, although there were also attempts by *fin de siècle* authors and artists to celebrate what was new and artificial and reject the false sincerity of rural life. Observers turned to the countryside to find the remainder of the pure, strong, healthy English stock they needed to revitalise society. They were shocked to find that this did not exist, thanks to the steady depopulation of the countryside that had begun during the industrial revolution and accelerated as the agricultural depression took hold. Therefore, there was also an impulse to try to understand the city and validate it, and to explore the rural like an alien land, not just to see it as a site of leisure. The condition of the rural was increasingly perceived to be one of national importance, like motherhood, as fears about the efficiency of the nation and race, and therefore the safety of the empire, grew.

Books by authors like Hardy, Mitford and Jefferies enabled a new kind of rural expertise to develop. Jefferies wrote of the past as much as of the conditions of the present and celebrated the eugenic ideal of 'strength and beauty' as formed by country life. As Jan Marsh has said, as

the countryside declined in population and prosperity from the 1860s, the ambivalence of the rural as a place of either peace or boredom ended. Instead, a nostalgia for the old ways developed among the urban upper classes.[12] At the same time poets like Arnold and painters like Clausen began to shift away from ideas of nature as something which could guide and comfort humanity, to seeing it as something awful and terrible to behold.

Rural women were represented as truly feminine, unthreatening quaint figures in their villages and cottages, or sexual objects. These images constructed what women's lives and femininity should be through the polarities of what was good and what was bad. The ideal cottage wife and mother was one side of the coin; the youthful, pretty temptress or prostitute on the other. These images came from the wider division of perceptions of the countryside, and the mixing of old and new visions of rural femininity. I began by looking at the myth of rural femininity and considering how this was produced, and what effect it had had on those who constructed it and those who were represented through it. I have ended by looking at the wider myths of the Beau Ideal, Englishness and empire. This should not be surprising. The construction of respectable femininity, so important to the cultural hegemony of the bourgeoisie, developed through a projection of values onto the rural, and the reworking of ideology within a variety of texts. The myth of the rural woman was formed through the intersection of several discourses. To question her existence or experience then and now, was and is to question the authority of those discourses, and necessitates a reworking of both myth and reality in a dynamic equilibrium which has little to do with reflection, everything to do with the ongoing construction of new, powerful and pleasurable identities. This process of negotiation is as important today as it was in 1843, 1863 and 1893, and has had a very real impact on women's everyday lives.

NOTES

1 Jefferies, R. *The Dewy Morn, A Novel*, London, 1982, 1st edn. 1884, pp. 4–5, 7–10.
2 Jefferies, *The Dewy Morn*, p. 10.
3 Davidoff, L., 'Class and gender in Victorian England' in Newton, J. L. *et al. Sex and Class in Women's History: Essays from Feminist Studies*, London, 1985, pp. 20– 2; McNelly, C., 'Natives, women and Claude L`evi-Strauss, a reading of *Tristes Tropiques* as myth' in *Massachusetts Review*, 16, 1975.
4 Jefferies, *The Dewy Morn*, pp. 1–4, 6, 13, 48–9.
5 Howitt, W., *The Boy's Country-Book*, 1880, pp. 129–30.
6 See Roberts, M., 'Sickles and scythes: women's work and men's work at harvest time', *History Workshop*, 7–8, 1979, pp. 3–20.

7 Davidoff, L., L'Esperance, J., and Newby, H., 'Landscape With figures: home and community in English society' in Mitchell, J. and Oakley, A., *The Rights and Wrongs of Women*, Harmondsworth, 1986.

8 English, B., 'Lark Rise and Juniper Hill: a Victorian community in literature and history', *Victorian Studies*, 29, N. 1, 1985, pp. 7–17, 33–4; Howkins, A., *Reshaping Rural England, A Social History, 1850–1925*, London, 1991, p. 249.

9 Thompson, F., *Lark Rise to Candleford, A Trilogy*, Harmondsworth, 1979, 1st edns. 1939, 1941, 1943, p. 58.

10 Thompson, *Lark Rise*, pp. 58–9.

11 Mitford, M. R., *Our Village*, London, 1893, 1st edn. in five parts, 1824–32, pp. 13–19, 50–3, 78, 116.

12 A. Marsh, J., *Back to the Land: The Pastoral Impulse in Victorian England from 1880–1914*, London, 1982, p. 4.

ᶜᴼᵛ SELECT BIBLIOGRAPHY

PUBLIC DOCUMENTS

British Parliamentary Papers

'Census of Great Britain' 1801: 1801 (140). vi.813 – 1801–2 (9). (112). vi. vii; 1811: 1812 (316). (317). xi; 1821: 1822 (502). xv; 1831: 1831 (348). xviii.1; 1851: 1852–53 [1631]. lxxxv.1., [1632]. lxxxvi.1., [1691–I]. lxxxviii. pt.I.1., [1691–II]. lxxxviii. pt.II.1.; 1861: 1862 [3056]. L.1., 1863 [3221]. liii. pt.I.265., pt.II.1., [3221]. liii.1.; 1871: 1873 [c.872]. lxxii. pt.I.1., [c.872–1]. lxxi. pt.II.1.; 1881: 1883 [c.3797]. lxxx. 583., [c.3722]. lxxx.1.; 1891: 1893–94 [c.7058]. cvi.1., [c.7222]. cvi. 629.; 1901: 1905 Cd.2660.CII.1., 1904 Cd.2174.cviii.1.; 1911: 1913 Cd. 7018., Cd.7019. lxxviii.321. lxxix.1., 1917–18 Cd.8491.xxxv.483.; 1921: Cmd.1485.xvi.257.

'Report From His Majesty's Commissioners on the Administration and Practical Operation of the Poor Laws' PP 1834: (44).xxvii; (44).xxviii; (44).xxix; (44).xxx; (44).xxx1; (44).xxxii; (44).xxxiii; (44).xxxiv.

'First Report of the Factories Inquiry Commission, Employment of Children in Factories' PP 1833:, (450).xx; (519).xxi.

'Sixth Report of the Children's Employment Commission' (1862) PP 1867: [3796]xvi.

'Reports From Select Committees on the Act for the Regulation of Mills and Factories' PP 1840–41: (203).x.

'Reports From the Royal Commission on Labour', PP 1892–94: [C.6708]xxxiv; [C.6708–V]xxxv; [C.6708–II]xxxiv; [C.6894–I]xxxv; [C.6894–III]; [C.6894–V]; [C.6894–XIII]; [C.6894–XXV]xxxvii pt.II; [C.6894–XXIV].

'Reports of Special Assistant Poor Law Commissioners on the Employment of Women and Children in Agriculture,' PP 1843: [510]xii.

'Reports From the Commissioners on the Employment of Children, Young Persons and Women in Agriculture,' PP 1867–70: [4068]xvii; [4068–I]; [4202]xiii; [4202–I]; [C.70]xiii; [C.221]; [C.221–I].

'Reports of the Royal Commission on the Depressed State of the Agricultural Interest', PP 1880–82, 82: [C.3309]xiv; [C.3309–I]; [C.3309–II]; [C.2678]xviii; [C.3375–I]xv; [C.3375–II]; [C.3375–III]; [C.3375–IV]; [C.3375–V]; [C.3375–VI].

'Reports From the Select Committee and Others on Allotments and Small Holdings and Peasant Proprietors with Proceedings', PP 1888–94: (358).xviii; (313).xii; (223).xvII; [C.6250]lxxxiii; (122).lxviii.

'Reports of the Royal Commissioners on the Agricultural Depression,' PP 1894–97: [C.7400]xvi pt.I; [C.7400–II]; [C.7400–II] pt.II; [C.7400–III] xvI pt.III; [C.7981]xvi; [C.8021]xvii; [C.8146]; [C.8540]xv; [C.8541]; [C.8300]; [C.7365]xvi pt.I; [C.7372]; [C.7334]; [C.7374]; [C.7342]; [C.7728]xvi; [C.7691]; [C.7671]; [C.7755]; [C.7623]; [C.7624]; [C.7735]; [C.7842]xvii; [C.7871]; [C.7764]; [C.7915]; [C.7915–I]; [C.7625]; [C.7742]; [C.8125]xvi.

'Sixth Report of the Medical Officer of the Privy Council,' PP 1863, Cd. 3416 xxviii.i.

'Report on Wages and Earnings of Agricultural Labourers in the United Kingdom', PP 1900, Cd. 346 lxxxii. 557.

'Report and Wages, Earnings and Conditions of Employment of Agricultural Labourers in the United Kingdom,' PP 1905, Cd. 2376 xcvii. 335.

'Reports of the Inter-Departmental Committee on Physical Deterioration', PP 1904, Cd. 217 xxxii. 1 I; Cd. 2210 xxxii. 145 II; Cd. 2186 xxxii. 655 iii.

'Report on the Decline in the Agricultural Population of Great Britain 1881–1906', PP 1906, Cd. 3273 xcvi. 583.

'Reports on the Wages and Conditions of Employment in Agriculture', PP 1919, Cmd. 24 ix. 1 I; Cmd. 25 ix. 207 II.

Hansard's Parliamentary Debates

Third Series, lxxviii, clxxix-clxxxvii, ccx, ccxvi, cccl-cclvi.

Fourth Series, i-ii, ix-xxxiv, cxli, clxxiv.

Fifth Series, liii, lxx-lxxi.

NEWSPAPERS AND PERIODICALS

All the Year Round, A Weekly Journal Conducted by Charles Dickens, With Which is Incorporated Household Words

The Berwick Advertiser

The Central Somerset Gazette and Western Counties Advertiser

The Clarion

The Contemporary Review

Country Life: The Journal for all Interested in Country Life and Country Pursuits

Cumberland and Westmorland Herald

The Daily News

The Eastern Weekly Express

The Eastern Weekly Press

The Eastern Weekly Leader

The Edinburgh Review or Critical Journal

Eliza Cook's Journal

The English Labourer's Chronicle, or The Labourer's Union Chronicle and Journal of the National Agricultural Labourer's Organisation, or The Labourer's Union Chronicle

The Englishwoman's Review of Social and Industrial Questions

The Fife Herald, Kinross, Strathearn and Clackerman Advertiser

The Fortnightly Review

The Frome Times, Agricultural, Commercial and General Advertiser for Somerset, Wiltshire and Dorset

The Hexham Courant and South Northumberland Advertiser

The Illustrated London News

Journal of the Royal Agricultural Society

The Lady's Magazine, or Entertaining Companion for the Fair sex, Appropriated Solely to their Use and Amusement

Longman's Magazine

Macmillan's Magazine

Mark Lane Express, Agricultural Journal and Live Stock Record

The Morning Chronicle

The Norfolk News, Eastern Counties Journal and Norwich, Yarmouth and Lynn Commercial Gazette

The North of England Farmer and Northern Counties Gazette

The Pall Mall Gazette

Punch, or the London Charivari

The Quarterly Review

The Saturday Magazine
The Saturday Review of Politics, Literature, Science and Art
The Scots Observer, An Imperial Review
The Socialist Review
The Somerset County Gazette, Dorset Herald, Devon Courier and West of England Advertiser
The Spectator
The Times
The Women's Suffrage Journal

UNPUBLISHED THESES

Ainsworth, E., 'Ideology and rural society, c.1780s–1840s, in West Sussex' MA dissertation, University of Sussex, 1985.
Baker, C. M.,'Homedwellers and Foreigners: the Seasonal Labour Force in Kentish Agriculture', MPhil thesis, University of Kent, 1979.
Banks, S. J., 'Open and Close Parishes in Nineteenth Century England', PhD thesis, University of Reading, 1982.
Dyck, C. I., 'William Cobbett and the Farm Workers 1790–1835', PhD thesis, University of Sussex, 1986.
Marsh, J., 'Georgian Poetry and the Land', PhD thesis, University of Sussex, 1973.
Miller, C. A., 'Farming, Farm work and Farm Workers in Victorian Gloucestershire', PhD thesis, Bristol University, 1980.
Rodee, H. D., 'Scenes of Rural and Urban Poverty in Victorian Painting and Their Development 1850 to 1890', PhD thesis, Columbia University, 1975.

COUNTRY AND FARMING BOOKS

Andrews, G. H., *Modern Husbandry; A Practical and Scientific Treatise on Agriculture*, London, 1853.
Bacon, R. N., *The Report on the Agriculture of Norfolk, to Which the Prize was Awarded by the Royal Agricultural Society of England*, London, 1844.
Bourne, G., *Change in the Village*, London, 1959, 1st edn. 1912.
Cobbett, W., *Cottage Economy*, London, 1926, 1st edn. 1821.
—— *Rural Rides*, London, 1957, 1st edn. 1830.
Fordham, M., *The English Agricultural Labourer 1300–1925*, London, 1925.
Garnier, R. M., *Annals of the British Peasantry*, London, 1908.
Gilly, W. S., *The Peasantry of the Border: an Appeal in Their Behalf* Edinburgh, 1973, 1st ed. 1842.
Gould, S. B., *Old Country Life*, London, 1890.
Green, S. B., *The Tyranny of the Countryside*, London, 1913.
—— *A History of the English Agricultural Labourer 1870–1920*, London, 1927.
Gretton, S. M., *Burford Past and Present*, London, 1946, 1st edn. 1920.
Haggard, H. R., *Rural England, Being an Account of Agricultural and Social Researches Carried Out in the Years 1901–1902*, London, 1902.
Hammond, J. L. and B., *The Village Labourer 1760–1832*, New York, 1967, 1st edn. 1913.
Hasbach, W., *A History of the English Agricultural Labourer*, London, 1966, 1st edn., 1894.
Heath, F. G., *The English Peasantry*, London, 1874.
—— *Peasant Life in the West of England*, London, 1880.
Heath, R., *The English Peasant; Studies: Historical, Local and Biographic*, London, 1893.
Holdenby, C., *Folk of the Furrow*, London, 1913.

Howitt, W., *The Rural Life of England*, Shannon, 1971, facsimile of 3rd edn. 1844.

—— *The Boy's Country-Book*, London, 1880.

Hudson, W., *Nature in Downland*, London, 1925, 1st edn. 1900.

—— *A Shepherd's Life: Impressions of the South Wiltshire Downs*, London, 1910.

Jefferies, J. (ed), *Field and Hedgerow, Being the Last Essays of Richard Jefferies*, London, 1948, 1st edn. 1889.

Jefferies, R., *Hodge and His Masters*, London, 1966, 1st edn. 1880.

—— *The Toilers of the Field*, London, 1981, 1st edn. 1892.

Jessopp, A., *England's Peasantry and Other Essays*, London, 1914.

Kay, J., *The Peasant Proprietors, Vol. 1 of the Social Condition and Education of the People in England and Europe; Shewing the Results of the Primary Schools and of the Division of Landed Property in Foreign Countries*, Shannon, 1971, 1st edn. 1850.

Kebbel, T. E., *The Agricultural Labourer: A Short Summary of his Position, Partly Based on the Report of her Majesty's Commissioners Appointed to Inquire into the Employment of Women and Children in Agriculture, and Republished from the 'Pall Mall Gazette' and the 'Cornhill Magazine'*, London, 1870.

Marshall, W., *The Rural Economy of Norfolk*, London, 1795.

—— *Review and Abstract of the County Reports to the Board of Agriculture*, London, 1818, 1st edn. 1811.

Masterman, C. F. G., *The Condition of England*, London, 1910, 1st edn. 1909.

Matthews, A. H. H., *Fifty Years of Agricultural Politics, Being the History of the Central Chamber of Agriculture 1865–1915*, London, 1915.

Mingay, G. E. (ed), *The Agricultural State of the Kingdom in February, March and April 1816; Being the Substance of the Replies of Many of the Most Opulent and Intelligent Landholders to a Circular Letter Sent by the Board of Agriculture to Every Part of England, Wales and Scotland*, London, 1970, 1st edn. 1816.

Mitchell, G., *The Skeleton at the Plough, Or the Poor Farm Labourers of the West; with the Autobiography and Reminiscences of George Mitchell, 'One from the Plough'*, London, 1874.

Mitford, M. R., *Our Village*, London, 1893, 1st edn. in 5 parts, 1824–32.

Pedder, D. C., *Where Men Decay, A Survey of Present Rural Conditions*, London, 1908.

Perry, G. W., *The Peasantry of England, an Appeal to the Nobility, Clergy and Gentry on Behalf of the Working Classes, in which the Causes which have Lead to their Present Impoverishment and Degraded Condition, and the Means by which it May Best be Permanently Improved are Clearly Pointed out: the whole Drawn from Personal Observation and Patient Research and Illustrated by Numerous Interesting Facts, and Copious Statistical Data*, London, 1846.

Pringle, A., *General View of the Agriculture of the Country of Westmoreland, with Observations for the Means of Improvement, Drawn up for the Consideration of the Board of Agriculture and Internal Improvement*, London, 1805, 1st edn. 1793.

Raymond, W., *English Country Life*, London, 1910.

Rowntree, B. S. and Kendall, M., *How the Labourer Lives, a Study of the Rural Labour Problem*, London, 1913.

Somerville, A. *The Whistler at the Plough; Author of Letters 'One Who Has Whistled at the Plough' and Agricultural Customs in Most Parts of England, with Letters from Ireland: Also "Free Trade and the League": a Biographic History*, Manchester, 1852.

Anon. *The Standard Cyclopedia of Modern Agriculture and Rural Economy in 12 Volumes*, London, 1912.

Stephens, H., *The Book of the Farm, Detailing the Labours of the Farmer, Farm-Steward, Ploughman, Shepherd, Hedger, Farm-Labourer, Field-Worker, and Cattle-Man, in Six Divisions*, Edinburgh, 1891, 1st edn., 1844.

Thomas, E., *The South Country*, London, 1984, 1st edn. 1909.

Tuckett, J. D., *A History of the Past and Present State of the Labouring Population; Including the Progress of Agriculture, Manufacture and Commerce*, Shannon, 1971, 1st edn. London, 1846.

Whitehead, C., *Agricultural Labourers*, London, 1870.

Young, A., *The Farmer's Kalendar*, Wakefield, 1973, 1st edn. London, 1771.

DIARIES, BIOGRAPHY, AUTOBIOGRAPHY, AND MEMOIR

Arch, J., *The Story of His Life Told by Himself, and Edited with a Preface by the Countess of Warwick*, London, 1898.

Ashby, M. K., *Joseph Ashby of Tysoe 1859–1919, A Study of English Village Life*, London, 1974, 1st edn. 1961.

Baldry, G., (ed)., *The Rabbit Skin Cap, A Tale of A Norfolk Countryman's Youth*, London, 1950, 1st edn. 1939.

Bourne, G., *The Bettesworth Book, Talks with a Surrey Peasant*, London, 1902.

—— *Memoirs of a Surrey Labourer, A Record of the Last Years of Frederick Bettesworth*, London, 1907.

—— *Lucy Bettesworth*, Firle, 1978, 1st edn. 1913.

—— G., *William Smith, Potter and Farmer, 1790–1858*, London, 1919.

—— *A Farmer's Life, With a Memoir of the Farmer's Sister*, Firle, 1979, 1st edn. 1922.

—— *A Small Boy in the Sixties*, Cambridge, 1927.

Burn, J., *The 'Beggar Boy' An Autobiography: Relating Numerous Trials, Struggles, and Vicissitudes of a Strangely Chequered Life, With Glimpses of English Social, Commercial and Political History, During Eighty Years 1802–1882*, London, 1882.

Chamberlain, M., *Fenwomen, A Portrait of Women in an English Village*, London, 1975.

Cole, G. D. H., *William Cobbett*, London, 1925.

Davies, M. L. (ed), *Life as We Have Known it, By Co-Operative Working Women*, London, 1990, 1st edn. 1931.

Evans, G., *The Pattern Under the Plough – Aspects of the Folk-Life of East Anglia*, London, 1966.

—— *The Farm and the Village*, London, 1969.

—— *Where Beards Wag All – The Relevance of the Oral Tradition*, London, 1970.

—— *The Days That We Have Seen*, London, 1975.

—— *From the Mouths of Men*, London, 1976.

—— *Ask the Fellows Who Cut the Hay*, London, 1977.

Fletcher, R. (ed.), *The Biography of a Victorian Village: Ruth Cobbold's Account of Wortham, Suffolk 1860*, London, 1977.

Hardy, S. (ed), *The Diary of a Suffolk Farmer's Wife, A Woman of Her Time*, Basingstoke, 1992.

Harman, T., *Seventy Summers, The Story of a Farm*, London, 1987.

Hodder, E., *The Life and Work of the Seventh Earl of Shaftesbury, K.G.*, London, 1888.

Jermy, L., *The Memoirs of a Working Woman*, Norwich, 1934.

Jessopp, A., *The Trials of a Country Parson*, London, 1894.

Langdon, R., *The Life of Roger Langdon: Told by Himself With Additions by His Daughter Ellen*, London, 1909.

Luty, M., *A Penniless Globe Trotter*, Accrington, 1937.

Mackerness, E. D. (ed), *The Journals of George Sturt 1890–1927, in Two Volumes, a Selection*, Cambridge, 1967.

Mitchell, G. (ed.), *The Hard Way Up: The Autobiography of Hannah Mitchell, Suffragette and Rebel*, London, 1968.

Penn, M., *Manchester Fourteen Miles*, Firle, 1979, 1st edn. 1947.

Pentecost, E., *A Shepherd's Daughter*, Petworth, 1987.

Reid, R. D., (ed.), *The Diary of Mary Yeoman of Wanstrow, Co. Somerset*, Wells, c.1926.

Rose, W., *Good Neighbours: Some Recollections of an English Village and its People*, Cambridge, 1942.

Silvester, S., *In A World That Has Gone*, Leicesterm, 1968.

Smith, D., *No Rain in Those Clouds, Being and Account of My Father John Smith's Life and Farming From 1862, to the Present Day*, London, 1943.

Smith, I., *A Hired Lass in Westmorland, The Story of a Country Girl at the Turn of the Century*, Penrith, 1982.

Somerville, A., *The Autobiography of a Working Man, By 'One Who Has Whistled at the Plough'*, London, 1848.

Thompson, F., *Lark Rise to Candleford, A Trilogy*, Harmondsworth, 1979, 1st edns. 1939, 1941, 1943.

Unwin, C., *The Hungry Forties, Life Under the Bread Tax, Descriptive Letters and Other Testimonies From Contemporary Witnesses*, Shannon, 1971, 1st edn. London, 1904.

Williamson, Mrs., 'The Bondage System', in Anon., *Voices From the Plough*, Hawick, 1869.

SECONDARY SOURCES

Armstrong, A., *Farmworkers, A Social And Economic History 1770–1980*, London, 1988.

Banks, S. J., 'Nineteenth-century scandal or twentieth-century model? A new look at "open" and "close" parishes', *Economic History Review*, 2nd series, xii, 1988.

Barrell, J., *The Dark Side of the Landscape*, Cambridge, 1983.

Barret-Ducrocq, F., *Love in the Time of Victoria*, London, 1991, translated by Howe, J.

Barrett, M., Corrigan, P., Kuhn, A. and Wolff, J. (eds.), *Ideology and Cultural Production*, London, 1979.

Barthes, R., *Mythologies*, London, 1972.

Berger, J., Blomberg, S., Fox, C., Dibb, M., and Hollis, R., *Ways of Seeing*, Based on the BBC Television Series, London, 1984.

Bermingham, A., *Landscape and Ideology, The Rustic Tradition 1740–1860*, London, 1987.

Berridge, V., and Edwards, G., *Opium and the People, Opiate Use in Nineteenth Century England*, London, 1981.

Bradford Art Galleries and Museums and Tyne and Wear County Council Museums, *Sir George Clausen R.A., 1852–1944*, Bradford, 1980.

Bradley, H., *Men's Work: Women's Work, A Sociological History of the Sexual Division of Labour in Employment*, Cambridge, 1989.

Brettell, R. R., and C. R., *Painters and Peasants in the Nineteenth Century*, Geneva, 1983.

Brooker, P. and Widdowson, P., 'A literature for England' in Colls, R., and Dodd, P. (eds.), *Englishness: Politics and Culture 1880–1920*, London, 1987.

Carter, I., 'The Scottish peasantry' in Samuel, R. (ed.), *People's History and Socialist Theory*, London, 1981.

Chambers, J. D. and Mingay, G. E., *The Agricultural Revolution 1750–1880*, London, 1966.

Clark, T. J., *Image of the People: Gustave Courbet and the 1848 Revolution*, London, 1973.

Cohen, R., *The Unfolding of the Seasons*, London, 1970.

Collingwood, R. G., *The Idea of Nature*, Oxford, 1964.

Collins, B., *Charles Kingsley, The Lion of Eversley*, London, 1975.

Collins, E. J. T., 'Harvest technology and labour supply in Britain 1790–1870', *Economic History Review*, 2nd series, xxii, 1969.

—— 'Migrant labour in British agriculture in the nineteenth century' *Economic History Review*, 2nd series, xxix, 1976.

Cosgrove, D. and Daniels, S. (ed.), *The Iconography of Landscape: Essays on the Symbolic Representation, Design and Use of Past Environments*, Cambridge, 1988.

Cunningham, H., *The Children of the Poor – Representations of Childhood Since the Seventeenth Century*, London, 1991.

Davidoff, L., 'Class and gender in Victorian England' in Newton, J. L. *et al.*, *Sex and Class in Women's History: Essays from Feminist Studies*, London, 1985.

—— L'Esperance, J. and Newby, H., 'Landscape with figures: home and community in English society' in Mitchell, J. and Oakley, A., *The Rights and Wrongs of Women*, Harmondsworth, 1986.

—— and Hall, C., *Family Fortunes: Men and Women of the Middle Class 1780–1850*, London, 1987.

English, B., 'Lark Rise and Juniper Hill: a Victorian community in literature and history', *Victorian Studies*, 29, 1985.

Finlayson, G. B. A. M., *The Seventh Earl of Shaftesbury 1801–1885*, London, 1981.

Fisher, J. R., *Clare Sewell Read, 1826–1905, A Farmer's Spokesman of the Late Nineteenth Century*, Hull, 1975.

Fletcher, T. W., 'The great depression of English Agriculture 1873–1896' in Minchinton, W. E. (ed.), *Essays in Agrarian History*, Newton Abbot, 1968.

Foucault, M., *Power/Knowledge, Selected Interviews and Other Writings, 1972–1977*, (ed.) Gordon, C., Brighton, 1980.

—— *Discipline and Punish: The Birth of the Prison*, trans. A. Sheridan, Harmondsworth, 1979.

Fussell, G. E., *The English Rural Labourer: His Home, Furniture, Clothing and Food, From Tudor to Victorian Times*, London, 1949.

—— and K., *The English Countrywoman: A Farmhouse Social History AD 1500–1900*, London, 1953.

—— *The English Dairy Farmer 1500–1900*, London, 1966.

Gaskell, S. M., 'The making of a model village', *The Local Historian*, 16, 1984.

Gerard, J. A., 'Invisible servants: the country house and the local community', *Bulletin of the Institute of Historical Research*, lvii, 136, 1984.

—— 'Lady bountiful: women of the landed classes and rural philanthropy', *Victorian Studies*, 30, Winter 1987.

Goddard, N., 'The development and influence of agricultural periodicals and newspapers 1780–1880', *The Agricultural History Review*, 31, 1983.

Goode, J., 'Women and the literary text' in Mitchell, J. and Oakley, A., *The Rights and Wrongs of Women*, Harmondsworth, 1986.

Gramsci, A., *Selections from the Prison Notebooks*, ed. and trans. Hoare, Q. and Nowell Smith, G., London, 1971.

Gray, R., 'The languages of factory reform in Britain c.1830–1860' in Joyce, P. (ed.), *The Historical Meanings of Work*, Cambridge, 1987.

Green, D., *Great Cobbett: The Noblest Agitator*, London, 1983.

Green, N. and Mort, F., 'Visual representation and cultural politics', *Block*, no.7, 1982.

Harman, B. L., 'In promiscuous company: female public appearance in Elizabeth Gaskell's *North and South*', *Victorian Studies*, 31, 1987–88.

Higgs, E., 'Women, occupations and work in the nineteenth century censuses', *History Workshop*, 23, 1987.

Hobsbawm, E. and Rudé, G., *Captain Swing*, London, 1969.

Hollis, P., *Ladies Elect, Women in English Local Government 1865–1914*, Oxford, 1987.

Horn, P., *Labouring Life in the Victorian Countryside*, London, 1976.

—— 'The employment of children in Victorian Oxfordshire', *Midland History*, iv, 1977.

—— 'Rural unionism in the 1890's: the Berkshire agricultural and general workers union' *Local History*, 13, 1979.

—— 'The recruitment, role and status of the Victorian country teacher,' *History of Education*, 9, 1980.

—— 'Victorian villages from census returns', *Local History*, 15, 1982.

Hostettler, E., 'Gourlay Steell and the sexual division of labour', *History Workshop*, 1977.

Howkins, A., *Poor Labouring Men, Rural Radicalism in Norfolk 1870–1923*, London, 1985.

—— 'The discovery of rural England' in Colls, R. and Dodd, P. (eds.), *Englishness: Politics and Culture 1880–1920*, London, 1987.

—— *Reshaping Rural England, A Social History 1850–1925*, London, 1991.

Hudson, H., *Munby, Man of Two Worlds, The Life and Diaries of Arthur J. Munby 1828–1910*, London, 1974.

James, L., 'Landscape in nineteenth century literature' in Mingay, G.E. (ed.), *The Victorian Countryside*, London, 1981.

John, A., *By the Sweat of their Brow, Women Workers at Victorian Coal Mines*, London, 1984.

Jones, D., 'Thomas Campbell Foster and the rural labourer: incendiarism in East Anglia in the 1840's', *Social History*, 1976.

Juneja, M., 'The peasant image and agrarian change: representations of rural society in nineteenth century French painting from Millet to Van Gogh', *Journal of Peasant Studies*, 15, 1988.

Kaplan, C., *Sea Changes: Essays on Culture and Feminism*, London, 1986.

Keith, W. J., 'The land in Victorian literature' in Mingay, G. E. (ed.), *The Victorian Countryside*, London, 1981.

—— *The Rural Tradition: William Cobbett, Gilbert White and Other Non-Fiction Prose Writers of the English Countryside*, Toronto, 1975.

—— *The Poetry of Nature: Rural Persepctives in Poetry From Wordsworth to the Present*, Toronto, 1980.

Kerr, B., *Bound to the Soil: A Social History of Dorset 1750–1918*, London, 1968.

King, P., 'Gleaners, farmers and the failure of legal sanctions in England 1750–1850', *Past and Present*, 1989.

Kitteringham, J., 'Country work girls in nineteenth century England' in Samuel, R. (ed.), *Village Life and Labour*, London, 1975.

Mackay, J., and Thane, P., 'The Englishwoman' in Colls, R. and Dodd, P. (eds.), *Englishness: Politics and Culture 1880–1920*, London, 1987.

Marsh, J., 'The unemployed and the land', *History Today*, 32, 1982.

—— *Back to The Land, The Pastoral Impulse in Victorian England From 1880–1914*, London, 1982.

McConkey, K. (ed.), *Peasantries*, Newcastle, 1981.

MacDonald, S., 'Agricultural improvement and the neglected labourer', *Agricultural History Review*, 31, 1983.

McNelly, C., 'Natives, women and Claude Levi-Strauss, a reading of *Tristes Tropiques* as myth', *Massachusetts Review*, 16, 1975.

Mendus, S. and Rendall, J. (eds.), *Sexuality and Subordination: Interdisciplinary Studies of Gender in the Nineteenth Century*, London, 1989.

Miller, C., 'The hidden workforce: female fieldworkers in Gloucestershire 1870–1901', *Southern History*, 6, 1984.

Mingay, G. E. (ed.), *The Agrarian History of England and Wales*, vi *1750–1850*, series ed. Thirsk, J., Cambridge, 1989.

Moi, T., *Sexual/Textual Politics: Feminist Literary Theory*, London, 1985.

Morgan, D. H., *Harvesters and Harvesting 1840–1900: A Study of The Rural Proletariat*, London, 1982.

Mort, F., *Dangerous Sexualities: Medico-Moral Politics in England Since 1830*, London, 1987.

Nead, L., *Myths of Sexuality: Representations of Women in Victorian Britain*, Oxford, 1988.

Newby, H., *Country Life: A Social History of Rural England*, London, 1987.

Newton, J. and Rosenfelt, D. (eds.), *Feminist Criticism and Social Change, Sex, Class, and Race in Literature and Culture*, New York, 1985.

Obelkevich, J., *Religion and Rural Society: South Lindsey 1825–1875*, Oxford, 1976.

Ortner, S. B., 'Is the female to male as nature is to culture?' in Rosaldo, M. Z. and Lamphere, L. (eds.), *Woman, Culture and Society*, Stanford, 1974.

Pinchbeck, I., *Women Workers and The Industrial Revolution 1750–1850*, London, 1985, 1st edn. London, 1930.

Porter, J. H., 'The "revolt of the field": the Devon response,' *Southern History*, 7, 1985.

Prime, H., 'Art and agrarian change, 1710–1815' in Cosgrove, D. and Daniels, S. (eds.), *The Iconography of Landscape: Essays on The Symbolic Representation, Design and Use of Past Environments* Cambridge, 1988.

Reed, M., 'The peasantry of nineteenth century England: a neglected class?', *History Workshop*,1984.

—— 'Indoor farm service in nineteenth century Sussex: some criticisms of a crtitique', *Sussex Archaeological Collections*, 123, 1985.

Reitzel, W. (ed.), *The Autobiography of William Cobbett: The Progress of a Ploughboy to a Seat in Parliament*, London, 1947.

Rendall, J., *The Origins of Modern Feminism, Women in Britain, France and The United States, 1780–1860*, London, 1985.

Roberts, E., *Women's Work 1840–1940*, London, 1988.

Roberts, M., '"Words they are women and deeds they are men": images of work and gender in Early Modern England', Charles, L. and Duffin, L. (eds.), in *Women and Work in Pre-Industrial England*, London, 1985.

—— 'Scickles and scythes: women's work and men's work at harvest time', *History Workshop*, 7–8, 1979.

Robertson, B. W., 'In bondage: the female farm worker in South East Scotland', in Gordon, E. and Breitenbach, E. (eds.), *The World is Ill Divided, Women's Work in Scotland in The Nineteenth and Early Twentieth Centuries*, Edinburgh, 1990.

Sales, R., *English Literature in History 1750–1830, Pastoral and Politics*, London, 1983.

Scarry, E., 'Work and the body in Hardy and other nineteenth century novelists', *Representations*,1983.

Seccombe, W., 'Patriarchy stabilized: the construction of the male breadwinner wage norm in nineteenth century Britain', *Social History*, 11, 1986.

Short, B., 'The decline of living-in servants in the transition to capitalistic farming: a critique of the Sussex evidence', *Sussex Archaeological Collections*, 122, 1984.

Short, B., 'A rejoinder', *Sussex Archaeological Collections*, 123, 1985.

Snell, K. D. M., 'Agricultural seasonal unemployment, the standard of living, and women's work in the South and East 1690–1860', *Economic History Review*, 34, 1981.

—— *Annals of the Labouring Poor*, Cambridge, 1985.

Somerville, J., `Women, a reserve army of labour?', *M/F*, no. 7, 1982.

Spear, J. L., *Dreams of an English Eden: Ruskin and his Tradition in Social Criticism*, New York, 1984.

Springall, L. M., *Labouring Life in Norfolk Villages 1834–1914*, London, 1936.

Stack, J. A., 'The provision of reformatory schools, the landed class and the myth of the superiority of rural life in mid-Victorian England', *History of Education*, 8, 1979.

Stallybrass, P., and White, A., *The Politics and Poetics of Transgression*, London, 1986.

Stanley, L. (ed.), *The Diaries of Hannah Cullwick, Victorian Maidservant*, London, 1984.

Thane, P., 'Women and the Poor Law in Victorian and Edwardian England', *History Workshop*, 1978.

Treble, R., 'The Victorian picture of the country' in Mingay, G. E . (ed.), *The Victorian Countryside*, London, 1981.

Valenze, D., 'The art of women and the business of men: women's work and the dairy industry c.1740–1840', *Past and Present*, 130, 1991.

Valverde, M., '"Giving the female a domestic turn": the social, legal, and moral regulation of women's work in British cotton mills 1820–1850', *Journal of Social History*, 21, 1987–88.

—— 'The love of finery: fashion and the fallen woman in nineteenth century social discourse' *Victorian Studies*, 32, 1989.

Vance, N., *The Sinews of the Spirit: The ideal of Christian Manliness in Victorian Literature and Religious Thought*, Cambridge, 1985.

Vaughan, W., 'Leisure and toil: differing views of rural life 1750–1850' in Spargo, D. (ed.), *This Land Is Our Land: Aspects of Agriculture in English Art*, London, 1989.

Weissman, J., *Half Savage and Hardy and Free: Women and Rural Radicalism in the Nineteenth Century Novel*, Connecticut, 1987.

Williams, M., *Thomas Hardy and Rural England*, London, 1977.

Williams, R., *Cobbett*, Oxford, 1983.

—— *The Country and the City*, London, 1985.

Wood, C., *Paradise Lost: Paintings of English Country Life and Landscape 1830–1914*, London, 1988.